BALTIMORE HARBOR

BALTIMORE

ROBERT C. KEITH

HARBOR

A Pictorial History

THIRD EDITION

THE JOHNS HOPKINS UNIVERSITY PRESS

Baltimore and London

In memory of
Mother, ever encouraging,
and Dad, who taught us to prowl
the waterfront and enjoy the ships

© 1982, 1985, 1991, 2005 Robert C. Keith
All rights reserved. Published 2005
Printed in the United States of America on acid-free paper
9 8 7 6 5 4 3 2 1

First published, as *Baltimore Harbor: A Picture History,*
by Ocean World Publishing Co., 1982
Revised 1985
Johns Hopkins Paperbacks edition, 1991
Third edition, 2005

The Johns Hopkins University Press
2715 North Charles Street
Baltimore, Maryland 21218-4363
www.press.jhu.edu

Library of Congress Cataloging-in-Publication Data

Keith, Robert C.
Baltimore harbor : a pictorial history / Robert C. Keith.—3rd ed.
 p. cm.
Includes index.
ISBN 0-8018-7980-9 (pbk. : alk. paper)
1. Harbors—Maryland—Baltimore—History. I. Title.
HE554.B3K44 2005
387.1'09752'6—dc22 2004011283

A catalog record for this book is available
from the British Library.

TITLE PAGES: Looking southeast over Baltimore harbor, 1981.
David W. Harp. Baltimore Sunpapers

Baltimore—that sleepy, dreamy city.
I don't think there's anything you can do to make it loud.

—GERTRUDE STEIN

CONTENTS

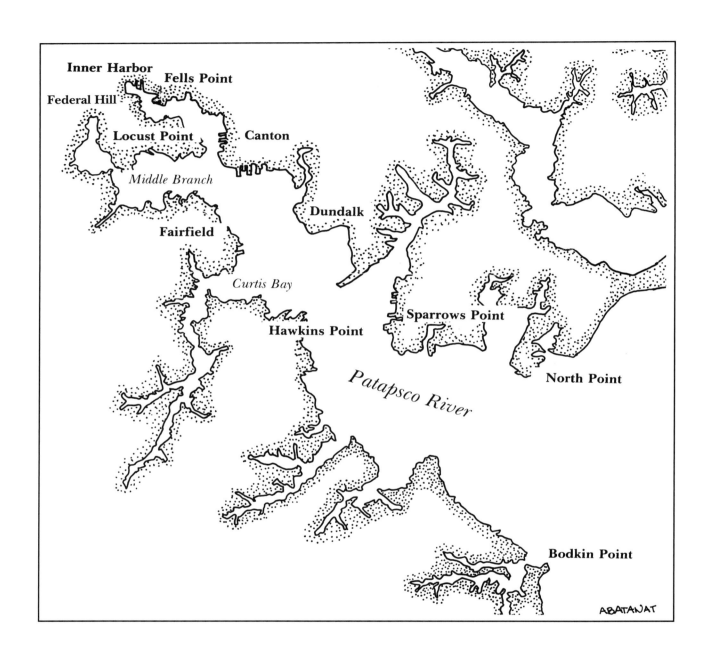

Inner Harbor

Fells Point

Federal Hill

Locust Point

Canton

Middle Branch

Dundalk

Fairfield

Curtis Bay

Hawkins Point

Sparrows Point

North Point

Patapsco River

Bodkin Point

ABATANAT

PREFACE

This book will take you on an imaginary voyage through the coves and inlets of a wonderful old American seaport.

Baltimore harbor, like the city which has arisen around it, is made up of a series of neighborhoods, each with its distinctive maritime history and personality.

We will visit them all, noting some of the major episodes that have marked their past and the changes that have taken place over the years, some of them rather startling.

For the purposes of this book, I have given a very broad definition to the term *Baltimore harbor*, making it almost synonymous with the entire Patapsco River estuary. Old-timers tend to think of the "real" harbor as the part west of Fort McHenry and Lazaretto Point. But that definition leaves out the busy outer harbor, where most of the commercial action takes place today. For historical and practical reasons the book includes the harbor approaches at the Patapsco's mouth, which afford the first shelter for small craft visiting Baltimore. All of the points listed in the table of contents will take on clear identities, from the perspective of the waterfront, as you progress through the book.

The geographical format provides an easy introduction to the harbor for any who come to Baltimore

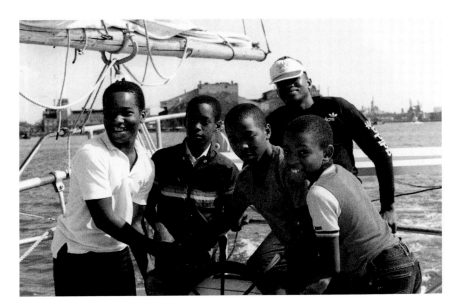

Students discover Baltimore's water world
behind the wheel of the skipjack, *Minnie V.*
Photo by Arnett Brown

for business or pleasure. I am proud that earlier editions of this book have been selected by the Maryland Port Administration as a regular part of the welcoming package it gives to captains of cargo ships entering the port for the first time.

In revising this book in 1985, the most surprising thing to me was the need to relegate to the past tense—after only three years—such hallowed harbor institutions as Maryland Shipbuilding and Drydock in the Middle Branch, Bethlehem Steel's ship repair yard on Federal Hill, Allied Chemical's world-class Chrome Works in Fells Point, and the massive Western Electric cable factory in Dundalk.

The "deindustrialization" of the harbor, and its ensuing "gentrification," were well under way. By 1988, regulation of rail rates was wreaking havoc with the very business of the harbor—moving cargo—as competing ports to the south jockeyed for advantage. Said the Baltimore *Sun* that year: "Baltimore is getting clobbered by the Virginia Port Authority." Job loss on the docks moved apace with job loss in the factories, and the proliferation of "service" jobs—seasonal sales clerks and low-wage cleanup crews at Harborplace—was no substitute.

In updating the book after twenty-two years, the changes to be found along the waterfront are seismic, but mostly for the good. One of Baltimore's secrets is economic diversity. The Johns Hopkins medical institutions in East Baltimore have replaced Bethlehem's Sparrows Point steel plant as the state's largest private employer. The buildings of American Can in Canton and the Procter and Gamble soap factory on the Locust Point waterfront have been made into prime office sites and incubators for new mechanical and biological technologies. Fairfield has not become beautiful, but it hosts a conglomeration of multinational companies fueling the economy.

Proximity to Washington, D.C., is another city asset. When it comes to filling office spaces, selling waterfront condos, and sustaining the tourist flow, Baltimore has a place to turn, especially once rapid rail connections more efficiently bind the two urban centers. Meanwhile, ships call and an invigorated Maryland Port Administration is anything but down for the count.

◪ ◪ ◪

The idea for this book arose from my participation on a committee for the programming of the lightship *Chesapeake.* The little red ship was brought to the

Inner Harbor by the City of Baltimore in 1981, on indefinite loan from the National Park Service.

It was evident that the vessel could serve as a base for harbor education programs. But there was a shortage of teaching materials—and especially any materials that would introduce teachers and students to history, economics, and all the other factors that make the seaport of Baltimore tick. Compulsion got the better of me in the winter of 1981–82 and I tackled this project. I am by trade an editor and writer, not an historian or educator. This is not a textbook, but, to my delight, it has provided a frame of reference for several educational programs.

The first educational user was the Chesapeake Bay Foundation, which moved its harbor environmental studies program to the lightship, utilizing portions of the crew areas as classroom space to supplement trips on the foundation's boat *Osprey.* Foundation educators critiqued the book during its development, and later put it to use to broaden the scope of their program.

After 1983, the book undergirded an educational program of my own making—tours of the old port section under sail aboard the skipjack *Minnie V.* (for Vetra—an Eastern Shore family name). This classic Chesapeake oyster dredge boat was rebuilt by the city in 1981 and placed in the custody of the Maryland Historical Society for winter dredging and summer use in the harbor. Working with the society, I set up a subcharter to Ocean World Institute, Inc., and managed to get the vessel certified by the Coast Guard to carry twenty-four passengers when its oystering gear was removed. This was a first for a shallow-draft skipjack and cleared the way for public tours as well as special programs for students. We used the harbor to develop a field experience in social studies—to complement what the Chesapeake Bay Foundation offers in environmental science. In 1986 a new organization—later to become the Living Classrooms Foundation—introduced educational programs aboard its beautiful new *Lady Maryland,* a reproduction of the extinct Chesapeake Bay "pungy" schooner. The foundation subsequently added several vintage Chesapeake Bay boats, including the *Minnie V.,* to its fleet, greatly enlarging the coverage of maritime educational activities in the harbor.

ACKNOWLEDGMENTS

As this book goes into its seventh printing in a revamped edition, I am honored to continue under the imprimatur of the Johns Hopkins University Press. My first "publisher" would be pleased also. When Charles M. Connor and I sat down together in the summer of 1982 with rough text and folders of pictures, we persuaded ourselves that the book would command popular interest. Mr. Connor's support was instrumental in enabling my own small publishing company to bring the book quickly to press. Unfortunately he did not live to see his judgment vindicated. He died of heart failure on August 22, 1982, before the book was printed.

Mr. Connor was president of John S. Connor, Inc., a firm started by his father in 1917 to provide diversified maritime agency services to freight shippers, steamship companies, and others. When he died, his brother, Paul F. Connor, succeeded him as head of the company. One of Paul's first acts was to carry through on Charles's commitment to the book. An advisory committee formed by Charles before his death was convened to advise on distribution of the book and to seek a living memorial from its proceeds. It was a privilege to work with such an all-star panel: Nancy Brennan, Paul F. Connor, Margaret E. Dougherty, Mary Ellen Hayward, Robert S. Hillman, Sandra S. Hillman, Donald Klein, Daniel J. Loden, George M. Radcliffe, Walter Sondheim, Jr., Jean Van Buskirk, and Henry Weil.

With proceeds from this book and additional monies, the Charles M. Connor Memorial Library Fund was established in 1984 for the annual purchase of maritime books, periodicals, and materials for the University of Baltimore's maritime library on North Charles Street. The scope has since expanded to cover general transportation and world trade.

The logistical help from the Connor Company, and from Paul Connor, Rich Higgins, Bonnie Ciboroski, and Jeanette Myers in particular, made distribution of the book a joyful experience, especially our rush back to the printers when the first 5,000 copies sold out after a few weeks. Total sales have now exceeded 25,000.

I repeat my thanks to many who were honored in person at our publication party on Pier 4 in October 1982: Laurie Baty, Paula Velthuys, and Eric Kvalsvik, who gave such cheerful help in bringing into the book the rich pictorial resources of the Maryland Historical Society, and Lynn Cox and Anne Deckret, who provided similar help with the photo collections at the Peale Museum. I remain indebted to Don Meyers, Lucille Langlois, Eileen Kelly, Jerry Smith, Steve and Nancy Smith, Richard Lay and Janet Harvey from the Chesapeake Bay Foundation, Fred Kelly of the Balti-

more Gas and Electric Company, Dave Harp, Clem Vitek and Fred Rasmussen from the *Sun,* Ben Wolmer of the Dundalk-Patapsco Neck Historical Society, and Laura Brown, who knew every photo in the University of Baltimore's Steamship Historical Society Library.

The book owes much to the published works of three pathfinders in the recording of Baltimore harbor history—Robert H. Burgess, H. Graham Wood, and Norman G. Rukert—and in appearance to the imaginative map work by Amy Atanat and the production efforts of Judy Jenner.

The expanded new edition has profited greatly in content and looks from the gentle guidance of Robert J. Brugger, regional book editor of the Johns Hopkins University Press, and the innovative design work of Kathleen Szawiola. I also want to thank acquisitions assistants Melody Herr and Amy Zezula and my neighbor Jacquie Greff for easing my introduction to the digital world, and senior manuscript editor Anne Whitmore, who, forced to read every word, saved me from embarrassments and helped bring clarity and polish to the text. I am grateful also to Rebecca Barber for helping me tap the photo and information resources of the Maryland Port Administration, Neville Sinclair for explaining the mysteries of Fairfield, and Trudy Slinger for her darkroom magic in turning a writer's snapshots into photos for publication.

Over the years a number of persons have taken the time to say a kind word or to share their own personal recollections or to point out errors or omissions. I thank you all for your comments and help.

BALTIMORE HARBOR

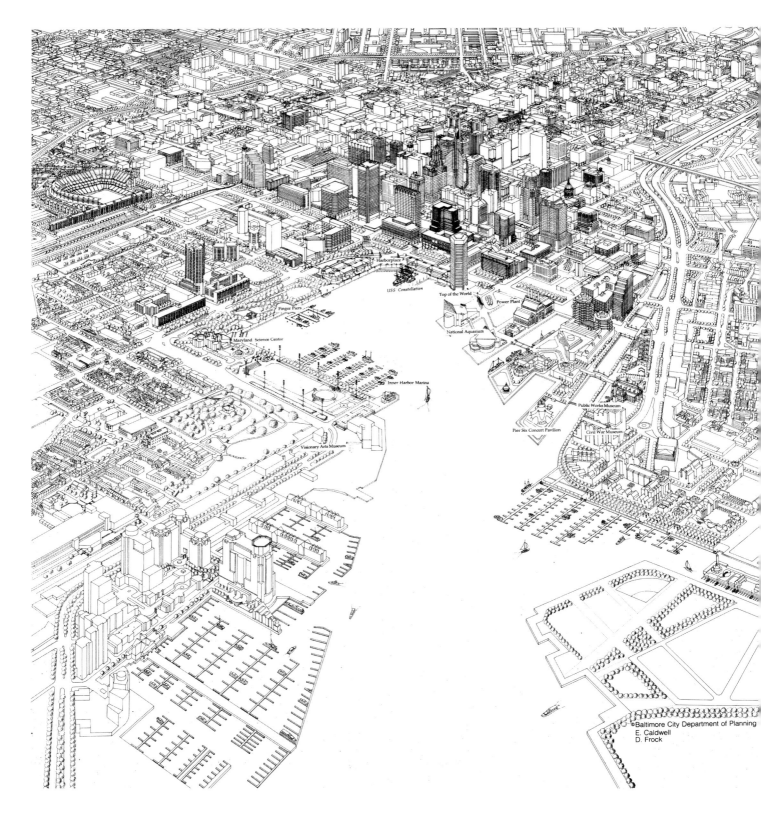

Artist's rendering of a 1989 plan for Baltimore Harbor. Baltimore City Department of Planning

QUEEN OF THE BAY

Baltimore's Inner Harbor. What image does that bring to mind? For younger generations, it suggests paddle boats, pleasure yachts, lively nightlife, the smart shops of Harborplace.

But for our fathers and mothers, and their fathers and mothers, mention of the harbor would suggest something quite different—creaky wooden piers, rats scurrying about, the deep-throated blasts of steamboat whistles rending the air, and the smell of smokestacks.

For a century and a half, until well within the memory of many living persons, Baltimore was the steamboat hub of Chesapeake Bay. The shallow waters of the Inner Harbor, inhospitable to deep-draft ocean ships, were perfectly suited for mooring paddlewheel steamers in the heart of downtown. The steamboats poked their noses into the Light Street piers about where the Harborplace food pavilion now sits, or perhaps further south, bursting with vegetables, seafood, and passengers from down the bay and imparting an aroma and excitement never to be forgotten.

STORIED PAST

At North Point, which commands a view of the entrance to the Patapsco River, an observer in 1796

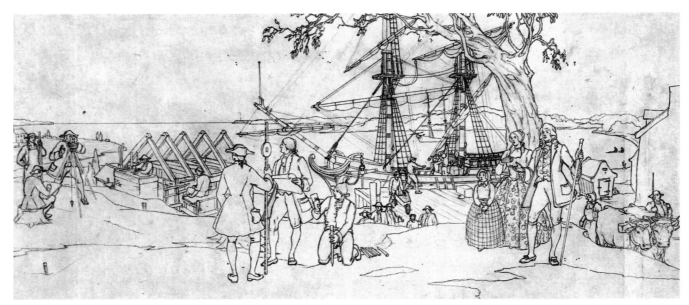

A conjectural view of the development of Baltimore Town, surveying under way, in the early 1730s. R. McGill Mackall, Maryland Historical Society

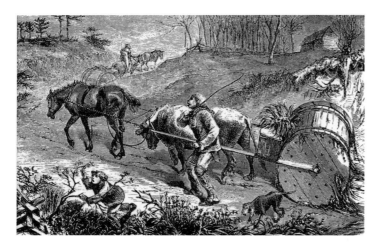

A depiction of how planters rolled hogsheads—large barrels—of tobacco to shipping points in the 1700s. The pathways between plantations or farms and the water naturally became known as "rolling roads." *Harper's Weekly*, 1869

Baltimore, 1752. How the town looked—with 25 houses, 200 residents and one pier in shallow water—when Dr. John Stevenson shipped an experimental cargo of flour to Ireland. The trade he set in motion helped turn the sleepy harbor into a major seaport. This view from what became Federal Hill is modeled on a drawing by John Moale, whose father owned land and operated a store on the Middle Branch of the Patapsco, a few miles to the south. J. Thomas Scharf, *History of Baltimore City and County*

kept track of shipping traffic with a telescope. That year he counted 109 ships, 162 brigs, 350 schooners and sloops, and 5,464 assorted Chesapeake Bay craft, all making their way toward Baltimore harbor. Both the number and variety of vessels make clear the extent to which Baltimore dominated bay commerce at that time.

In this book we will follow the evolution of the harbor from the very beginning to modern times. It is hard to imagine, looking at Baltimore's jumbled commercial shoreline, that at one time all of it was nothing but marsh and trees. Yet that is what Capt. John Smith and his party saw when they sailed up the Patapsco River in 1608. Sixty years after Smith's visit and thirty-four years after the arrival of the first settlers in southern Maryland, Thomas Cole obtained a warrant for 550 acres of land in Baltimore County, at the place where Jones Falls enters the Patapsco River—

the present-day Inner Harbor. He called the surrounding basin of water Cole's Harbor. It was a shallow basin in those days and saw few ships. The Jones Falls outlet was a wide marsh. Water extended north to the present Water and Gay streets and west to the present Charles Street. One dirt road, later to be called Calvert Street, led to the water, and at that juncture stood a county tobacco wharf, about where Lombard crosses Calvert today.

In 1729, some local entrepreneurs obtained a charter to establish Baltimore Town on a portion of Cole's land. (The name was brought to America by the English Lord Baltimore, who founded the Maryland colony in 1634. It derived from a town on the eastern shore of St. George's Channel, County Cork, in Ireland; the Irish *Beal-Ti-Mor* means great place or circle of Baal, the Sun God.) A few years later another charter was obtained, for a town to the east, on the other

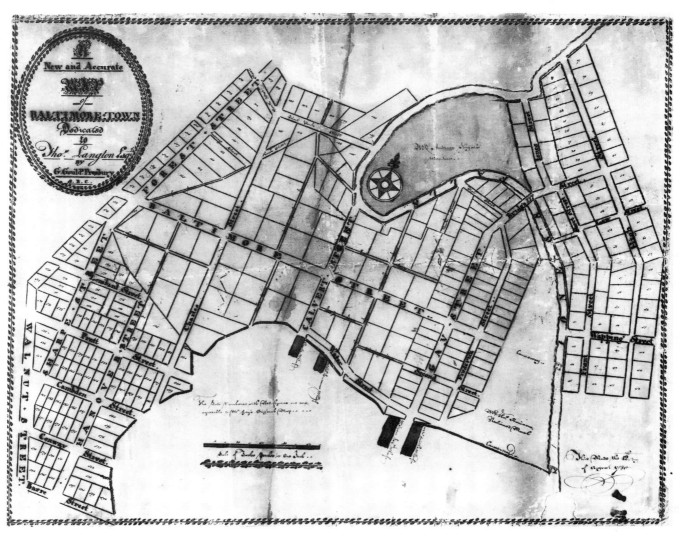

Piers in 1780. Baltimore's harbor was quite shallow at the single wharf, at the end of Calvert Street (*broad north-south street at center*) until the mid-1700s. Local merchants then began the construction of long finger piers in an effort to reach deeper water. William Buchanan and John Smith each built a long wharf of pine cord in 1759; William Spears built a 1,000-foot pier five years later. In 1783, the Ellicott brothers built a wharf at Pratt and Light streets, at the center of what is now Harborplace, to export the flour produced at their giant mill west of the city. Maryland Historical Society

FACING PAGE:

Baltimore after the American Revolution. A. P. Folie drew this map in 1792, four years before the assembly incorporated Baltimore as a city. By this time, Jones Town (*top center, east of Jones Falls*) and Fells Point (*farther east, ending in the hook*) lay within the boundaries of Baltimore, and the town's population was growing briskly. Charles Street bounded the harbor on the west. Beyond the Jones Falls (*at center running south from top of map*) Wilks Street (now Eastern Avenue) ran along the north side, and Bond Street in Fells Point marked the eastern boundary. The Jones Falls outlet was still a marsh, and residents needed to go north to King George's Street (now Lombard) to cross it. The Folie map also depicts a canal that after 1783 ran from the foot of Calvert Street north a long block, up to Water Street. The area of the canal, which Captain John Daniel Danels used as a base for his fleet of British-bashing privateers, carried the name Cheapside, after an unsavory dock area in London. Authorities filled in the canal in 1814 so as to extend Pratt Street as a continuous street across the northern edge of the port. In 1984, during excavation for the parking garage under the Gallery shopping center, archeologist Elizabeth Comer and her team, working for the city and the developer, the Rouse Company, unearthed Cheapside's heavy wharf timbers and artifacts ranging from tools to pieces of Chinese porcelain. Maryland Historical Society

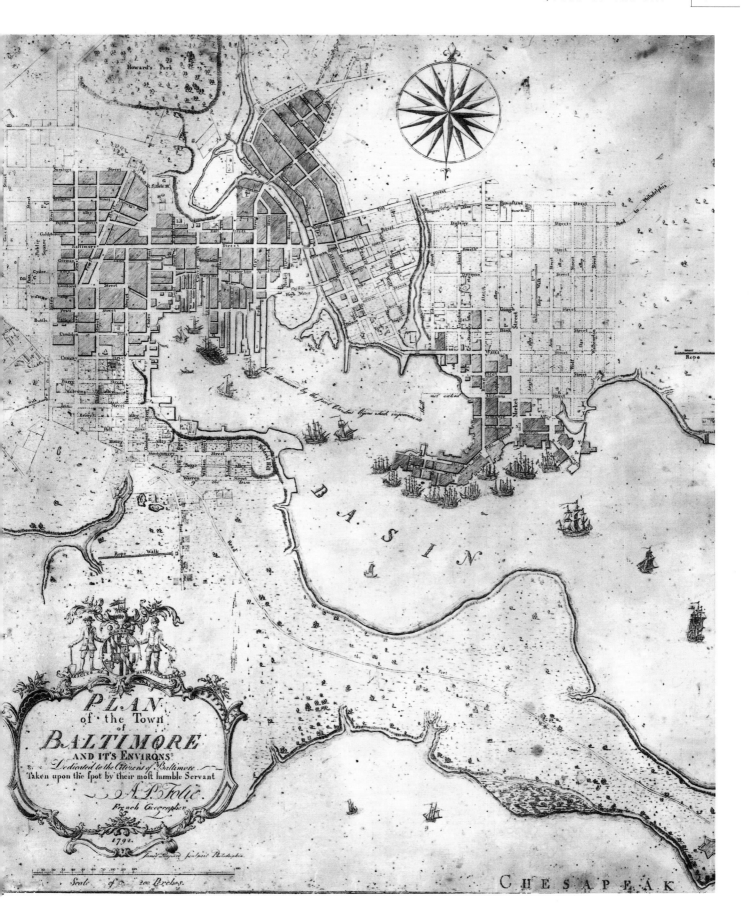

PLAN
of the Town
of
BALTIMORE
AND IT'S ENVIRONS
Dedicated to the Citizens of Baltimore
Taken upon the spot by their most humble Servant
A. P. Folie
French Geographer

1792

Scale of 200 Perches.

CHESAPEAK

side of Jones Falls, to be called Jones Town (now Old Town) after David Jones, who had settled and opened a store there in 1661. Among those involved in the Jones Town development were the Fell brothers, Edward and William. Edward had arrived from England in 1726 and set up a store on what was to be the Jones Town site. William, a carpenter from Lancashire, arrived four years later and purchased a 100-acre tract a mile or so to the south, on an indentation of water called Copus Harbor, where he erected a mansion and small shipyard. By the time of his death in 1746, William Fell had expanded his Copus Harbor holdings to 1,100 acres. His son Edward laid these off as the town of Fells Point in 1763.

No one could have foreseen that these hamlets, Baltimore Town, Jones Town, and Fells Point, would one day form the core of a great city, because for much of the eighteenth century, the Patapsco remained a sleepy backwater of the Chesapeake. Its few residents concerned themselves with the production of tobacco. The seat of Baltimore County was at Joppa, some twenty miles to the northeast. Everyone assumed that the main business of the river would continue to be tobacco—growing it and curing it, packing it in wooden "hogsheads," and shipping it to Europe.

Then, in 1750, an Irish-born physician, John Stevenson, arranged for the shipment from Baltimore of a cargo of flour, as an experiment. The flour was well received in Stevenson's native Ireland because of its purity and resistance to mold. He arranged for additional shipments, becoming a merchant himself and building a warehouse. He was recognized, even in his own time, as the true founder of Baltimore, the man who saw that it should become the port for America's export of flour. Geography favored this role for Baltimore: she had access to the sea, on the one hand, and to the wheat fields of Pennsylvania and Maryland on the other; and she was very near the "fall line," where rivers like the Patapsco, Gwynns Falls, and Jones Falls drop steeply from the interior plateau to tidewater, providing a means of power to operate mills.

Growth came swiftly in the ensuing years. A major shipbuilding industry arose at Fells Point and Federal Hill. The first Baltimore steamboat was built here in 1813. The nation's first public carrier railroad, the Baltimore and Ohio, was started in 1827, ultimately connecting the Patapsco wharves at Locust Point with the coalfields of Appalachia and the towns and grainfields of the Midwest. Later came the Western Maryland Railroad, connecting with the Norfolk and Western Railroad, and the Pennsylvania (later Conrail), which constructed its wharves on the northeast side of the city, at Canton.

The advent of steam power meant that vessels out of Baltimore could crisscross Chesapeake Bay on regular schedules, strengthening the city's domination of the region. Baltimore thus became "Queen" of the bay—the principal market for its produce, the region's financial and cultural leader, and the place to which residents of small towns around the bay went to shop.

Baltimore's influence was not limited to the Chesa-

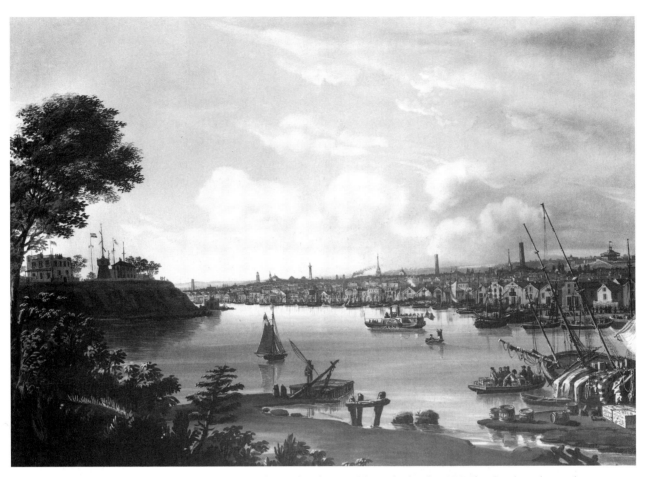

This gouache (opaque watercolor) by Italian artist Nicolino Calyo shows Baltimore harbor in 1836. The view is to the northwest from Locust Point and brings the buildings at right, at the foot of Jones Falls, a bit closer than they were in reality. At center, the steamboat *George Washington* is arriving from Philadelphia. On the left is Federal Hill, with its observation tower and signal flags; at its base is a glass factory. The 37-by-50½-inch painting hangs at the Baltimore Museum of Art, which first learned of it in 1974, when it came to auction from a private collection in Mexico City. Baltimore Museum of Art

peake. Until the Civil War disrupted trade patterns, Baltimore served as a commercial gateway to the South, financing its ventures, exporting its cotton, and sending it wholesale and retail goods from the North and abroad.

And that was not all. Because of the fortunes of geography, Baltimore became, and remains, a seaport for the Midwest, serving as a funnel through which much of that region's commerce passes on the way to and from the Atlantic Ocean and the world beyond. In 1852 Baltimore's great experiment in commercial railroading, the Baltimore and Ohio, made good on

its promise and reached Wheeling, West Virginia (then part of Virginia), on the Ohio River. Ever after, promoters of the port have pitched the city's proximity to the interior of the country. "We are 140 miles nearer to Chicago than is New York," wrote a Baltimore shipping agent in 1882, trying to drum up business, "289 miles nearer to Cincinnati and 249 nearer to St. Louis."

Baltimore's fortuitous position astride these three strands of commerce—the Chesapeake Bay, the South, and the Midwest—made her a natural point for the stockpiling, warehousing, and redistribution

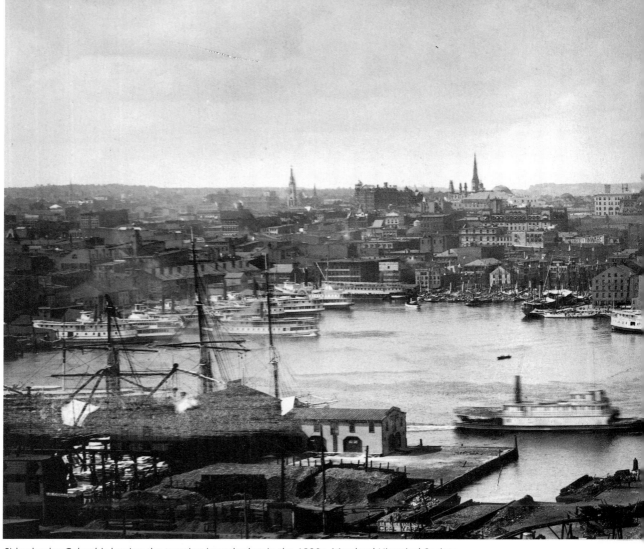

Sidewheeler *Columbia* leaving the teeming inner harbor in the 1890s. Maryland Historical Society

of goods. It led also to the rise of industries for processing and packaging: canning of vegetables and oysters, refining of petroleum, processing of bird droppings and chemicals into fertilizer, milling of wheat into flour and of iron into steel. And so, waterfront industry grew hand in hand with waterfront commerce.

In the 1840s, Thomas Kensett, Jr., a young man from New York, set up a small cannery at the foot of Federal Hill. He found a practical method of cooking and preserving oysters and vegetables in tin-coated iron canisters. As a result, Baltimore grew into the world's greatest food-canning center, a position it held until the middle of the twentieth century, when

packing houses were established on the Eastern Shore, closer to the sources of supply. The coming of electric refrigerators and frozen foods had further impact on the canning industry.

Baltimore in 1832 became the first American city to receive a boatload of bird guano from islands off Peru, on the other side of Cape Horn. One of the customers was Junius Brutus Booth, father of the man who later assassinated President Lincoln. Booth mixed the droppings of the Peruvian cormorants with bone dust that he ground up at his farm in Harford County. By 1865 the Baltimore market was consuming 60,000 tons of Peruvian and Mexican guano a year at the average price of $50 a ton. Guano imports

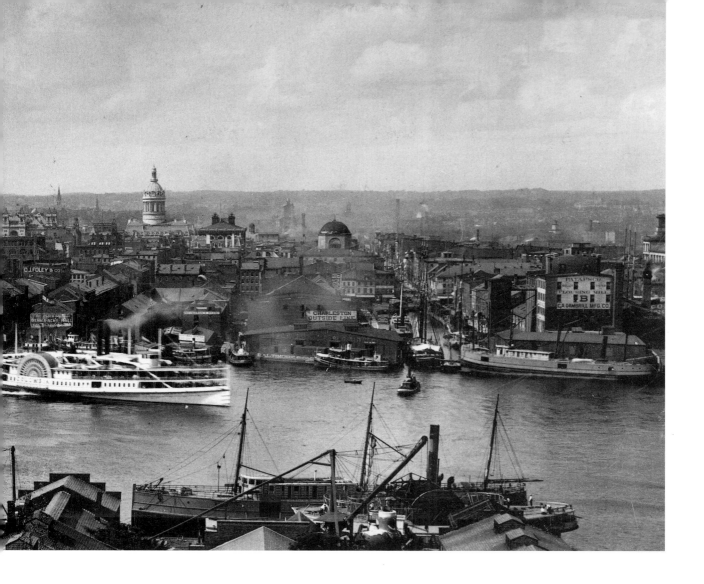

were supplemented by shipments of lime phosphate of volcanic origin, from a small island near Jamaica. Phosphate of lime was found to be good fertilizer, and it provided the beginnings of Baltimore's chemical fertilizer industry. There was always a ready market, because tobacco farming badly depleted local soils. For many years Baltimore led the world in fertilizer production.

Baltimore, in its industrial heyday, led in a number of other industries, as well. Until fairly recently, the Davison and Mathieson chemical plants on Curtis Bay were the world's largest producers of sulphuric acid, a primary material in the chemical industry. Bethlehem Steel's Sparrows Point plant was the largest

steel mill on tidewater. Chrome, sugar, and porcelain plants on the harbor were, at the time of their construction, the largest facilities of their kind anywhere. The making of those products, along with soap, paint, and a host of other items, provided a decent livelihood for thousands of Baltimoreans.

Over the last hundred years, the need for space caused the port and its industry to spread downriver, enveloping Dundalk and Sparrows Point on the north side, and Fairfield, Curtis Bay and Hawkins Point on the south. The march of industry brought tax revenues and jobs, but it has taken a heavy toll on the river. Bottom muds have become so fouled by spillage and deliberate dumping that bacterial mutants are

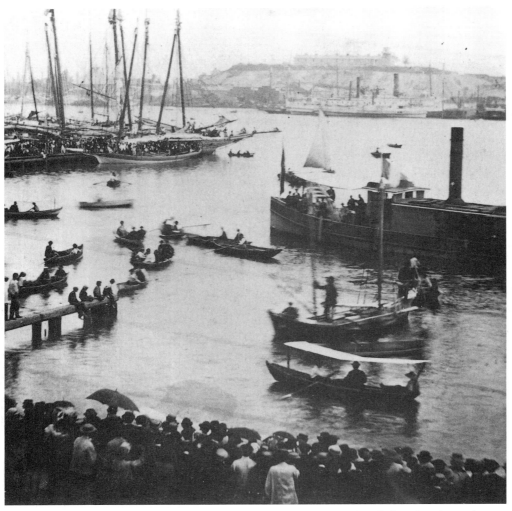

The downtown waterfront was a favorite gathering place for Baltimoreans long before the advent of Harborplace. In 1867 David Bachrach captured a crowd assembled to watch the departure of the small sailboat *John T. Ford* on an ill-fated voyage to Europe. Federal Hill rises in the background. Baltimore Gas and Electric Company

reported by scientists and heavy metals pose a threat to the food chain. Needed dredging has always been slowed by disputes over where to dispose of the toxic spoils.

In recent decades, the image of a fouled Patapsco was matched by the image of a Baltimore that was itself undergoing decay and decline, as it faced economic threats common to many northern cities. A reduction in the number of strong local philanthropic and industrial institutions seemed to magnify the threat to Baltimore. By increasing degree in the twentieth century, Baltimore became a branch-office town. "Pittsburgh has the Mellons and Baltimore has the watermelons," a disillusioned developer complained in the 1980s. None of the steamship companies in the World Trade Center building and few of the shipping agencies are locally owned. Only a few of the major facilities on the shores of the Patapsco have local headquarters. For the remainder, decisions about the disposing of civic largesse take place in boardrooms

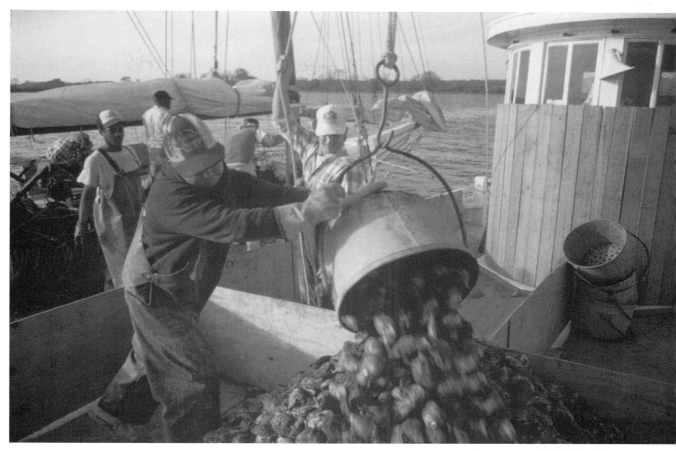

Watermen transfer a day's oyster harvest from a skipjack sailing dredge boat to a buyboat which will carry them to market. Chesapeake Bay oyster production peaked at 14 million bushels in 1887—almost beyond belief compared to the minute yields of recent years—and much of the harvest was carried to Baltimore for processing and redistribution. Oysters canned in factories on the harbor were shipped to California and Europe. The Pennsylvania Railroad ran bushels of live oysters north on special trains, with banners proclaiming "Maryland Oysters" tacked to the cars. Chesapeake Bay oysters were prized both for their taste and for the fact that they could survive as many as thirty days out of water. Photo by Chris Judy

in Chicago, New York, Pittsburgh, and other distant places. Baltimore Harbor reflects conglomerate America. Even the once-powerful Baltimore and Ohio Railroad has lost its identity, having been swallowed up in the giant CSX system and being directed from Jacksonville, Florida.

Baltimore nonetheless has shown an ability to survive and prosper. Its strength comes in part from industrial diversity. The fact that its economy is not based on any one local product or company has

proved to be a blessing in hard times. The city also draws strength and vitality from its proud citizenry. It is a city with deep family roots at all levels, from artisan to banker. Its mayor for many years, William Donald Schaefer, became a national symbol of urban regeneration. Under Schaefer, the once rat-infested wharves of the steamboat days were transformed into one of the most attractive gathering places on the East Coast. The Harborplace pavilions, built in 1980 for less than a third the cost of a single supertanker, gen-

The construction and repair of great ocean-going ships has always accompanied the movement of cargo in Baltimore. Here, in about 1945, workers march into the fray at the Bethlehem Steel yard at Sparrows Point. Maryland Historical Society

erated excitement and hope. The next elected mayor, Kurt L. Schmoke, focused his attention on education and economic opportunity for a populace that had become predominately black, but he was unable to stem the growth of crime, the flight of whites to the suburbs, and the deterioration of the public schools. The young, vigorous Martin O'Malley took the reins in 2000, capturing the imagination of both black and white residents as he strove to bring new energy to the city.

As during the previous three hundred years, the current economic invigoration of Baltimore has its roots on the waterfront, in tourism and economic development that underpins the tax base of the city. In 1927, Gilbert Grosvenor wrote in *National Geographic,* "No stranger can go to Baltimore to day without catching something of this resolute city's spirit." He nicely captured the eternal secret of Baltimore.

HARD ECONOMICS

As the port of Baltimore nears its 300th anniversary, in 2006, it is demonstrating its resiliance as a player in world trade. From its early days, Baltimore has rightly touted its comparative closeness to the nation's heartland. Traditionally, the cost of moving freight overland, to or from a port, depended on mileage; and on that count, Baltimore prevails over New York City. After World War II, Baltimore saw itself losing general cargo (manufactured goods, as opposed to raw goods like coal, grain, ore, and petroleum) to New York. There were several reasons: more ships sailed

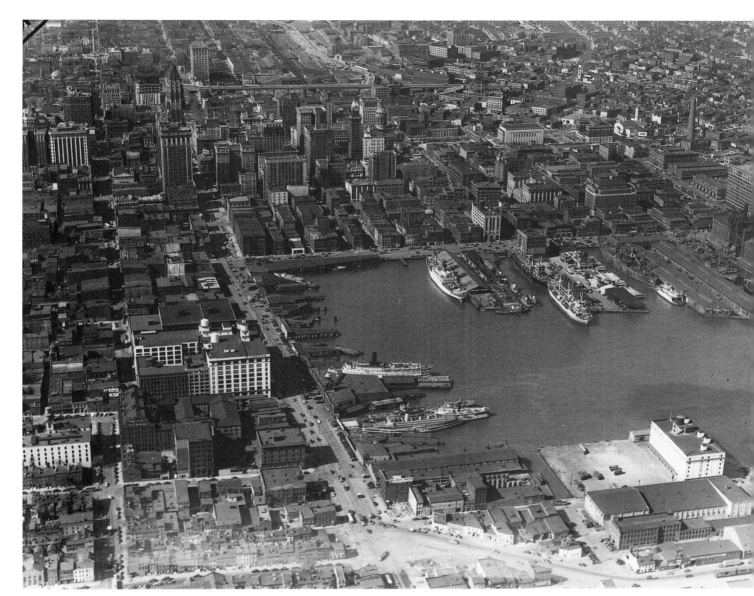

An aerial view of the Inner Harbor in 1948, in the last days of the steamboat era. Maryland Historical Society

out of New York, reducing delays and consequent pierside storage charges for shippers; the big New York shipping agencies avoided fee-splitting by moving everything through their own jurisdiction; the Baltimore port presented a picture of organizational confusion. The biggest problem was at pierside. Baltimore had grown up as a "railroad port," and now, after the war, the railroads were unwilling to make room at their facilities for the developing truck traffic that was changing the face of American transportation. A ship could dock free at the railroad piers, and a railcar was allowed seven days at the Locust Point yards without storage charge. By contrast, when a truck came along with goods for a ship, a charge was levied: $1 a ton to put the goods on the dock, another $1.75 a ton if they had to be moved later. Storage charges were levied after two days. "The worst thing about Baltimore is the piddling charges," a ship agent complained. Moreover, it was difficult physically for trucks to reach the Baltimore piers and difficult for trucking companies to coordinate pickups and deliveries with the arrival of ships because the

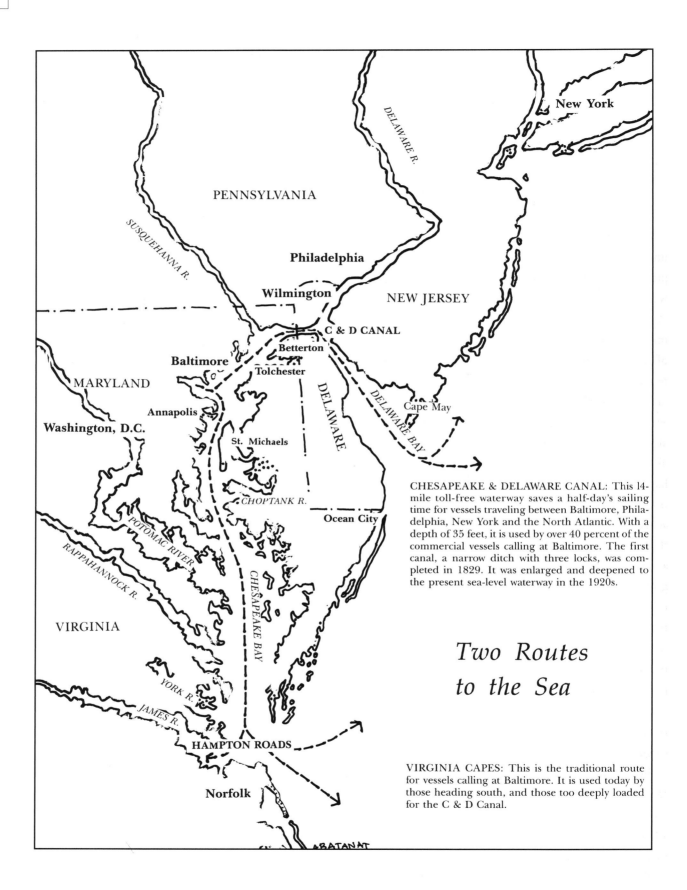

New York

DELAWARE R.

PENNSYLVANIA

SUSQUEHANNA R.

Philadelphia

Wilmington

NEW JERSEY

C & D CANAL

Betterton

Baltimore

Tolchester

DELAWARE

DELAWARE BAY

MARYLAND

Annapolis

Cape May

Washington, D.C.

St. Michaels

CHOPTANK R.

POTOMAC RIVER

Ocean City

RAPPAHANNOCK R.

CHESAPEAKE BAY

VIRGINIA

YORK R.

JAMES R.

HAMPTON ROADS

Norfolk

ABATANAT

CHESAPEAKE & DELAWARE CANAL: This 14-mile toll-free waterway saves a half-day's sailing time for vessels traveling between Baltimore, Philadelphia, New York and the North Atlantic. With a depth of 35 feet, it is used by over 40 percent of the commercial vessels calling at Baltimore. The first canal, a narrow ditch with three locks, was completed in 1829. It was enlarged and deepened to the present sea-level waterway in the 1920s.

Two Routes to the Sea

VIRGINIA CAPES: This is the traditional route for vessels calling at Baltimore. It is used today by those heading south, and those too deeply loaded for the C & D Canal.

railroads would not make berth assignments known until the last minute. On top of all this, the railroad piers were reaching a state of decay and the railroads were neither willing nor able to maintain them.

In 1950 an engineering firm recommended a $129 million program of port improvement and creation of an eight-county commission to run the port. This report was the forerunner of action by the Maryland General Assembly in 1956 creating the Maryland Port Authority as a state agency. Three years later the new authority began development of Dundalk Marine Terminal on a former airfield on the north side of the harbor, with the express purpose of accommodating truck-borne cargoes. In 1964, the MPA took a forty-year lease on the B&O's Locust Point piers (including the grain pier but not the conveyor system, elevator, and silos) and began a $30 million reconstruction program, creating seventeen modern berths with accommodations for both rail and truck traffic. It bought the Pennsylvania Railroad's Pier 1 terminal on Clinton Street in Canton for $1.4 million. The MPA immediately set out to make Baltimore a "shippers' port" instead of a "carriers' port." Ships pay $3,000 to $6,000 a day for a berth, but their shipping customers receive many inducements to bring high volumes of cargo through the port.

In 1971 the state brought the Port Authority under the umbrella of its Department of Transportation and renamed it Maryland Port Administration. Some port advocates would like to see the old form restored, so that the agency could again raise bonds on its own.

Baltimore can never take its competitive edge for granted. The same quirk of geography that puts Baltimore longitudinally west of New York—a northeast-southwest trending Atlantic shoreline—puts the seaport of Charleston, South Carolina, just about as far west of Baltimore. Moreover, Charleston is slung under the Midwest in such a way that it is approximately the same distance from St. Louis as is Baltimore. New Orleans, on the Gulf Coast, is closer to St. Louis than Baltimore or Charleston. A century ago, shipping delays caused by long periods of quarantine deterred heavy use of southern ports, but this is no longer a factor. The Baltimore port manager for United States Lines complained in 1980 that it cost $71 to move a cargo container through the port of Baltimore, compared to $61 for Norfolk and $41 for Charleston. During the 1980s, deregulation of rail rates began to obscure Baltimore's mileage advantage and gave the southern ports new opportunities to lure business by offering cut-rate deals. At the same time, container lines built ever-larger ships and put them on world schedules that made the extra time needed to run up and down the Chesapeake Bay too much of a time penalty, compared to calling at Jacksonville, Savannah, Charleston, and Norfolk, all directly on the ocean. In the west, ports like Long Beach and Oakland, California, clamored to handle cargoes for the Far East. The "railbridge" from the Midwest to California is costlier than shipping through Baltimore, but faster by several weeks in reaching Asia. So the threat of lost business keeps Maryland Port Administration planners and rate makers forever on their toes.

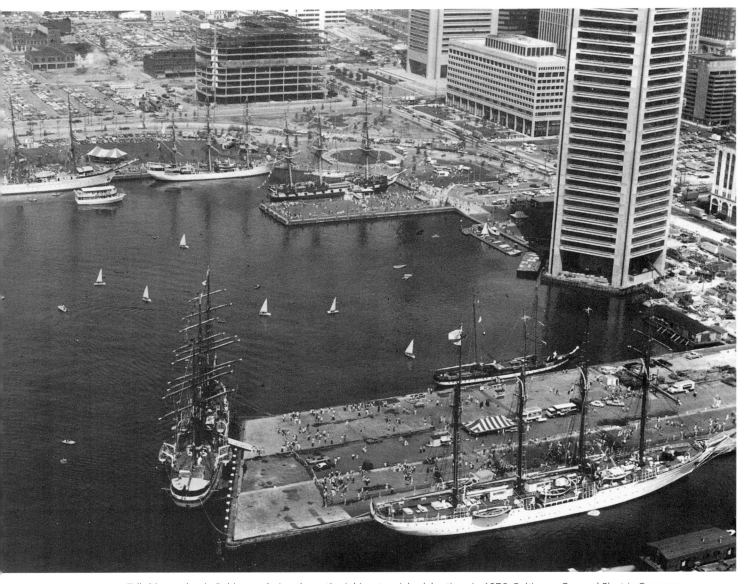

Tall ships gather in Baltimore during the nation's bicentennial celebrations in 1976. Baltimore Gas and Electric Company

Despite the setbacks from deregulation of rail rates, the port of Baltimore entered the twenty-first century in an upbeat mood. While rate deregulation may have taken the edge off Baltimore's mileage advantage for rail service, it did not impair the mileage advantage the port enjoys with the national highway system and the ever-growing movement of cargo by trucks. Baltimore remains the closest port to the Midwest by any transportation mode.

Rail service to the port has probably improved with the carving up of Conrail (the former Pennsylvania Railroad system) between Norfolk Southern and CSX. Norfolk Southern, long allied with the rival southern ports, is now a Baltimore player, serving Canton and the Dundalk terminal. CSX operates the old B&O/Chessie System/Western Maryland facilities on Locust Point and serves Seagirt Marine Terminal by arrangement with the Canton Railroad Company.

Assessing the changing conditions, particularly the

flattening out of container cargo business, the Port Administration in 1996 adopted a strategic plan that called for diversification of its cargo handling capacities. The focus was put on niche products, such as paper and pulp, automobiles, and heavy farm and construction equipment.

In 2002, the MPA opened a state-of-the-art automobile terminal on the former Maryland Shipbuilding and Drydock site at Masonville on Middle Branch. The new facility stands next door to two private auto terminals built on former Bethlehem shipyard land by AMPORTS (American Port Services) at a cost of $26 million. MPA is holding some of its Masonville land in reserve for future needs.

The port community has voiced concern about the creeping gentrification of the waterfront, as developers clamor to exploit the precious views. In an interview with *Port of Baltimore* magazine, Bud Nixon, who retired in 2002 as the chief executive officer of Rukert Terminals, called for "strict zoning for industrial areas that draws a line between recreational, residential and industrial uses. For that, we need a strong master plan. . . . We should keep the deep water we have for future maritime needs, not residential, hotels and sushi bars." In 2002 the City Planning Department drafted a master plan that embraced protection of deep water sites for future port use, but action on the plan was delayed until a San Francisco–based consulting firm completed a year-long study taking a close look at the plan's potential impact on various parts of the harbor. As endorsed by the city in April 2004, the master plan draws a line around the harbor,

separating waterfront property deemed suitable for business and residential development from industrial land on deep water, safeguarding the latter from non-industrial use for at least the next ten years. The plan was good news for the Private Sector Port Coalition, which Nixon chairs, as it gives Coalition members the confidence to expand their operations over the next decade without fear of neighbors' moving in and complaining about the noise and smell.

Meanwhile, MPA's cargo strategies have been paying off:

- Foreign auto imports through state and private terminals rose to 438,422 cars in 2003, an 88,422-car jump over the previous year. The port ranks second in the nation in this category, after New York. In the export of American cars, Baltimore is first, because of its relative proximity to Detroit.

- In 2003, Baltimore held on to its position as the nation's Number 1 port in "RoRo" tonnage, handling 382,000 tons of heavy equipment that can roll on and off the vessel under its own power, such as tractors and bulldozers. Baltimore handles 42 percent of all such equipment that moves through East Coast ports. Wallenius Wilhelmsen Lines' new RoRo hub terminal at Dundalk is destined to become the company's largest in the world.

- An 83 percent spike in newsprint and magazine paper imports in 2001 and 2002 pushed Baltimore into the position of Number 1 nationwide in forest products, which also include lumber and pulpwood.

- Baltimore's cruise ship business surged to 40 ship calls in 2002 and 60 in 2003, up from 13 in 2001. A desire

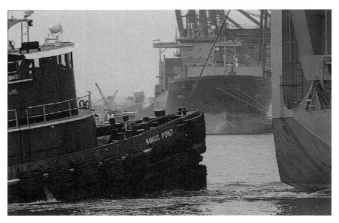

A hard-working tug, *Kings Point*, and ocean-going ships combine for a portrait of bustle in the port late in the twentieth century. Maryland Port Administration

among northeasterners to board a cruise ship without flying to Florida may have contributed to the increased demand.

• Baltimore moved ahead in handling ship containers in 2003, topping 422,000 units in this major cargo niche where its ranking has slipped to seventh or eighth among East Coast ports.

The port's container business got a major shot in the arm in March 2001 when the Mediterranean Shipping Company agreed to continue using Seagirt container terminal for another ten years. According to the Baltimore *Sun,* when Seagirt was "shopping for its first tenants in 1988," Mediterranean, which had only a few secondhand ships at the time, "was passed over." By 2002, Mediterranean ranked second in the world in container capacity and was bringing ships to Baltimore four times a week. By using secondhand ships, the company keeps its capital costs low, and it targets less-congested ports that have strong local markets and limited direct service by major carriers. Analysts also point out that the company is run by mariners who understand ships and can make quick business decisions. Capt. Lorenzo Di Casagrande, the company's hands-on manager of Baltimore operations,

told the *Sun,* "we all come from the merchant marine . . . we come with that kind of pride." MPA adminstrator Jim White said, "I find dealing with them very refreshing."

About 38.8 million tons of cargo moved through the port of Baltimore in 2002, 23.6 million in foreign trade and 15.2 million in domestic trade. The preponderance consisted of bulk commodities: exports and imports of coal and imports of petroleum products, sulphur, sugar, salt, phosphates, gypsum, iron, alumina, and other ores. In 2003, coal led the exports with 3 million tons; and iron ore, mainly to the Sparrows Point steel plant, led the imports, with 3.7 million tons. Virtually all of the bulk commodities moved through private terminals, such as Ruckert, Steinweg, and Consolidation Coal. The remaining tonnage consisted of various items of general cargo, including about 4.7 million tons of container cargo, 1 million tons of automobiles and trucks, over 40,000 units of RoRo cargo, and 1.5 million tons of paper, pulp, and lumber. Most of this cargo, including two-thirds of the cars and trucks, moved through the state terminals at Dundalk and Locust Point.

Reports indicate that the revenue impact on the state's economy for various types of cargo ranges from $28 a ton for iron ore to $267 per ton for automobiles, which often have accessories installed at the port. The average 40-foot container generates an estimated $146 per container.

According to the Baltimore Maritime Exchange, which tracks ship traffic from its radio center on Bayliss Street, 1,887 arriving and departing ships, or

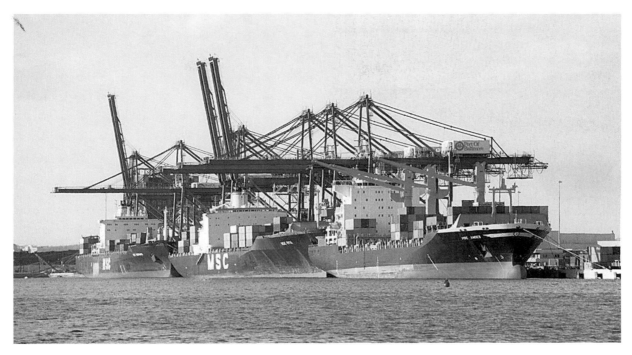

Mediterranean Shipping Company container ships lined up at Seagirt Marine Terminal in about 1999. Once scoffed at as a small player, Mediterranean became the terminal's largest customer. Bill McAllen, Maryland Port Administration

an average of about 5.2 ships calling every day, moved cargo through the port of Baltimore in 2003. The number of ships is far less today than it was in earlier years because of enormous increases in the sizes of ships and their capacities.

The decline in number of ships visiting the port and the switch to use of containers for most general cargo shipment took a heavy toll on longshoreman jobs, but this job category has seen some improvement in Baltimore in recent years because of the intensive labor required in handling automobiles, RoRo, and forest products. An MPA study calculated that 16,120 persons were directly employed in all aspects of port activity in 2003; 8,600 of them employed at private terminals. The study estimated that $1.5 billion in revenues was generated by port activity at the public and private terminals. The estimated value of cargo in foreign trade was $26 billion.

Observers in Baltimore harbor may be surprised by the relatively small number of vessels of American registry to be seen. The United States emerged from World War II as the world's number one maritime power, but its position has steadily eroded. Today, American ships operated by American crews carry less than 5 percent of general cargoes entering or leaving U.S. ports in foreign trade and less than 3 percent of bulk cargoes.

Americans no longer seek seafaring careers, and few have the opportunity to travel by sea. Meanwhile, in many port cities, technology has forced the removal of many shipping activities to remote, hard-to-find parts of the waterfront. All of these factors tend to insulate the commercial maritime world from public consciousness. In Baltimore harbor, you can still go out and see the ships; they are close at hand, and their comings and goings provide a living demonstration that we are still a sea-dependent nation.

20

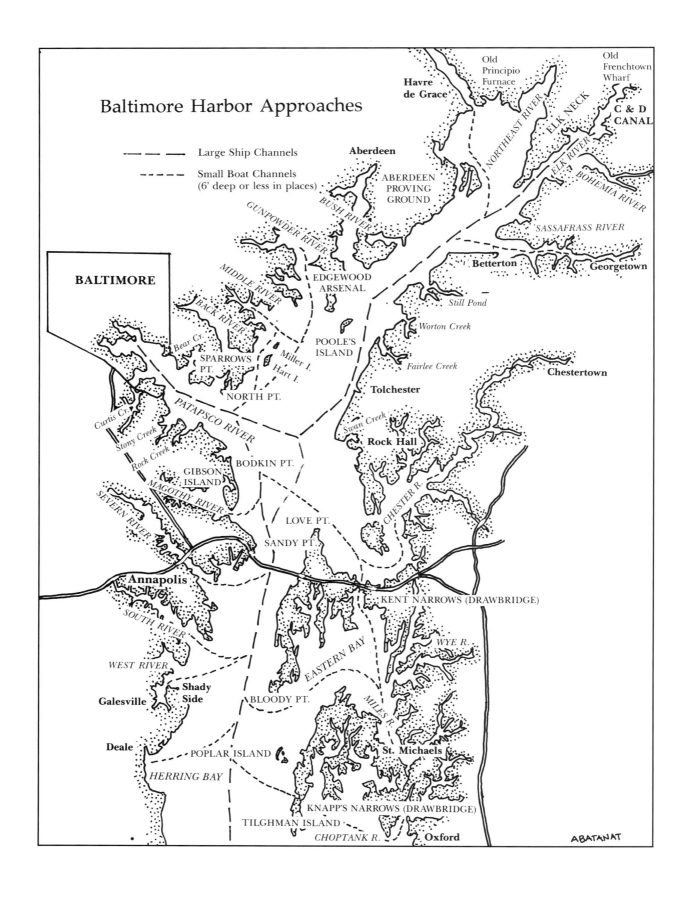

Baltimore Harbor Approaches

Large Ship Channels

Small Boat Channels
(6' deep or less in places)

BALTIMORE

Old Principio Furnace

Old Frenchtown Wharf

Havre de Grace

Aberdeen

NORTHEAST RIVER

ELK NECK

ELK RIVER

C & D CANAL

BOHEMIA RIVER

BUSH RIVER

GUNPOWDER RIVER

ABERDEEN PROVING GROUND

SASSAFRASS RIVER

Betterton

Georgetown

MIDDLE RIVER

EDGEWOOD ARSENAL

Still Pond

Worton Creek

BACK RIVER

Bear Cr.

Miller I.

Hart I.

POOLE'S ISLAND

Fairlee Creek

Chestertown

SPARROWS PT.

NORTH PT.

Tolchester

Swan Creek

Rock Hall

Curtis Cr.

Stony Creek

PATAPSCO RIVER

Rock Creek

GIBSON ISLAND

BODKIN PT.

CHESTER R.

MAGOTHY RIVER

SEVERN RIVER

LOVE PT.

SANDY PT.

Annapolis

KENT NARROWS (DRAWBRIDGE)

SOUTH RIVER

WYE R.

WEST RIVER

EASTERN BAY

Galesville

Shady Side

BLOODY PT.

MILES R.

Deale

POPLAR ISLAND

St. Michaels

HERRING BAY

KNAPP'S NARROWS (DRAWBRIDGE)

TILGHMAN ISLAND

CHOPTANK R.

Oxford

ABATANAT

THE MARINER'S VIEW

Unlike other histories of Baltimore, and other guidebooks, our effort looks at the city and its harbor from the vantage point of someone actually out on the water—a follower in the wake of Capt. John Smith, a seafarer, a pleasure boater, a passenger on the deck of one of the harbor cruise boats.

In downtown Baltimore, several vessels make a business of taking visitors around the harbor. The *Bay Lady* and *Lady Baltimore* move in and out of the harbor on luncheon and dinner trips and periodic day-long excursions to Annapolis. The skipjack *Minnie V.* and replica lumber schooner *Clipper City* roam the old harbor under sail, while *Prince Charming* offers one-hour narrated tours.

Those who have the opportunity can bring their own boats to Baltimore. The Light Street seawall and the old freighter piers in the Inner Harbor have been consigned to pleasure boat transient docking. It may be difficult to find a prime spot along the seawall on a summer weekend, but there's usually space at one of the old piers, and skippers with dinghies can always drop anchor and row ashore.

Through most of its history, Baltimore was not thought of as a stopping point for recreational boaters. Visions of dirty water, heavy commercial traffic, 14 miles of possible upwind tacking, and lim-

Paint and Powder acting group on a Patapsco outing. Maryland Historical Society

ited docking facilities all worked against it. In the 1980s, by contrast, Baltimore became one of the hottest spots on the Eastern Seaboard for yachtsmen to visit.

The emergence of Baltimore as a pleasure boat mecca would come as a surprise to George and Robert Barrie, who introduced Chesapeake Bay to the yachting community in the early 1900s. Their delightful book, *Cruises, Mainly in the Bay of the Chesapeake,* published in 1909, has become a classic. In it, they wax eloquent about the rivers of the bay:

Chesapeake, from the Algonquin K'tchisipik, meaning "Great Water," is truly a fitting name for the noble Bay whose sparkling waves lap the shores of Maryland and Virginia. This magnificent sheet of water is nearly two hundred miles long, and its greatest width is about one-eighth of its length, but the Bay itself is not all; numerous rivers, such as the Potomac, Rappahannock, Choptank, Chester, with many others of less imposing size and innumerable creeks . . . total up a greater number of square miles. These latter, really little estuaries, are misnamed, as the word creek is apt to bring to one's mind a dirty little stream running between muddy banks; but this is not the case. They are beautiful, placid indentations with green fields or bits of woodland coming almost to the water's edge and only a narrow strip of beach intervening. Some are very narrow at the mouth, but inside spread out and branch off in differ-

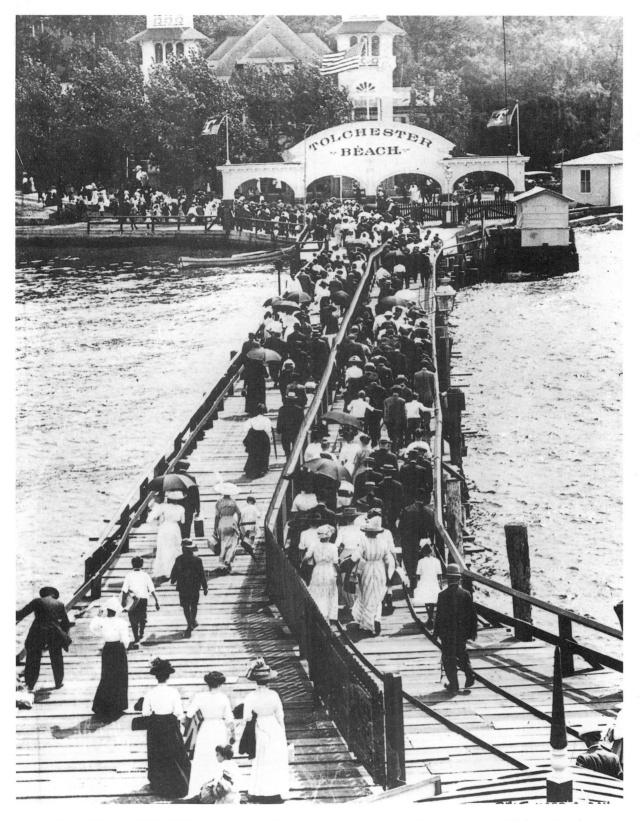

From 1877 until the mid-1930s, Baltimoreans enjoyed their harbor on two-hour steamboat excursions to Tolchester Beach across the bay. As many as 20,000 a day thronged ashore on the wooden pier, shown here, from such steamers as the *Emma Giles, Louise, Susquehanna, Annapolis,* and *Express.* A. Aubrey Bodine, Sunpapers

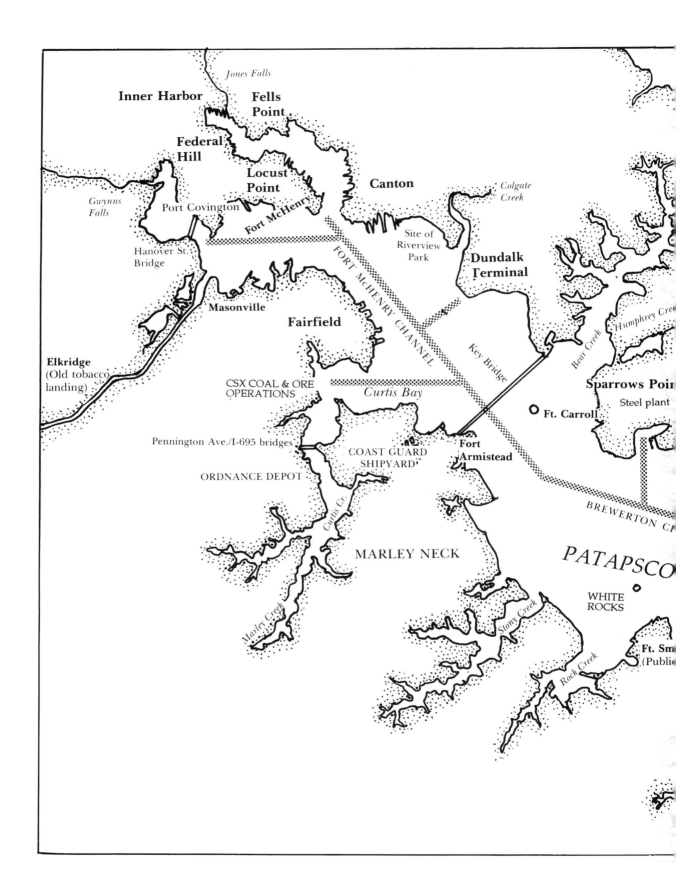

Inner Harbor

Fells Point

Jones Falls

Federal Hill

Locust Point

Canton

Colgate Creek

Port Covington

Fort McHenry

Gwynns Falls

Hanover St. Bridge

Site of Riverview Park

Dundalk Terminal

FORT McHENRY CHANNEL

Humphrey Cre

Masonville

Fairfield

Bear Creek

Curtis Bay

Key Bridge

Sparrows Poin

Steel plant

Elkridge (Old tobacco landing)

CSX COAL & ORE OPERATIONS

Ft. Carroll

Pennington Ave./I-695 bridges

COAST GUARD SHIPYARD

Fort Armistead

ORDNANCE DEPOT

BREWERTON C

Curtis Cr.

PATAPSCO

MARLEY NECK

WHITE ROCKS

Marley Creek

Stony Creek

Ft. Sm (Public

Rock Creek

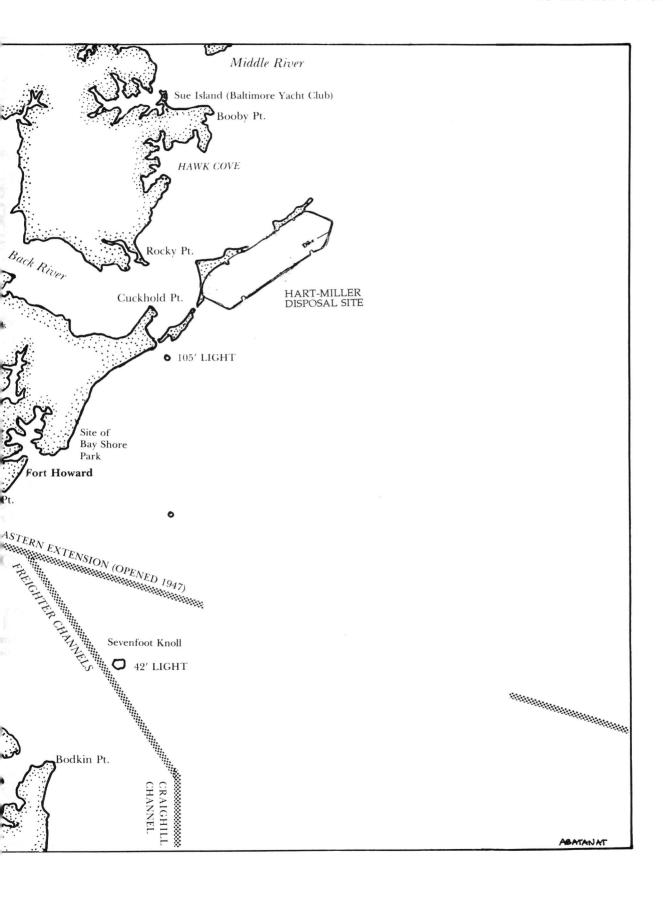

Middle River

Sue Island (Baltimore Yacht Club)

Booby Pt.

HAWK COVE

Rocky Pt.

Back River

Cuckhold Pt.

HART-MILLER
DISPOSAL SITE

○ 105' LIGHT

Site of
Bay Shore
Park

Fort Howard

Pt.

ASTERN EXTENSION (OPENED 1947)

FREIGHTER CHANNELS

Sevenfoot Knoll
○ 42' LIGHT

Bodkin Pt.

CRAIGHILL CHANNEL

ABATANAT

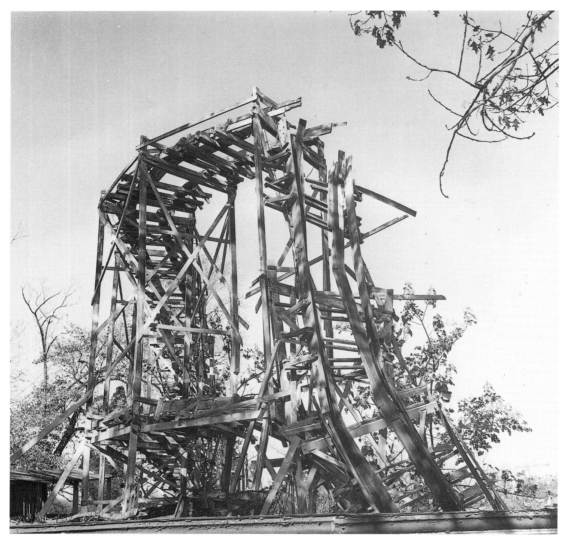

Patronage of Tolchester Beach fell off during the Depression. In 1936, the Tolchester Beach Improvement Company was auctioned off to bondholders. Its 50 acres, four piers, and last two ships, the *Emma Giles* and *Express,* brought $66,000. Excursions to Tolchester were revived after World War II, but the park closed for good after a bankruptcy sale in 1962. Taken in 1966, this photo shows ruins of the Whirlpool Dips, a rollercoaster. A marina occupies the site of the old park today. Maryland Historical Society

ent directions. Nearly all of them end abruptly, and one may think he has some distance yet to go before reaching the head, when one is suddenly confronted with a little piece of marsh through which runs a small brook, and that is as far as one can go. The Bay would lose a large part of its fascination if there were no rivers to explore, no bays to sail about in, no snug little creeks or coves in which to drop anchor at night. Providence must have made the Chesapeake early in the morning after a good night's rest and the Delaware late in the evening after a long, hard day, as the

latter is all that is mean, unpleasant, low, and aggravating, while the former is the direct antithesis.

The painful thing about this passage, for Baltimoreans, is that the Barries do not mention the Patapsco River as a destination. Nor, evidently, did they ever deign to visit it. Certainly they were aware of the river. In another chapter, they describe a sail across the mouth of the Patapsco while traveling from Poole's Island south to the Magothy:

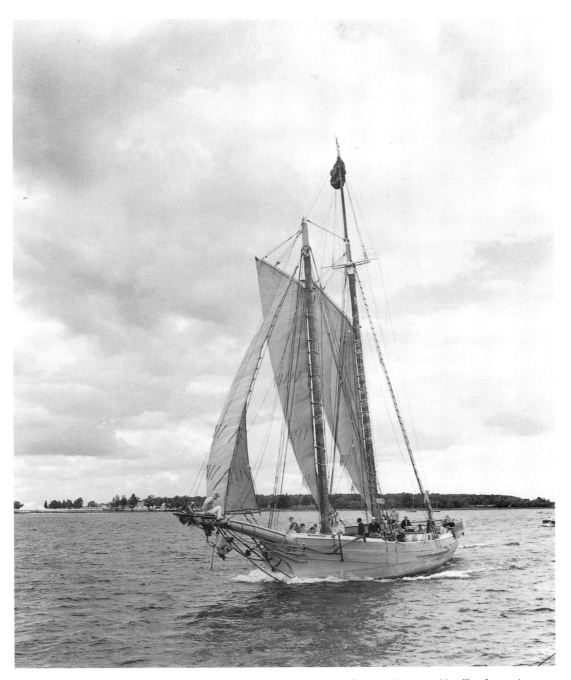

There's no better way to see the Patapsco than by sailing ship. A crew of two or three would suffice for a schooner of this size in commercial use; the many hands here aboard the *William H. Michael* are probably Sea Scouts on a training voyage, or perhaps a race. Maryland Historical Society

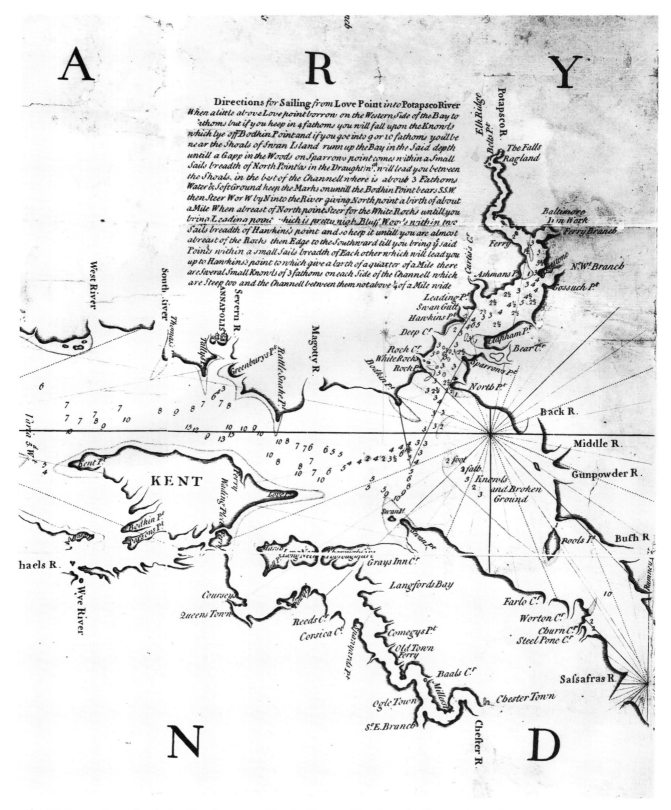

This 1735 map gives sailing instructions for approaching the Patapsco River from the Chester River and Love Point across the bay, turning by a "sails breadth" and aiming for a "gapp in the woods." The river is shown wide and deep up to Elk Ridge Landing, which was the chief tobacco port in those days. The mapmaker, sea captain Walter Hoxton, did not mention Baltimore Town. Maryland Historical Society

Here we had a fine piece of sailing; as the wind freshened we ran along with the rail awash and sometimes under. From the Patapsco were coming all sorts of craft—steamers, bugeyes, canoes, skiffs; in short, anything that would float, all laden with mortals bound for Tolchester Beach, to spend the Glorious Fourth and their money.

So the Barries knew of the Patapsco and the free-spending, fun-loving people who inhabited it. One might surmise that the reason they never paid a visit had to do with the way the river lies. It makes no sense to sail up the Patapsco when the wind is blowing from the northwest, or to leave it by sail when the wind is from the southeast. Better to anchor and drink beer. But this is not what deterred the Barries. Visiting Baltimore just never occurred to them. With the exception of the passage quoted, where they had been lured off course by shifting winds, they always stayed on the other side of the bay: "Going down the western shore from Poole's Island to the Patapsco is not safe for a boat drawing more than six feet, as there are unbuoyed lumps. The regular channel is close to the eastern shore."

So there you have it. Coming down from Philadelphia by way of the Chesapeake and Delaware Canal, the Barries clung to the other side of the bay. Returning from their explorations in the lower parts, they were anxious to get home, and followed the same route. Their book became yachtsmen's gospel, so for decades the idea of visiting the Patapsco was never considered by boating people. Nor was encouragement offered in Fessenden Blanchard's *Cruising Guide to the Chesapeake,* which through many editions described the upper Patapsco as "too commercial" and wrote off the Northwest Branch, or inner harbor, as being "of little interest to yachtsmen."

Even today, the Patapsco seems out of the way for boaters coming from the north, down the Eastern Shore channel. To visit Baltimore seems like doubling back. But for those coming up from the south, the prospect is different. Once you pass under the Chesapeake Bay Bridge at Sandy Point, it is just as convenient to continue straight ahead, to the Patapsco, as it is to veer off to the right, toward Rock Hall, Tolchester, and the head of the bay. Another appealing approach to the Patapsco is from the southeast, out of Eastern Bay, through Kent Narrows, past Love Point and across the main part of the bay to the river. The Love Point approach is detailed in the colonial era map reprinted here, oriented with west at the top.

Either way, coming up from the south or across the bay from Love Point, the boater must head for Bodkin Point, the first landmark at the entrance to the river. Once Bodkin Point is cleared, the boater is home free to downtown Baltimore, about 14 miles due northwest. Whether the voyage is a true one, from the deck of a boat with sun and spray in the face, or an imaginary one, in the security of a properly oriented armchair, the voyager will be curious about what lies up the smaller bays and creeks that lead off the main river and what transpires at the awesome commercial installations. Many of the answers will be found on the following pages.

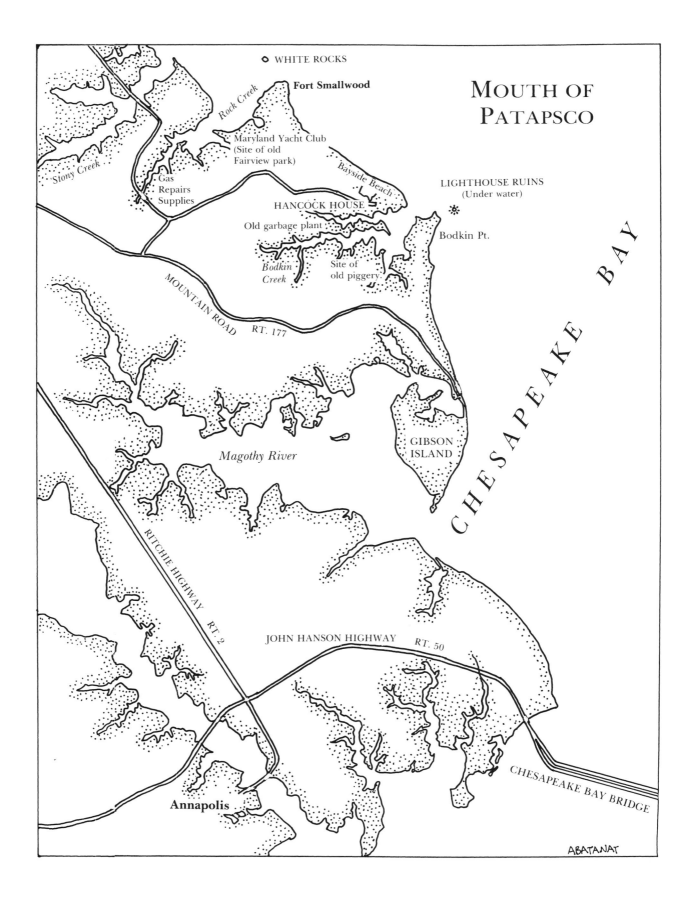

MOUTH OF PATAPSCO

WHITE ROCKS

Fort Smallwood

Rock Creek

Maryland Yacht Club
(Site of old
Fairview park)

Stony Creek

Bayside Beach

LIGHTHOUSE RUINS
(Under water)

Gas
Repairs
Supplies

HANCOCK HOUSE

Old garbage plant

Bodkin Pt.

Bodkin
Creek

Site of
old piggery

MOUNTAIN ROAD

RT. 177

CHESAPEAKE BAY

GIBSON
ISLAND

Magothy River

RITCHIE HIGHWAY RT. 2

JOHN HANSON HIGHWAY RT. 50

CHESAPEAKE BAY BRIDGE

Annapolis

ABATANAT

CHAPTER TWO

THE PLEASURE CREEKS

Three creeks at the lower mouth of the Patapsco—Bodkin, Rock, and Stony—have so far been spared the intrusion of industry. Residents enjoy a lifestyle of fishing, crabbing, and pleasure boating. The names of the communities—Bayside Beach, Alpine Beach, Paradise Beach, Venice on the Bay, Fairhaven Beach, Orchard Beach—recall past days of glory when they were the summer swimming holes of Baltimore. That was before the Bay Bridge was built and the Atlantic Ocean was brought within a four-hour drive.

In the aerial view on pages 32–33, wooded Bodkin Creek spreads its tentacles in five directions inland from its narrow mouth, offering snug anchorage at every hand. The creek sheltered many a working oyster fleet in years past. Today the shore is lined with small docks and private residences, whose occupants delight in their ready access to the open bay, even if it does mean an hour's drive to work every day. For visitors, the creek offers fuel, a few supplies, and safe anchorage but no restaurants or other attractions.

Ventnor's Marina at Graveyard Point stands on a site used by the City of Baltimore in the 1920s to set up a large piggery for garbage disposal. The idea was to barge the city's garbage to Bodkin Creek and feed it to 15,000 pigs. The city bought 160 acres, built a wharf, laid concrete floors for the piggery and began

the barging, but after the first pigs had gone to slaughter, the contractor disappeared with $15,000. Another contractor built a reduction plant just across the creek at Spit Point, where he cooked garbage into grease and sold it to the soap companies. The operation was discontinued in the 1930s under pressure from residents disgusted with the odors.

Bodkin Creek is a base for the Maryland Marine Police, known in its early days as the "Oyster Navy" because of its fights to keep "pirates" off the Chesapeake Bay oyster beds. Officer K. L. Phillips won immortality at his Bodkin post in 1966 when he filed this brief report: "Found bottom half of girl's bathing suit at Bodkin Point. Returned same to owner. Had no trouble locating her. Very little activity this date."

HANCOCK'S RESOLUTION

Hancock's Resolution (see p. 34), at Bayside Beach on the west side of the Bodkin Creek entrance, is said to be the oldest structure in Maryland north of the Severn River.

The stone house was built by Stephen Hancock, a British military officer, who was sent up from St. Mary's City in the mid-1600s to guard the Patapsco as a result of warfare between the Seneca and Susquehannock Indians. Hancock was assisted in the con-

struction of the house by Susquehannocks who came in for protection.

The house remained the home of a Hancock for three hundred years, until 1962, when it was willed to Historic Annapolis, a preservation society. It was restored by Friends of Hancock's Resolution and is open 1-4 P.M. on Sundays, April through October, and other times by appointment (410-255-4048).

Hancock House played an important role in the War of 1812, when it was the home and headquarters of Capt. Francis Hancock, of the Maryland Militia, 22nd Regiment. Whenever the British fleet came above Annapolis, Hancock would raise a signal flag, which signal was in turn taken up at Steeple House Farm above North Point, on the other side of the Patapsco, where it could be seen from the observatory at Federal Hill in downtown Baltimore. The timely warnings had much to do with the successful defense

Bodkin Creek. Bodkin Point is at lower right, in this view from the early 1980s. Greenhorne & O'Mara, Inc. (See also maps on pages 30 and 35.)

of the city at Fort McHenry in 1814, celebrated in the National Anthem.

DISAPPEARING LIGHTHOUSE

Now you see it, now you don't. . . . On navigation charts, the approach to Bodkin Point from Chesapeake Bay shows every element of a Coast Guard safe boating quiz: one "rky," two "obstr," two wreck symbols, one "hrd," one place showing only a foot of water, two splotches of land awash and another place with "yl S" which evidently signifies yellow sand for anyone unfortunate enough to sample it. In the midst of all this, the chart shows submerged "Ruins," spelled out with the vowels, perhaps for extra drama.

The explanation is that Bodkin Point once extended further into the bay, and at its tip stood a large stone light tower and tender's house. Since then, the

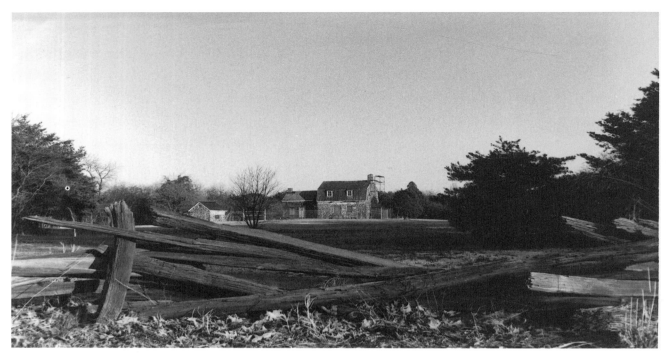

Hancock's Resolution in 1982. Photo by author

two structures have collapsed and washed away or slipped beneath the surface. The total submergence of the buildings, along with the six-foot granite slabs used in a seawall meant to protect them, gives weight to claims by scientists that the waters of the Chesapeake Bay are rising 1 to 1¼ inches every ten years. The changes over an eighty-year period can be seen by comparing the two charts shown opposite.

The sunken rocks pose a continuing hazard; every year, boats of unwary travelers are towed into Bodkin Creek marinas for repairs. The hidden dangers can be avoided by steering to the east of a pole with a green marker and green flashing light, but the Bodkin Creek entrance is marked by three poles with green markers, two of which have green flashing lights, and woe to the boater who guides by the wrong marker. Boaters can resolve all doubts by steering a few hundred yards further east into the steamer channel, but that invites a different kind of adventure. Residents

would like to see the rocks scooped into a pile and marked, or removed altogether.

ROCK CREEK AND STONY CREEK

The Indian name *Patapsco* first appears on land grants of about 1655. According to one source, it is derived from *Pota*—to jut out, to bulge; *psk*—a ledge of rock; and the locative *ut*—at; hence *Pota-psk-ut*—at the jutting ledge of rock, probably referring to White Rocks, a startling outcropping of sandstone rocks in the river near the point where Rock Creek enters.

Rock Creek derives its name from these rocks, just as Stony Creek, a short distance to the west, is named for a heap of brown rocks, believed to be of the same geological stratum, found at its mouth. After Bodkin, these two creeks are the last nonindustrial waters on the way into Baltimore harbor. Heavily populated, they are peppered with small-boat marinas and pri-

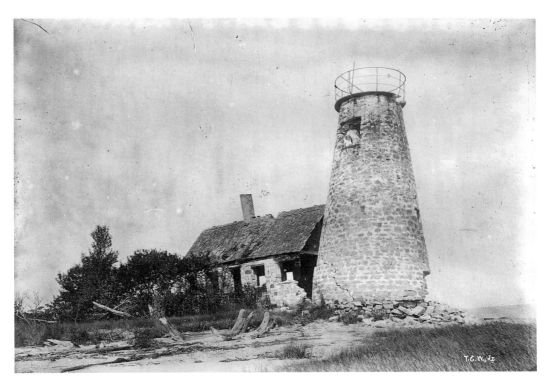

Bodkin Light, 1913. Maryland Historical Society

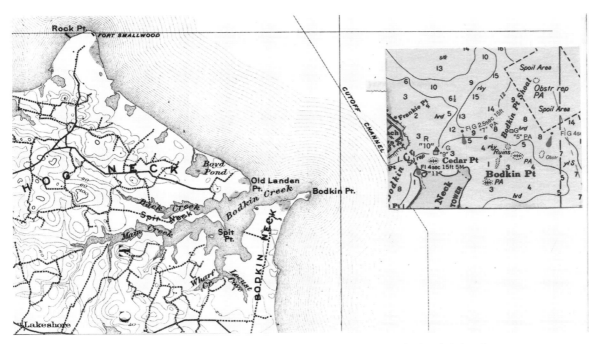

Bodkin Point in about 1900 (*left*) and in 1982 (*inset*). National Oceanic and Atmospheric Administration

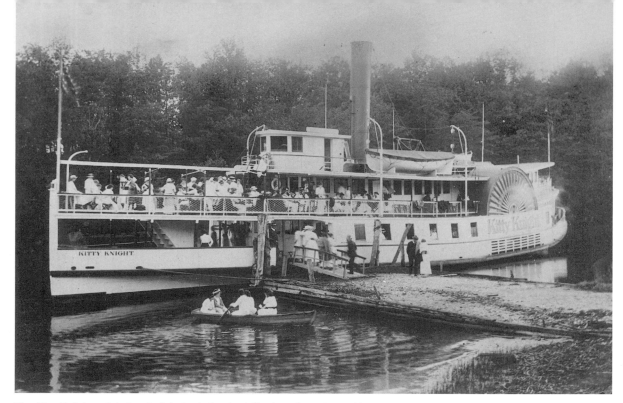

The *Kitty Knight* at Fairview Park in Rock Creek. Collection of Harriett Kohl

vate docks. Rock Creek is favored for overnight anchorage. Fort Smallwood, on Rock Point at the creek's mouth, is a 100-acre public park operated by the City of Baltimore, which purchased it from the federal government for $55,000 in 1926. Few traces remain of the fort, constructed in 1896.

From around 1900 until the Second World War, the Rock Creek Steamship Company ran steamers from Baltimore's Inner Harbor to beaches and amusement parks on the two creeks. A principal stop was Fairview, a small amusement park just inside the mouth of Rock Creek which, like the park at Tol-chester across the bay, was much favored by Sunday School groups because no alcohol was sold on the grounds. The Maryland Yacht Club took over Fairview Park in 1945.

On September 7, 1978, a wrecking crane dismantled the 136-foot paddlewheel steamer *Kitty Knight, ex. Van Corlaer the Trumpeter,* at a muddy bed in Rock Creek where she had lain abandoned for fifty-four years. Another Rock Creek steamer, formerly the *Avalon* but renamed the *Federal Hill* in 1937, was cut down to a barge in 1940 and continued to visit Baltimore for a number of years (see p. 113).

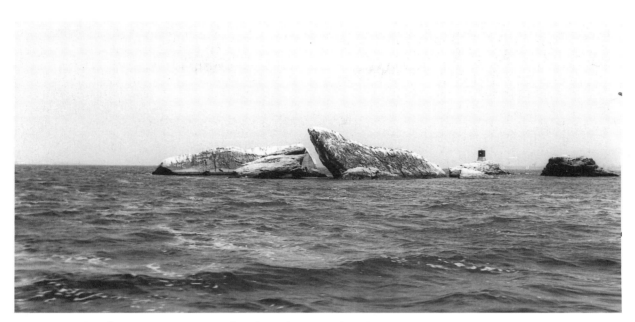

The White Rocks, off Rock Creek, reach to 20 feet above the water. Photo by author

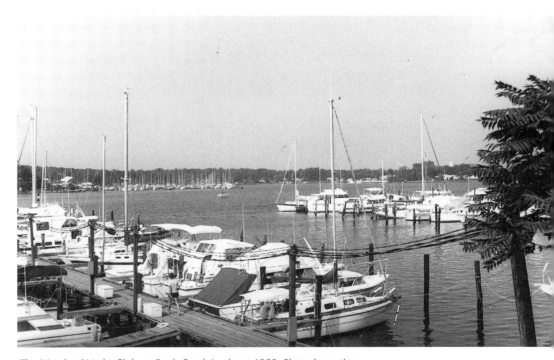

The Maryland Yacht Club on Rock Creek in about 1982. Photo by author

HAWKINS POINT

As you move upriver from Stony Creek you pass Marley Neck, the most grim and desolate section of the Patapsco's shores. Tall smokestacks mark the shoreline. Immediately west of Stony Creek is the Herbert A. Wagner plant of the Baltimore Gas and Electric Company; adjacent to it sits the company's newer Brandon Shores plant with its blinking strobe lights. Then, after about a mile and a half of featureless waterfront, comes Cox Creek, a future dumpsite for harbor sludge. Then, passing under the Francis Scott Key Bridge, you travel alongside the area known as Hawkins Point, which, in keeping with the gloomy atmosphere here, has become the toxic waste dump for Baltimore harbor industry.

The bridge, which carries I-695 traffic over the Patapsco River, was opened in 1978. Immediately west of the bridge is the Maryland Port Administration's Hawkins Point Terminal. The pier was erected during World War II as a terminal for loading ammunition. It was virtually destroyed by fire in 1951. In 1958 the Port Administration purchased the damaged pier and 137 acres of adjoining land for $1,510,000, rebuilt the pier, and leased it to the B&O Railroad so it could bring Chilean blister copper to a nearby refinery (then owned by Kennecott). Later the pier was revamped to receive and store alumina for the Eastalco

Aluminum Company of Frederick, Maryland, a sub-sidiary of Alcoa. St. Lawrence Cement and Hydro Agri also have built unloading facilities here.

Inland from this pier is a waste dump operated by the State of Maryland; it has been the repository for chemical residues from Glidden Paint, Browning Ferris Industries, QC Corporation, and others. In 1982 a portion of the dump was closed and materials were dredged up and removed. But the tract continued to receive chrome wastes from the Allied Chemical site in the Inner Harbor to facilitate remediation of that site for future development. In 1985 the City of Baltimore opened a 156-acre landfill west of the state landfill, to receive bulk trash, as well as ash from a downtown incineration plant. As a Baltimore *Evening Sun* writer commented in 1975, "It is not an area in which anything much worse can happen than has already occurred."

Twenty-two homeowners in the tiny community of Hawkins Point, just across the highway south of the landfills, felt increasing anguish as the dumping spread. In 1982 Governor Harry Hughes agreed to spend $1.5 million to buy them out, rather than incur the millions more it would cost to provide pure water, sewage, and other amenities in the face of the industrial encroachment.

On January 10, 1951, a ten-alarm fire engulfed the old Hawkins Point ammunition pier while it was being used as a staging area for construction of the Chesapeake Bay Bridge at Sandy Point. The $15 million loss made the fire the worst in the harbor since the great Baltimore fire of 1904. Included in the loss was the 25,000-ton decommissioned troop transport *George Washington,* which was tied up at the pier when the fire broke out. The German-built vessel was the "peace ship" that carried President Wilson to the Versailles peace conference after World War I. It carried 250,000 U.S. troops during World War II. Fire damage was so extensive that the ship was towed over to the Boston Metals Co. in Curtis Bay and scrapped.

THE *ALUM CHINE*

At 10:30 A.M. on March 7, 1913, the Welsh freighter *Alum Chine* blew up off Hawkins Point while loading 500 tons of dynamite for use in construction of the Panama Canal. It was the worst shipping disaster in the history of Baltimore harbor. Thirty-three men were killed and sixty injured. The 1,800-ton freighter and two railroad "carfloat" barges tied up alongside were torn to pieces and sent to the bottom of the harbor, along with the six railroad boxcars that carried the boxes of dynamite onto the barges. The tugboat *Atlantic* was damaged and sank while trying to escape. The explosion broke windows throughout Baltimore and as far away as Havre de Grace, thirty miles to the northeast, and Chestertown, twenty miles to the east, on the Eastern Shore. Earth tremors were felt in Philadelphia, Dover, and Atlantic City.

According to accounts, stevedores and crew members were transferring the wooden cases of dynamite from the railroad boxcars to the ship by hand when a

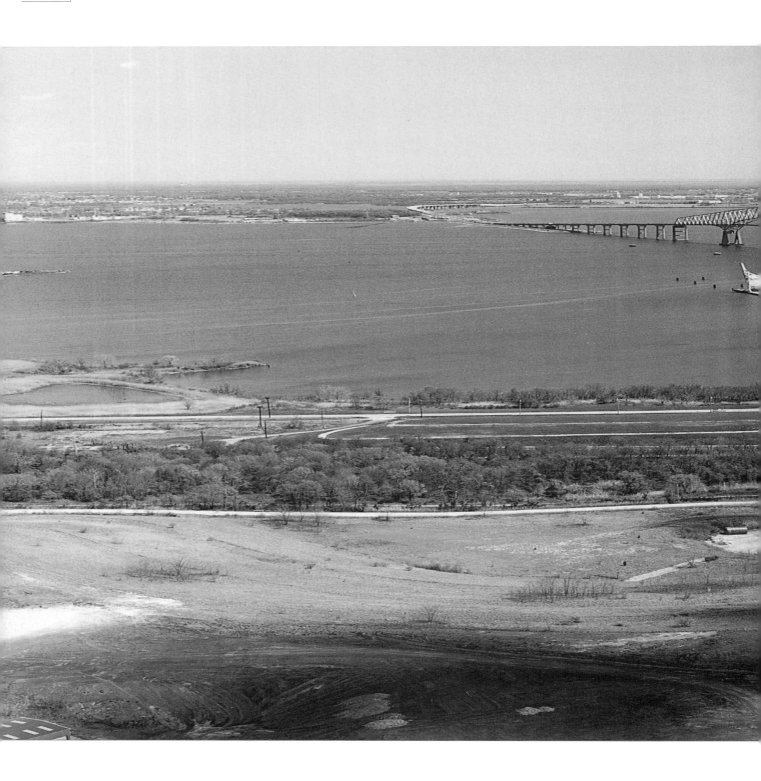

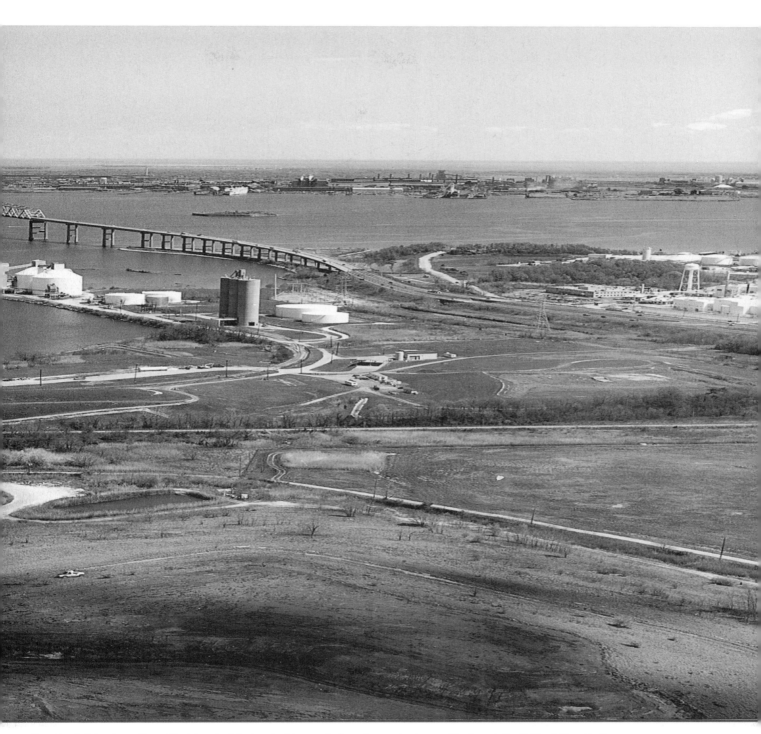

Hawkins Point puts on its prettiest face in this view looking north from the waste dumps. The Francis Scott Key Bridge carries I-695 over the Patapsco River. Estalco's aluminum unloading pier juts from the shore, while the trees of Fort Armistead can be seen just right of the bridge approach. Fort Carroll appears as a sliver in the river between the bridge and the former Bethlehem shipyard and steel plant on the far side. Airland Industrial Photo, Maryland Port Administration

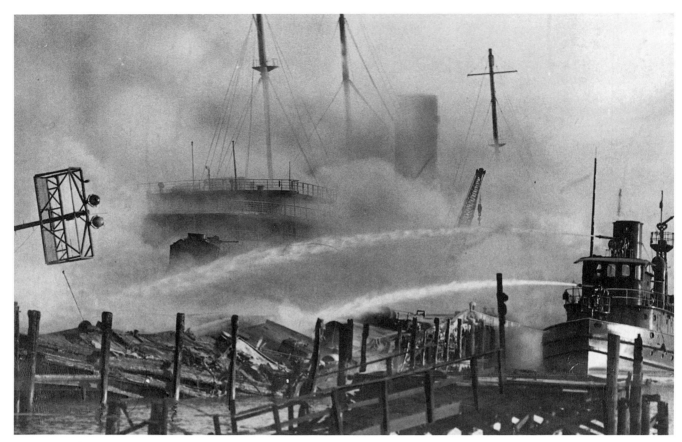

The demise of the *George Washington* in 1951 during a fire at the Hawkins Point ammunition pier. Baltimore *Sun*

foreman rammed his hook into a case of dynamite that had been placed crookedly. The dynamite caught fire, at first giving off dense smoke. Seven minutes later the explosion came.

The freighter's steward, John W. Forrest, jumped overboard at the first sign of fire and was picked up by a nearby motor launch. "As the launch then raced away from the *Alum Chine,* which by now was belching huge clouds of smoke, there suddenly was a deafening report," he later wrote. "It seemed to go dark as night and debris began falling all around us. When that rain stopped there was simply nothing at all where our ship had been, but from her position a white-crested wave as big as a mountain was coming at us, and when it struck it lifted our little boat in the air and tumbled us all over each other, leaving us

bruised, wet, and numb with cold. . . . Soon, hundreds of seagulls came to feast on the thousands of fish the blast had killed." By chance, photographer Alfred Waldeck happened to be out in the harbor at the time of the explosion and caught the remarkable mushroom cloud (*facing page*).

THE RIVER FORTS

Fort Armistead was built on Hawkins Point, along with Forts Howard at North Point and Smallwood at Rock Point, at the time of the Spanish-American War, when there was genuine concern that foreign battleships could sail up Chesapeake Bay and penetrate the harbor.

The crushed granite that was used in the cement of

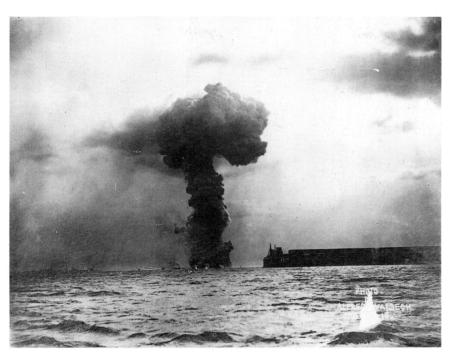

The loss of the *Alum Chine* in 1913 in an accidental detonation of huge amounts of dynamite. Peale Museum

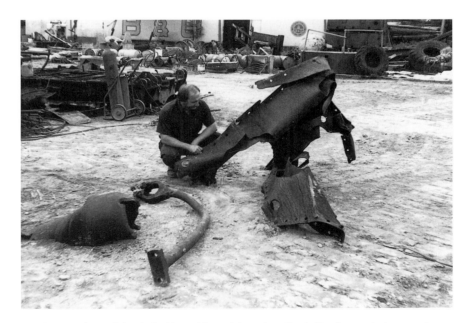

In 1976, workers of the A. Smith and Sons shipyard on Curtis Creek were laying a water main in the harbor when they brought up this severely bent connecting rod and other wreckage believed to be from the *Alum Chine.* Yard owner Jerry Smith has kept the pieces. Photo by author

Fort Armistead's gun emplacements, 1982. Photo by author

the forts makes the gun emplacements almost inde-structable. The cannons were removed to Fort Howard, across the harbor, around 1903, after the nearby Davison Chemical Company complained that practice firing was causing leaks in the company's sulphuric acid tanks. The army abandoned the fort alto-gether in 1921 and turned it over to the City of Baltimore for use as a park. The federal government reclaimed it twice, during World War II as part of its Hawkins Point ammunition dump, and in the 1950s as the site of an antiaircraft battery. In 1983–84 the City of Baltimore spruced up the 45-acre park, in-stalling a two-lane boat launching ramp, a fishing pier, paved walks, and picnic tables. The fortifications overlook the pier and boat ramp but are hidden from the public by weeds and vines. The park is reached from Fort Smallwood Road.

Fort Carroll, an artificial island in the harbor across from Fort Armistead, was constructed, of dense timbers, bricks, and granite slabs, about 1850 under the direction of Robert E. Lee, then a colonel in the Army of the United States. The four-acre fortress was intended to have four tiers of cannon ports, but work was halted when it was two tiers high, and then the second tier was cut back during a "modernization" program in the 1890s. The fort never served any real military purpose (advances in weaponry made it vul-nerable even before construction could be finished), and no one has known what to do with it for years. A Baltimore attorney, Benjamin N. Eisenberg, pur-chased it from the army in 1958 for $10,010, hoping to use it for a gambling casino (the purpose of the extra $10 was to top any competing offer of an even $10,000). Mr. Eisenberg's plan fell through when a court ruled that the property was in Baltimore County, where gambling was outlawed. The property was inherited by two sons and remained closed.

Signs warn visitors away. They should be heeded.

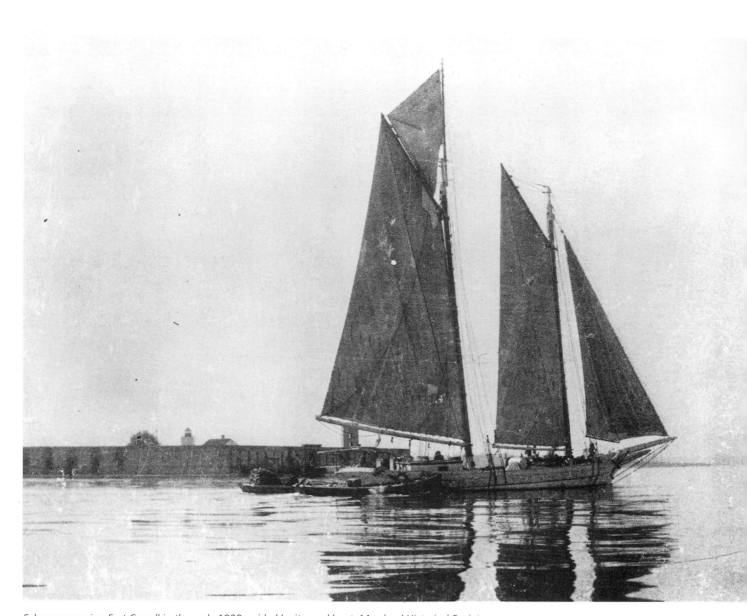

Schooner passing Fort Carroll in the early 1900s, aided by its yawl boat. Maryland Historical Society

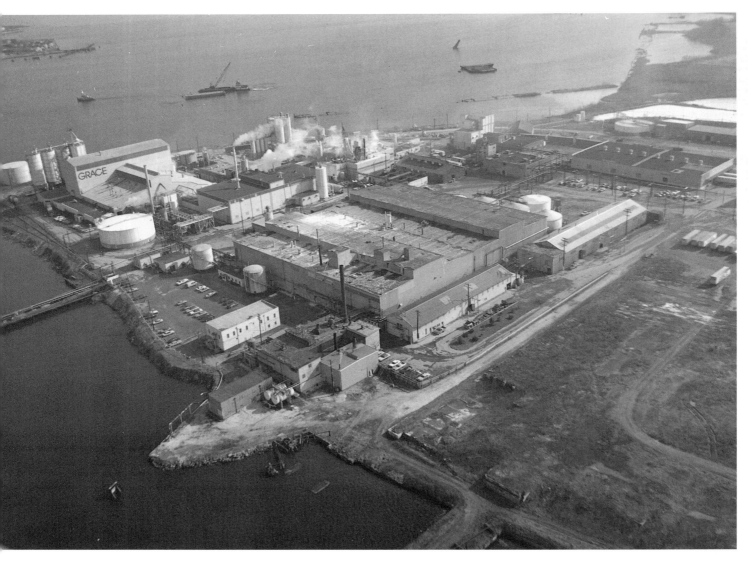

The W. R. Grace "auto cat" plant, identifiable by its four silos and "Grace" sign, was the largest plant in the world making chemicals for catalytic converters when completed in 1974. Protruding from the water at upper right are hulks of fifteen World War I wooden freighters. Also visible is the smokestack of the sunken *District of Columbia*, discussed in the next chapter. Baltimore Gas and Electric Company

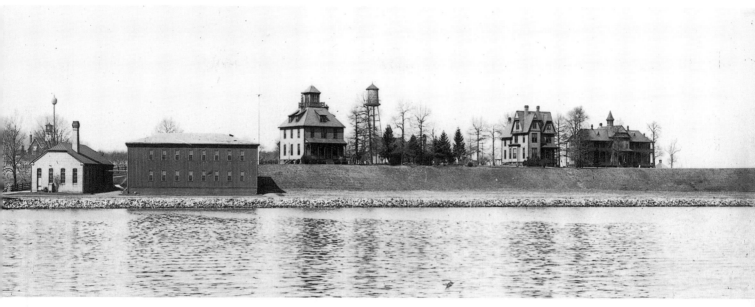

The buildings of the Quarantine Station, which stood for about ninety years on Leading Point. Maryland Historical Society

The rocky landing place can cause damage to boats. Inside the fort, unlit gun emplacements harbor dangerous pits and dropoffs.

QUARANTINE STATION

From about 1870 until 1963, on Leading Point, just west of Hawkins Point, stood a collection of stately buildings that included a detention barracks, a "leper house," and a "delousing plant"—all part of the Quarantine Station. The successor to the Lazaretto Point "pesthouse," the station was intended to protect the nation against contagious diseases brought in from overseas.

The City of Baltimore operated the Quarantine Station until the federal Public Health Service took it over in 1918. Worldwide reduction of diseases led to a phasing out of the operation; the last ship inspections took place around 1961. A quarantine service operated by the federal Department of Agriculture continues to board arriving ships at dockside to check for animal and plant diseases.

In 1963, the Maryland Port Administration purchased the old Quarantine Station tract, including a number of unmarked graves, for $269,500. Nothing remains of the buildings today.

CURTIS BAY WORKS

Grace Davison's Curtis Bay Works has operated in the Hawkins Point–Curtis Bay area since 1900. The Davison Chemical Company was founded in 1832 when William Davison opened a plant at what is now the bottom of Druid Lake. The company subsequently established plants at Canton and Hawkins Point and began development of the Curtis Bay site in 1909. Davison became a division of W. R. Grace and Company in 1954.

For many years, this plant was the world's leading producer of sulphuric acid and of phosphate rock fertilizer (superphosphate). Both activities were eventually phased out as the company sold these product lines and undertook the production of inorganic chemicals on the site. Current products include silicas, adsorbents, and catalysts serving a wide range of purposes in the food, cosmetic, paint, pharmaceutical, ink, petroleum, petrochemical, and chemical processing industries.

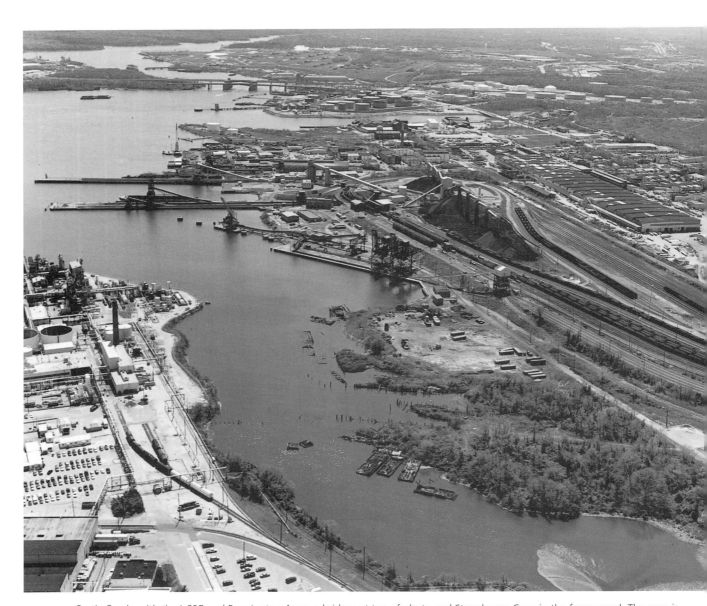

Curtis Creek, with the I-695 and Pennington Avenue bridges at top of photo and Stonehouse Cove in the foreground. The cove is the site of CSX Railroad's coal loading operation, the world's largest when opened by predecessor B&O Railroad in 1917. Two giant cranes at center of photo are used by CSX to unload ore, stone, and other bulk products. The long building at upper right, next to the Curtis Bay community, was built as a Pullman car factory and used in World War II to fabricate ship sections for the mass production of Liberty ships in nearby Fairfield. Maryland Port Administration

CURTIS BAY MEMORIES

Fessenden Blanchard's annual *Cruising Guide to the Chesapeake*, published during the 1960s, carried a warning about Curtis Bay and Curtis Creek: "Yachtsmen should stay out. . . . The creek is very commercial, dirty and unattractive."

And so it is. But it is also one of the most interesting stretches of water on Chesapeake Bay. Industrial ingenuity blossoms on a watery graveyard of ghost ships, as you will see on the following pages.

Chemical plants abound on Curtis Bay, serving a host of industrial users, from farmers to automakers. Oil tank "farms" can be seen everywhere, storing supplies of fuel oil and gasoline after they are brought by ship or pipeline. It is said that 70 percent of the petroleum used in Maryland comes out of here, much of it now fed in by the Colonial Pipeline, which originates in Texas.

Vessels entering Curtis Bay from the east first pass the plant and receiving pier of the U.S. Gypsum Corporation on Leading Point, then the Grace Davison chemical plant on Sledds Point.

The gypsum plant is U.S. Gypsum's sixth largest of thirty-four plants. Its product: drywall for building construction, under the Sheetrock brand, as well as a new line of Durock cement board. The plant produces enough Sheetrock each year for the construction of about 100,000 homes in the Maryland, Northern Virginia, and Philadelphia markets.

The company owns four vessels, which bring the powdery gypsum rock from two company mines in Nova Scotia. The rock, formed from calcium sulfate and water, is crushed and ground into powder, heated in 20-ton kettles to draw out three-fourths of the water, then sandwiched between rolls of paper on two 900-foot production lines. The sheets are cut from the moving line and baked in a 520-degree kiln before being packed off to your local Lowe's or Home Depot store.

The west side of Curtis Bay is also a major industrial area that few Baltimoreans ever see. In the CSX Railroad's coal-loading operation, giant cylindrical contraptions overturn railcars from Appalachia, one or two cars at a time, and shake out their contents onto conveyor belts that feed eight futuristic sorting towers. The towers distribute the incoming coal into storage piles, so that the required type and grade of coal will be immediately available when ships pull up to the piers to carry it away.

Coal exported from the CSX docks travels as far as Europe and as close as the nearby Brandon Shores plant of Constellation Energy. From the same spot a century ago, schooners with five, six, and even once seven masts picked up cargoes of coal for the textile mills of New England.

The newest of the CSX coal piers replaced two old piers with a history of breaking up ships. The piers

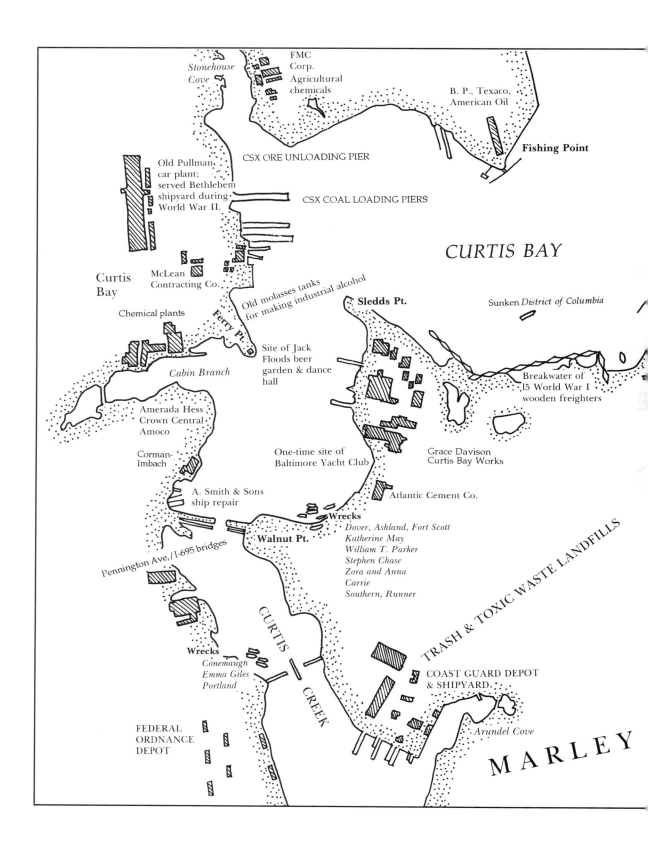

Stonehouse
Cove

FMC
Corp.
Agricultural
chemicals

B. P., Texaco,
American Oil

CSX ORE UNLOADING PIER

Fishing Point

Old Pullman
car plant;
served Bethlehem
shipyard during
World War II.

CSX COAL LOADING PIERS

CURTIS BAY

Curtis
Bay

McLean
Contracting Co.

Old molasses tanks
for making industrial alcohol

Sledds Pt.

Sunken *District of Columbia*

Chemical plants

Ferry Pt.

Site of Jack
Floods beer
garden & dance
hall

Breakwater of
15 World War I
wooden freighters

Cabin Branch

Amerada Hess
Crown Central
Amoco

Corman-
Imbach

One-time site of
Baltimore Yacht Club

Grace Davison
Curtis Bay Works

A. Smith & Sons
ship repair

Atlantic Cement Co.

Wrecks

*Dover, Ashland, Fort Scott
Katherine May
William T. Parker
Stephen Chase
Zora and Anna
Carrie
Southern, Runner*

Walnut Pt.

Pennington Ave./I-695 bridges

TRASH & TOXIC WASTE LANDFILLS

CURTIS

CREEK

Wrecks

*Conemaugh
Emma Giles
Portland*

COAST GUARD DEPOT
& SHIPYARD

FEDERAL
ORDNANCE
DEPOT

Arundel Cove

MARLEY

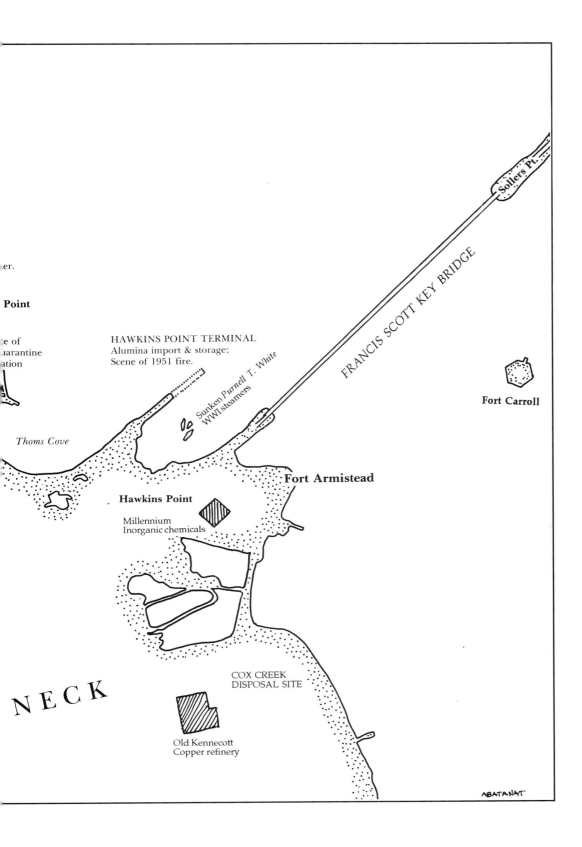

er.

Point

te of
uarantine
ation

HAWKINS POINT TERMINAL
Alumina import & storage;
Scene of 1951 fire.

*Sunken Purnell T. White
WWI steamers*

Thoms Cove

Hawkins Point

Millennium
Inorganic chemicals

FRANCIS SCOTT KEY BRIDGE

Sollers Pt.

Fort Carroll

Fort Armistead

N E C K

COX CREEK
DISPOSAL SITE

Old Kennecott
Copper refinery

ABATANAT

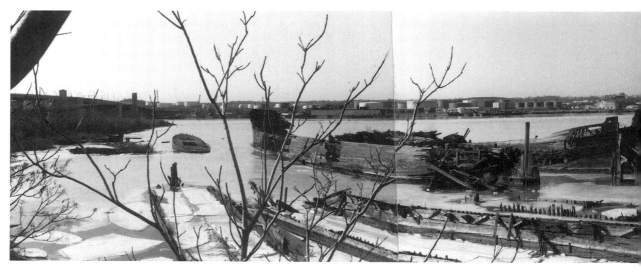

Carrie cement boat Dover Ashland
Zora and Anna
William T. Parker Stephen Chase
 barges

were owned by the Boston Metals Company, which closed its salvage operations here in August 1979. Chesapeake Bay steamboats and even warships and steel freighters met their doom at the Boston Metals docks for more than a half-century.

Upstream from the coal docks, shortly before the Pennington Avenue and I-695 bridges, is Ferry Point. Marked now by a sea of round Hess oil tanks, it was a popular attraction for some Baltimoreans a century ago. Revelers were lured here by the thousands, many coming by trolley across the old Light Street Bridge. Their destination: Jack Flood's beer park, where thirty showgirls awaited them, performing burlesque in white tights, then sitting with the customers and earning a 2½-cent commission on every 15-cent drink they "sold." The grounds had big shade trees, large open pavilions, picnic tables, a theater, and up to 125 waiters in long white aprons running back and forth with orders. Flood's served liquor on Sundays, which was the cause of its demise. "This brought the Billy Sunday crew, the Anti-Saloon League, the Home Defenders, and the Lord's Day Alliance down on him," a former employee reported. In 1916 Flood's

license renewal was denied, and the days of his Curtis Bay Park were over.

Upstream from Ferry Point, past two vehicular bridges and one railroad bridge, is the only shipyard of the United States Coast Guard, established here in 1899, when Curtis Bay was lined with peach orchards and the waters abounded in trout, perch, and rock. Across the creek and to the right is the giant government Defense Council Stockpile Center depot, once operated as a supply base by the army but now under the jurisdiction of the Defense Logistics Agency and tightly locked, with the intimidating admonition "No Cameras."

Farther upstream, at the top of the photo, is tree-lined Marley Creek, which has seen no commercial traffic for several decades, not since the last of the watermelon boats made secret visits to pick up truckloads of their product and take them to the downtown public wharves, giving the appearance of bringing in an authentic cargo from the lower Bay. Branching off to the west is Furnace Creek, where an old foundry made cannonballs during the Revolutionary War.

PHOTO BY THE AUTHOR

Fort Scott

gambler's yacht

barge

ABANDONED SHIPS

A visitor to Curtis Creek will find fascination at every hand, not only because of the great commercial installations, but because it is a graveyard of abandoned ships. Stansbury Cove, next to the Pennington Avenue bridge, was the earliest stopping point for European vessels on the Patapsco River, because of nearby artesian water supplies. (Heavy use of underground water by the Davison Chemical Company stopped the flow in the last century.) A British captain named Curtis brought ships here for water in the mid-1600s, which is apparently how the bay got its name.

Most of the ships left to disintegrate in this historic cove can be identified (author and former Baltimorean Robert H. Burgess, who kept track of the Curtis Bay wrecks until his death, provided much information about them). One intact hull belongs to a ferro-cement steamer built for the army during World War I. Wreckage along the beach to the left of the ferro-cement boat includes remnants of the schooners *William T. Parker* and *Zora and Anna.* To the right of the concrete hull lie the hulks of two large World War I–era vessels, the *Dover* and the *Ashland.* Peering out

An abandoned tug wastes away south of the Pennington Avenue and Beltway bridges. Photo by author

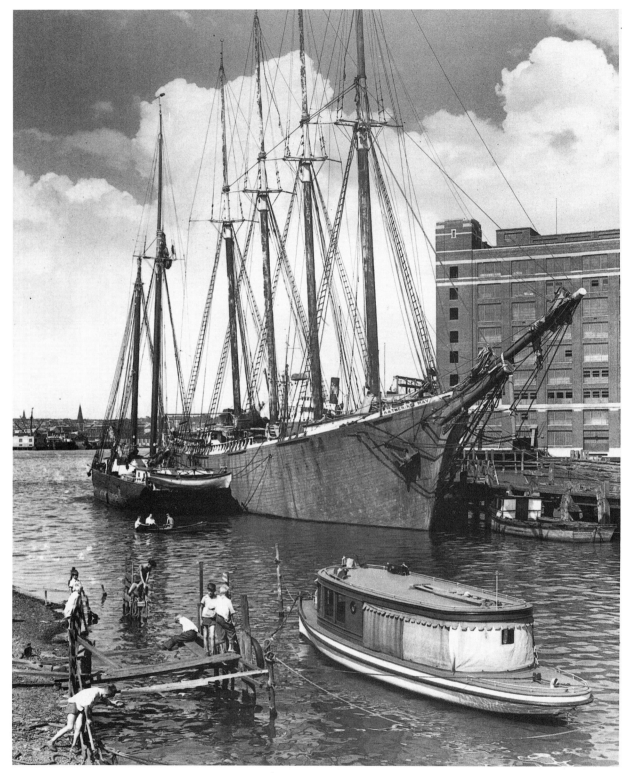

Four-masted schooner *Katherine May* laid up off the Domino Sugars refinery in the 1930s, with schooner *Mary Lee* alongside.
Photo by A. Aubrey Bodine

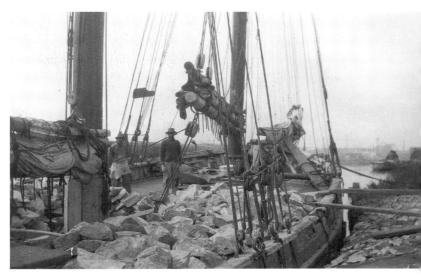

A schooner carrying a cargo of rock for bulkhead construction. Maryland Historical Society

just behind the bow of the *Ashland* is the hawsepipe of a World War II ocean rescue tug.

The crumbling remains include those of the World War I–era freighter *Fort Scott,* built in Oregon and, alongside the *Dover,* the schooner *Stephen Chase,* built in Dorchester County, Maryland, in 1878. Barely visible alongside the *Fort Scott* are remains of a gambler's yacht. The remains of the four-masted schooner *Katherine May* lie behind the *Dover,* as do the tugs *Runner* and *Southern* near the *Fort Scott.*

THE SCHOONERS

Of all the vessel types represented in the Curtis Bay graveyard, none played a more important part in Chesapeake Bay commerce than the large cargo schooners. Designed to operate with a minimum of crew, these wooden ships were a common sight in Baltimore harbor, transporting oysters, lumber, coal, and other bulk materials, as well as general cargo. A hundred of them were operating as recently as 1930.

The identities and lives of the Curtis Bay schooners were chronicled by Robert Burgess, and their vital statistics are recorded in annual *Merchant Vessels of the United States,* published since 1868. Here is a thumbnail rundown:

Purnell T. White. Four-masted schooner. Built Sharptown, Maryland, 1917. Dismasted at sea, 1934; towed to Norfolk, then Baltimore with intent to convert it to a barge; left to rot off Locust Point. Landfill was dumped over the hull, the decks fell in and the bow was set afire. In 1957, a massive dredging and clearance project was undertaken at Locust Point to make way for a fruit terminal. Astonishingly, the *White* was refloated and towed to Hawkins Point, where her remains are no longer identifiable.

Katherine May. Four-masted schooner. Built 1919 in Maine for $175,000. Came to Baltimore in 1931 from Bermuda under British registry. No cargo found during Depression, eventually took on water and sank at a pier near Federal Hill; was auctioned off for $405, raised and towed to Curtis Creek, but abandoned there.

William T. Parker. Three-masted schooner. Built Milton, Delaware, 1891. Lumber carrier. Stranded off Cape Henlopen, Delaware, August 27, 1899; repaired. Disabled in gale off North Carolina, September 10, 1908. Abandoned in severe storm off Carolinas about 1915; drifted to Maine and back down coast; towed to port and reconditioned. Topmasts removed about 1929. Rammed off Bloody Point in Chesapeake Bay, February 24, 1935, by steamer *Commercial Bostonian;* sailed to Annapolis for anchorage, then to Marley Creek, where lumber cargo was unloaded and A. Smith and Sons surveyed damage. Upon determina-

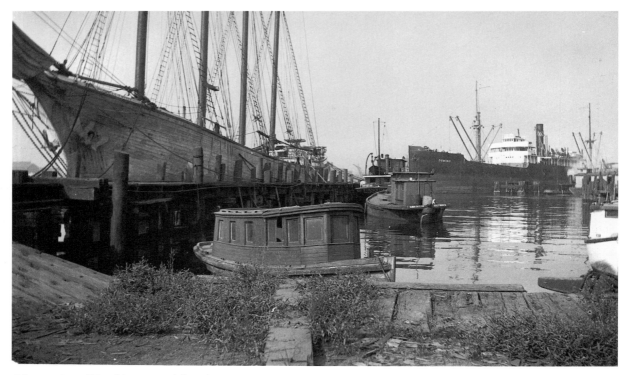

Schooner *Purnell T. White* at Woodall yard on Locust Point, 1931. The *White* was regarded as the handsomest of the large schooners that visited Baltimore in the last century. The graceful sheer of her deckline is very evident here. Maryland Historical Society

tion that repairs would be too costly, the *Parker* was towed to Locust Point, where it was used for seven years as a home. It was moved to Curtis Creek in 1945. A watchman, Jake Bluhm, and his wife lived aboard the hulk for several years, until a steamer broke loose from its tug one night and crashed into the *Parker*, nearly breaking it in two.

Zora and Anna. Built 1855 as *Ocean Bird*, making her the oldest known wreck in Curtis Bay; rebuilt as *Zora and Anna* at Sharptown, Maryland, 1910. Dimensions: 83.8 feet long, 23.8 feet wide, 6.3 feet deep; weighed 86 gross tons. Owner Joseph E. Elliott, whose home port was Annapolis. Abandoned 1941.

Carrie. Centerboard schooner. Dimensions: 93 feet long, 23 feet wide, 6.6 feet deep. Built 1882 in Cambridge, Maryland.

Stephen Chase. Centerboard schooner. Built Dorchester County, Maryland, 1876. Dimensions: 66.6 feet long, 23.9 feet wide, 6.7 feet deep. About 1939

Capt. Major Todd sold to a relative, Emmet Carew of Brooklyn, Maryland. Was moored next to *Katherine May* and someone lived aboard. Then was moved to inner side of *Dover*, where it filled and sank. Listed as abandoned 1946.

H. K. Price. Beached at A. Smith and Sons yard in 1933 with intention to convert to power, but hull was found too weak. Destroyed when new bridge was constructed over Curtis Creek.

Hanna and Ida. Broke off masts going under bridge on Chesapeake and Delaware Canal in 1935. Hull towed to Marley Creek for use as breakwater. Exact location unknown.

WORLD WAR I STEAMERS

The biggest and strangest of the Curtis Bay hulks are the remains of wooden freight steamers built during World War I. The freighters are the product of one

Bow of the wooden steamer *Dover,* a New Hampshire-built remnant of the World War I building program at Curtis Creek, 1982. Photo by author

of the least successful shipbuilding programs ever undertaken in this country. The United States Shipping Board proposed to build 800 to 1,000 of the 3,500 deadweight-ton ships within a period of eighteen to twenty-four months, in order to keep ahead of the losses of American tonnage to German submarines.

In the winter of 1917–18, a "river of wood" flowed by railroad from Oregon to Atlantic and Gulf shipyards—heavy lumber for hull construction. Only a small portion of the planned production was delivered before the Armistice of November 11, 1918. However, this was a government project that took on a life of its own, and the building of the ships continued even though the circumstances that led to their construction had ceased to exist. Other than meeting a wartime emergency, the ships had no value whatsoever. They lacked the stamina of steel vessels in carrying propulsion machinery and bucking heavy seas. They were too small to operate economically on long voyages yet generally too large and heavy to be used successfully as barges. They were built hastily of green timber and not properly caulked. Complained one irate skipper, referring to the materials used in his ship, "They sent out oak shoots in April and provided pine cones for the Christmas mess."

In September 1925, 200 of the wooden steamers, built at a cost of $1 million apiece, were burned to the waterline at Mallows Bay in the Potomac River, across from Quantico, Virginia, for scrap metal. In Baltimore, fifteen of the hulks were sunk end-to-end along the southeast shore of Curtis Bay to make a break-

water, which is still visible. Three other wooden steamers from that era, the *Dover, Ashland,* and *Fort Scott,* were acquired by Davison Chemical and used as barges to bring pyrite ore from Cuba. They were abandoned in Curtis Creek in 1923. Their superstructures are the largest of the hulks looming out of the mud at Stansbury Cove.

NIGHT BOATS

On the night of April 13, 1962, the *City of Norfolk* blew one long blast upon leaving her slip, just as ships of the Baltimore Steam Packet Company had been doing since 1840. The sound of the whistle reverberated about Norfolk harbor, as it had always done. The *City of Norfolk* moved out into the channel, her electric lights etching her white cabins against the dark and stormy night. Her lovely sheer made her graceful from every angle as she turned her stern to Norfolk and disappeared into the rain. It was a sight that Norfolk had seen on thousands of occasions, but one it would never see again. The last American night boat was making her final sailing. . . . When the *City of Norfolk* tied

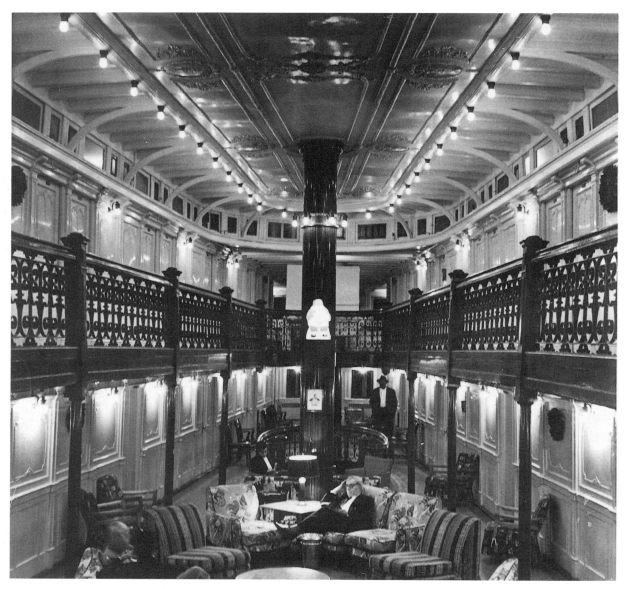

The elegant interior of the steamer *City of Norfolk*. Sunpapers photo by A. Aubrey Bodine

up in Baltimore the following morning, a characteristic American institution was ended, finally, inexorably and irrevocably. The night boat was an extinct form of transportation.

George W. Hilton gave us this evocative description in his 1968 book, *The Night Boat*. For a century, from the mid-1800s to the mid-1900s, the night boat was an established part of the American transportation system, carrying passengers and freight between cities a few hundred miles apart: Baltimore and Norfolk, Washington and Norfolk, Detroit and Cleveland, Detroit and Buffalo, New York and Albany, New York and Boston. Many of the night boats were paddlewheel steamers, or resembled the paddle-wheelers in profile: wooden superstructure built out from the hull on overhanging guards, giving a beamy and comfortable appearance. Hilton recounts their attraction: "A leisurely dinner at prices comparable to restaurants on shore, a relaxed evening on deck or in

RIGHT:

Top: The *District of Columbia.* Steamship Historical Society of America

Middle: Interior of the *District of Columbia.* Collection of R. Loren Graham

Bottom: The *District of Columbia* renamed the *Province-town,* afire at Pratt Street pier, 1969. Sunpapers photo

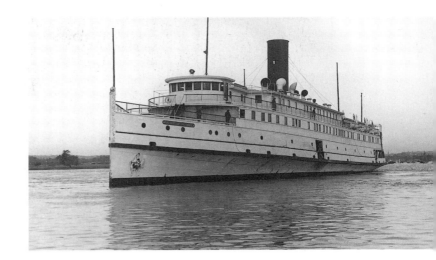

the grand saloon, and a night of sleep in the creaking comfort of a berth afloat." The price was an amazing bargain. Even at the end, when the Baltimore Steam Packet Company decided to abandon operations, the basic fare between Baltimore and Norfolk was only $5.50, with cabin charges ranging between $2 and $6.25.

The *City of Norfolk* and her companion ship, the *City of Richmond,* both of which were propeller ships, provided the last night boat service. The *Norfolk,* scheduled for scrapping, was struck by lightning and caught fire at the scrap yard, and the *Richmond* was lost while being towed to the Caribbean in 1964. They were not the last of their breed in existence. That distinction goes to the *District of Columbia,* whose remains are now at the bottom of Curtis Bay. This vessel was built in 1925 for the Washington-Norfolk run, down the Potomac River. In 1948, off Old Point Comfort, it collided with the tanker *Georgia* and suffered heavy damage. The Baltimore Steam Packet Company (also known as the Old Bay Line) bought the *District of Columbia,* repaired it, and kept it oper-ating out of Washington, D.C., until 1957. The ship was then brought to Baltimore as a backup to the *City of Richmond* and *City of Norfolk.* When those vessels ended their service in April 1962, the *District of Columbia* was taken to Cape Cod, renamed *Province-town,* and employed as a cruise ferry between Boston and Provincetown during the summer seasons of 1962 and 1963.

The ship was purchased by Charles Hoffberger and returned to Baltimore in 1964. Hoffberger's plan

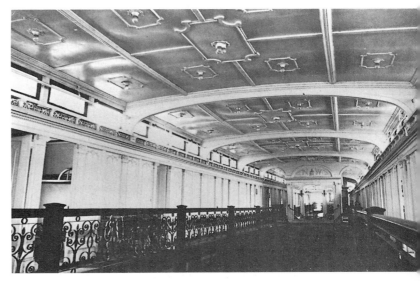

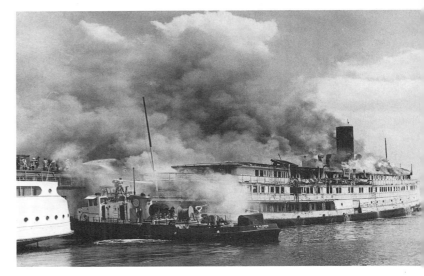

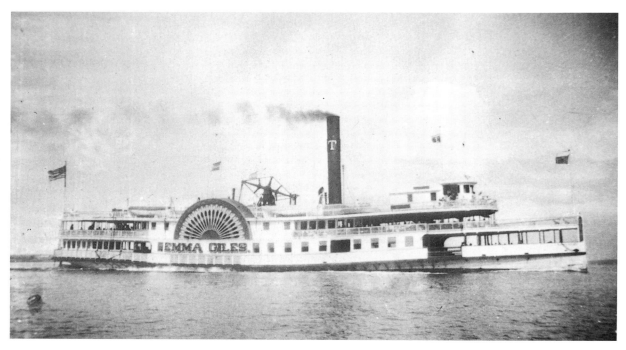

Baltimore's popular *Emma Giles*. After retirement, conversion to a barge, and service as a bulkhead, the 72-year-old hull was burned in 1959 to retrieve scrap metal. That same year, Emma Giles Parker, the steamship company director's daughter, who had christened her, died at age 81. H. Graham Wood Collection, Steamship Historical Society of America

was to restore her to operation in 1965, under the name *Chesapeake,* and to have her make two trips weekly from Washington to Yorktown and Norfolk. But bringing her into compliance with Coast Guard safety requirements proved too costly, and the plan was abandoned. Fire swept her upper decks in 1969 as she lay at her downtown Baltimore pier, dashing hopes of turning her into a restaurant. City authorities had the derelict towed to Curtis Bay in 1970. The following January she flooded and sank. A decade later there was talk of dynamiting her submerged hulk and taking the scrap. Meanwhile she lay on the bottom, her smokestack and air funnels exposed. They have since disappeared, marking the final passing of America's last night boat.

THE *EMMA GILES*

Of all the sidewheel passenger steamers to operate out of Baltimore, none was better known or more popular than the *Emma Giles,* built in 1887 for the Tolchester Company. For nearly a half-century she carried weekend excursionists from the Inner Harbor to the beaches across the Chesapeake at Tolchester, and on weekdays she moved passengers and cargo to other points along the bay: Port Deposit, Annapolis, West River, Little Choptank. A scene of a beehive with bees hovering over flowering plants was carved on her paddle boxes, along with the legend, "She was as busy as the bee."

At the close of the 1936 season, the Tolchester operation was suspended and the *Emma Giles* was sold. Two years later she was taken to the place where she was built, the former William F. Woodall shipyard at Locust Point, and converted to a barge. For about ten years she brought lumber to Baltimore from points in North Carolina, her owner, Capt. George F. Curlett, boasting that she could carry more lumber than any other barge working the inland waterway.

When transportation of lumber by barge dwin-

Stevedores transferring cargo from Chesapeake Bay steamer *Middlesex* at Lodge, Virginia. H. Graham Wood

dled, she was taken by a Baltimore shipbreaker to mudflats at the mouth of Curtis Bay, where she served for another ten years or so, as a bulkhead, surrounded with dirt. Then the site was needed for a new ore pier and all the hulks in the area, including that of the *Giles,* had to be removed. She was cleared of dirt, refloated, and towed up Curtis Creek beyond the Pennington Avenue bridge. Then she was set on fire, in an effort to expose her iron frames for scrap. A portion of her charred stern remained visible for a number of years. It seemed strange to look at that lifeless wreckage, and then recall a passage from George and Robert Barrie's 1909 book, describing the arrival of the *Emma Giles* in Annapolis around the turn of the century:

About half-past ten o'clock the steamer will be seen coming from behind Greenberry Point, and as she passes the lighthouse gives a long blast from her whistle. Then the "tailor" fishers lift up their rods and gather up their paraphernalia, swing in their legs, and stand among the curious crowd which has gathered, the larger portion being small boys, both white and black; the town loafers, and perhaps a few prospective passengers. In the background are half a dozen hacks, in most of which Washington rode the day he resigned his commission, and eight or ten wagons awaiting for the freight. In a few minutes she is along-side the wharf, the captain being a master hand at this; over the rails leans a crowd of women and children, the latter in such abundance that one is firmly convinced that all of the youngsters and babies of Baltimore are on an outing. Just as the lines are fast a laggardly hack or wagon will clatter down the vit-

rified brick street at full gallop, the horses covered with lather and the driver cracking his whip and yelling at the top of his voice to the gapping crowd; suddenly he pulls up, the horses sliding and the pole almost sticking into the barouche ahead. When the gang-plank is on the wharf, first off are passengers; a drummer or two, and a few people who have come on a visit, but the majority are "trippers," who, while the steamer remains, walk to the [Naval] Academy. Then comes another gangplank and pandemonium breaks loose in the form of fifteen [black stevedores] clad in the tatters of shirt, trousers, and shoes. They have been lined up on the main deck, each man with a truck in front of him loaded to its utmost; down one plank they tear; up into the freight house, which is soon filled; dump, and back on board by the other plank. They keep this up continuously even on the hottest of sultry August days, singing, shouting, and doing fancy steps, always in good humor, although they are pestered by small children getting in the way, and

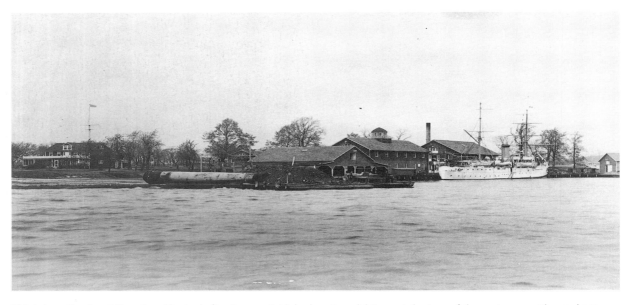

This is how the Coast Guard yard looked after it was established on Arundel Cove at the turn of the century. . . . The yard grew as the Lifesaving Service was combined with the Revenue Cutter Service in 1915 to form the Coast Guard; the Lighthouse Service was added in 1939. Additional shipways, shops, and piers were built soon after the outbreak of World War II. Baltimore Gas and Electric Company

there are some narrow escapes, but the stevedore makes a quick turn or a short stop and the stray youngster is hauled off by a chattering parent. . . . In the meantime, crates of vegetables, boxes of shoes, pieces of farming implements, sides of beef, even barrels of moulder's sand, window-frames, sofas, bags of flour or meal, which oftentimes leaves a trail along the deck and into the shed, boxes of canned goods, now and then a barrel of crab-bait, from which a thousand flies have been disturbed, is trundled off, leaving a reeking trail along which the persistent flies are buzzing like a pack of hounds on a fox's scent, coils of rope for the ship chandlers on the city dock, plumbers supplies; in fact, boxes and bundles of every conceivable size and shape containing all sorts of articles . . . are soon scattered over the wharf.

When nearly all are off a few shipments for the landings on West River are taken on, then the trucks are stacked and a carriage or cart followed by a horse is run off; the whistle blows, the last tripper dashes down and jumps on board just as the lines are cast off and the *Giles* backs off into the har-

bor, leaving a trail of froth dotted here and there by a shoe-box which contained some delicatessen.

By this time the hacks that were fortunate enough to get a fare have long since swayed off up the street and the others are now straggling off; the wagons are loading and soon they have disappeared; the loafers are gone; the anglers are once more absorbed in catching the toothsome "tailor"; the agent is sitting in the doorway of the freight shed to catch the breeze, his pocket handkerchief in one hand mopping his red face and fanning with his hat in the other. The usual reign of quiet being broken only by the occasional bleat of the small brown veal in the cattlepen waiting to be taken to Baltimore when the steamer stops on her return trip in the afternoon.

COAST GUARD YARD

A bit further up Curtis Creek is the yard and depot of the U.S. Coast Guard. The shipyard, with some 600 military and civilian employees, builds and overhauls

the Coast Guard's largest vessels. Repairs are performed here on the service's Gulf and Atlantic coast vessels, including winter refitting of the three-masted training bark *Eagle*. All the channel marker buoys for United States coastal waters were made here until the work was outsourced in the late 1980s.

An additional 600 non-shipyard Coast Guard personnel are based here, serving the Port of Baltimore shipping operations and buoy-tending and safety operations on the upper Chesapeake Bay.

A head-on view of the Coast Guard's three-masted training ship, *Eagle*, ashore for maintenance. U.S. Coast Guard photo

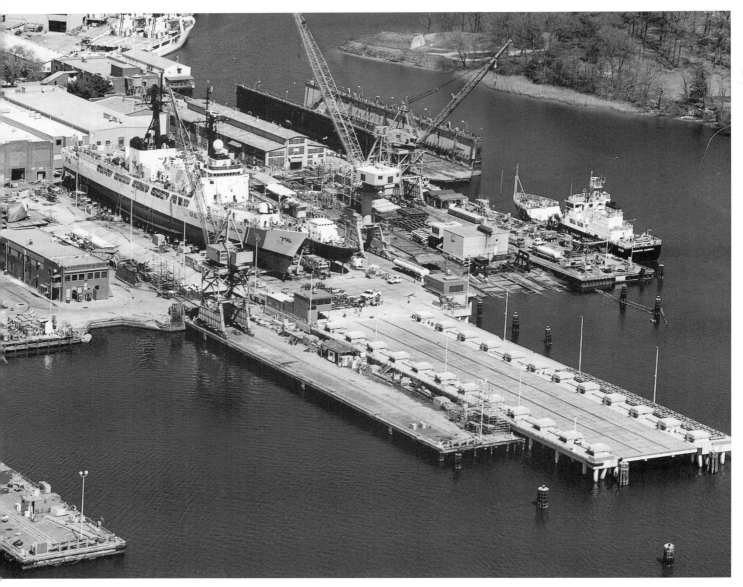

The Coast Guard's modern shipyard with a state-of-the-art shiplift put in service in 1996. After a ship floats over the lift, ship and lift are hoisted out of the water by twenty-four winches and cables. The ship is then trundled away to make room for another ship. Maryland Port Administration

MIRACLE AT FAIRFIELD

West of Curtis Bay, past the Patapsco sewage treatment plant at Wagner's Point, on a wide fist of land known as Fairfield and at the exact spot where the first harbor tunnel plunges below the ground, lies the most amazing industrial site in Baltimore harbor. This is the place where Bethlehem Steel Corporation built 508 steel ships during World War II.

The yard was established by the Union Shipbuilding Company during World War I. Union turned to shipbreaking in the mid 1920s. Among its victims: the *Morro Castle,* purchased for $39,000 and towed to the yard for scrapping after it was swept by fire off the Jersey Coast in 1934 with a loss of 134 lives.

With a government order for 50 ships—the first of the famed Liberty ships—Bethlehem leased the Union yard in 1941, added 12 shipways to the 4 already there, and took over the 33-acre Pullman and Standard Steel Company plant 2 miles to the south along the B&O Railroad line. The heavy-duty machinery of the Pullman plant—which turned out 25 railroad cars a day in its heyday—was rearranged into a mass production line for ship components. The components were brought to the shipyard by B&O and assembled on the ways.

The keel for the first ship, the *Patrick Henry,* was laid April 30, 1941. The ship was launched September

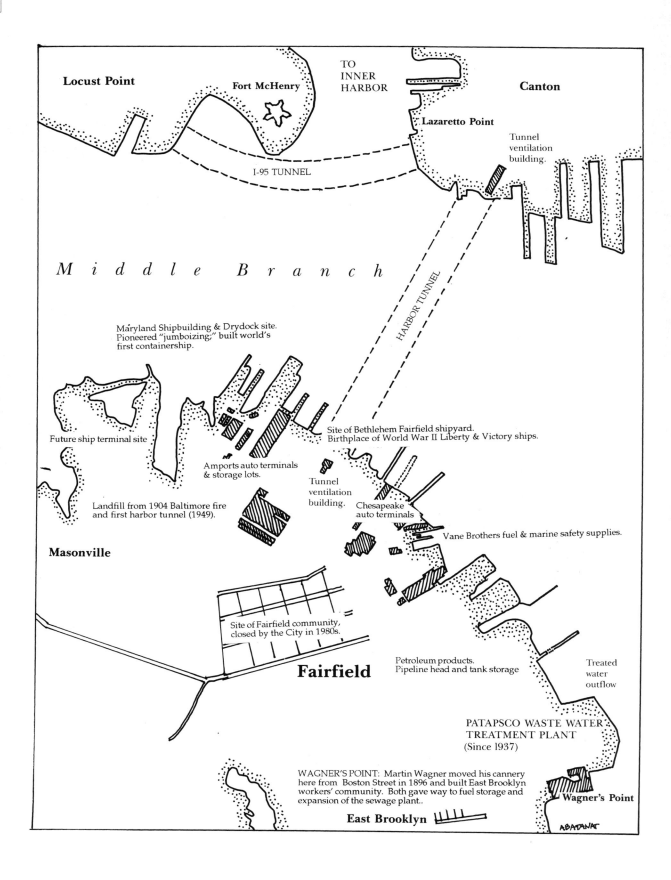

Locust Point

Fort McHenry

TO
INNER
HARBOR

Canton

Lazaretto Point

Tunnel
ventilation
building.

I-95 TUNNEL

Middle Branch

HARBOR TUNNEL

Maryland Shipbuilding & Drydock site.
Pioneered "jumboizing;" built world's
first containership.

Future ship terminal site

Site of Bethlehem Fairfield shipyard.
Birthplace of World War II Liberty & Victory ships.

Amports auto terminals
& storage lots.

Tunnel
ventilation
building.

Chesapeake
auto terminals

Landfill from 1904 Baltimore fire
and first harbor tunnel (1949).

Vane Brothers fuel & marine safety supplies.

Masonville

Site of Fairfield community,
closed by the City in 1980s.

Fairfield

Petroleum products.
Pipeline head and tank storage

Treated
water
outflow

PATAPSCO WASTE WATER
TREATMENT PLANT
(Since 1937)

WAGNER'S POINT: Martin Wagner moved his cannery
here from Boston Street in 1896 and built East Brooklyn
workers' community. Both gave way to fuel storage and
expansion of the sewage plant..

East Brooklyn

Wagner's Point

ABADANA

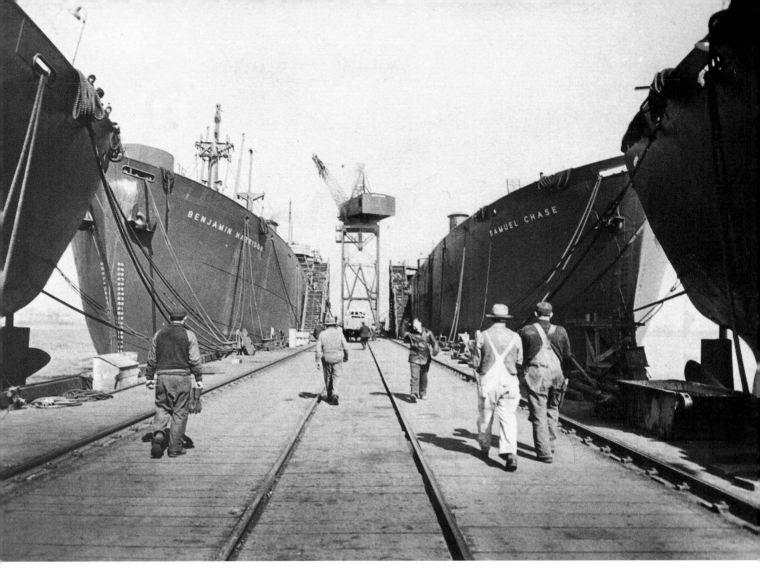

Bethlehem Steel shipyard during World War II. After launching, Liberty ships were towed to this pier to be completed and fitted out for sea. Sunpapers photo by A. Aubrey Bodine

27 and delivered December 30. By the time the yard reached peak round-the-clock production, it employed 47,000 persons and had brought the time between keel-laying and launch to less than 30 days (19 days was the record). There was a time when a ship was coming down the ways every 24 hours. With the end of the war, after building 384 Liberty ships (which if end-to-end would make a line 32 miles long) the yard switched in 1944 to Victory ships, faster and more suitable for postwar commerce. It built 94 of these along with 30 landing craft. In a grand finale shortly after the war's end, the yard conducted a triple launch of Victory ships, between September 19 and 22, 1945, and went out of business.

In a space of less than five years, Bethlehem's Fairfield yard built 5,187,800 tons of shipping, 10 percent of the American fleet, more tonnage and more ships than any other of the wartime mass production yards and a world shipbuilding record. The company attested to an aftertax profit of $14.2 million on the operation, about $28,000 per ship.

In 1946, Bethlehem, which by then owned the property, established the Patapsco Scrap Corporation to undo what had been done and feed the blast furnaces of Sparrows Point and other Bethlehem Steel plants. Many Liberty ships came back to die at the place where they had been born. One of them was the *Patrick Henry*. After a successful career under the

Launching of the first Liberty ship, the *Patrick Henry*, September 27, 1941. Called the "ugly ducklings of the sea lanes," the Liberty ships were 441 feet 7½ inches long, 56 feet 10¾ inches wide, and carried 10,500 tons of cargo in their five big holds. Their oil-burning steam reciprocating engine moved them at a speed of 11 knots. They cost about $1.9 million apiece to build. Their successors, the Victory ships, moved at 15 knots, driven by high-pressure steam turbines, and cost about $2,250,000 apiece. Peale Museum

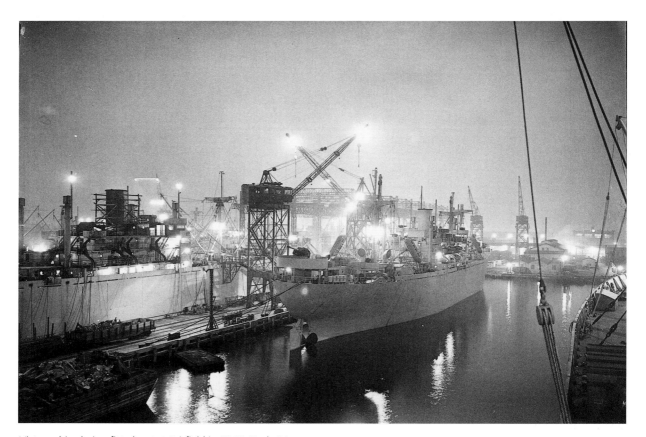

Victory ships being fitted out at Fairfield in 1945. Peale Museum

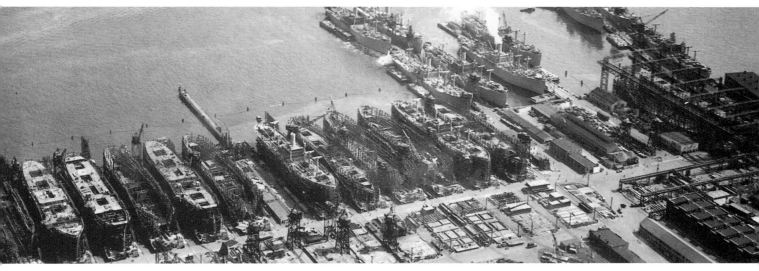

Bethlehem Steel's Fairfield Yard, seen here at war's end in 1945. The yard turned out more Liberty and Victory ships than any other shipyard. Sunpapers, A. Aubrey Bodine, ©Jennifer B. Bodine

operation of Lykes Steamship Lines of New Orleans, the *Patrick Henry* was retired to the reserve fleet in Mobile River, Alabama, on August 28, 1946, needing a $75,000 overhaul. A move to persuade the Propeller Club of Baltimore to preserve the ship as a symbol of the American merchant marine failed; she was returned to the Fairfield site for scrapping on October 26, 1958.

Early in 1960, after the government decided to sell many old Liberty ships from the reserve fleets, more than 100 of the vessels were tied up in Curtis Bay awaiting their fate. The Patapsco Scrap Yard subdued many of these, as well as several battleships, before closing down on June 30, 1964.

In the 1980s, 40 acres of Bethlehem Steel's Fairfield yards, including the three outfitting piers, were sold to Baltimore developer Struever Brothers, Eccles and Rouse, who marketed them as waterfront industrial property under the name Port Liberty.

For a time, Bethlehem Steel Corporation continued to use one of the shipyard buildings to house its Buffalo Tank Division, making all sizes of steel storage and pressure tanks for the chemical and petroleum industries. In 2000, the East Coast Granite Works took over the building, for production of polished granite slabs for floors and countertops—a specialty industry dominated for centuries by Italian stonemasons. East Coast Granite imports its raw product in 35-ton blocks, mostly from Brazil, and slices them with a massive $500,000 Italian-made gang saw. U.S. buyers find shipping from Baltimore less expensive and about five times faster than shipping from factories using the same equipment in Italy.

The old six-block-long Pullman plant still stands, forming the eastern boundary of the town of Curtis Bay and providing a home to a dozen light industries.

THE *JOHN W. BROWN*

With flags flying and a band playing Glenn Miller tunes, the refurbished Liberty ship *John W. Brown* sailed from Baltimore Harbor September 7, 2002, on a daytrip on Chesapeake Bay with 730 passengers aboard, celebrating the vessel's 60th birthday.

Fairfield workers laid the keel of the *Brown* in shipway #12 on July 28, 1942, and had the hull in the water five weeks later. Named for a union shipbuilding official from Maine, it is one of two Liberty ships remaining in service. The other, the *Jeremiah O'Brien*, based in San Francisco, was built in Bath, Maine.

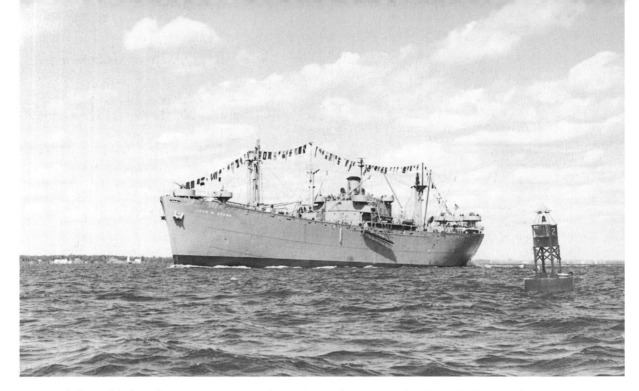

Converted Liberty ship the *John W. Brown* steaming down Chesapeake Bay on its first day cruise in 1991. Photo by Harry Brown

The *Brown* completed eight wartime trans-Atlantic voyages and five after the war, dodging torpedoes, air attacks, and the shipbreaker's torch. It took part in D-Day and the invasion of southern France in 1944. "Steaming a total of about 100,000 miles, she carried approximately 52,525 tons of cargo and more than a thousand troops from the United States to the war zones," according to Sherod Cooper, author of *Liberty Ship: The Voyages of the John W. Brown 1942–1946,* published by the Naval Institute Press in 1997.

The War Shipping Administration transferred the *Brown* to the New York City Board of Education in 1946 for use as a nautical vocational high school. In 1982 it was towed to the Reserve Fleet in Virginia's James River. Meanwhile, a group of Baltimoreans made plans to restore the vessel. They formed Project Liberty Ship in 1978 and a decade later, under the leadership of Capt. Brian H. Hope, a Chesapeake Bay pilot, brought the vessel to Baltimore. As its membership grew past 3,000, Project Liberty Ship was able to find more than $7 million in funding and bring thousands of hours of volunteer labor to reviving and sustaining the vessel.

Many of the faithful are World War II survivors. "For years they've poured their hearts, souls and sweat into keeping the old ship afloat. And it has returned the favor, making its aging crew young again," the Baltimore *Sun* observed in May 2000, as the *Brown* set out for a repair yard in Toledo, Ohio—via Halifax, Nova Scotia, and the St. Lawrence Seaway—for a paint job and some 15,000 new rivets. Upon her return, and despite her fame and good fortune, the *Brown* struggled for another sixteen years to secure a showplace berthage among the glitz of Baltimore's revitalized Inner Harbor. In 2004, prospects brightened that a prominent space would be found at last—at the old Woodall shipyard site on Key Highway, alongside the Domino Sugars plant. The opportunity arose when Robert Brandon, owner of the Tidewater Marina on the Woodall site, decided to shift some of his operations to a vacant site between TyCom and Wal-Mart on the Middle Branch.

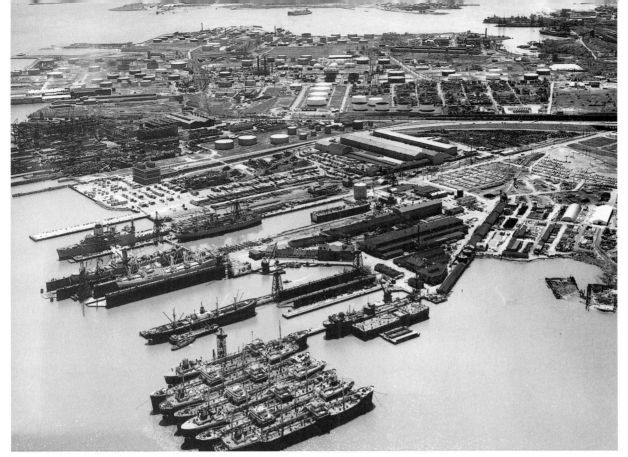

This aerial view, looking southeast, shows Fairfield in the mid-1960s, with the Maryland Shipbuilding and Drydock Company in the foreground. A Weyerhaeuser lumber pier and buildings are immediately behind the shipyard. The Harbor Tunnel Thruway bisects the picture, disappearing beneath the large, square ventilation building at left center. Remains of Bethlehem Steel's World War II shipyard can be seen beyond the ventilation building. Beyond the thruway, the small community of Fairfield (*right of center*) is barely distinguishable in a sea of oil and gas tanks. The residents of Fairfield have since been bought out by the city, to protect them from potential harm. Curtis Creek is at top of photo, with the CSX coal and ore piers visible in Stonehouse Cove at upper right. Baltimore Gas and Electric Company

MARYLAND DRYDOCK

West of the old Bethlehem yard are the remains of another harbor institution, the Maryland Shipbuilding and Drydock Company. This business was started in 1920 as the Maryland Drydock Company when Baltimore financial interests purchased the Globe Shipbuilding Company of Superior, Wisconsin, and moved it to the initial 70-acre tract at Fairfield.

The yard became known as a place where damaged or seaworn ships were doctored and returned to service or converted to some new purpose. The yard pioneered the technique of "jumboizing"—cutting a ship in half, separating the two sections, and welding a new section in the middle to increase capacity. Dur-

ing World War II the yard was enlarged to provide berths for thirty-one ships; "Shipbuilding" was added to the title in 1955. In January 1960 the yard converted the Grace Line freighter *Santa Eliana* to a container ship by adding side blisters or "sponsons" to make it wider; on June 14 of the same year it launched the world's first completely new container ship, the MV *Floridian,* for use by the Erie and St. Lawrence Corporation between New York City and Jacksonville. In 1967, the Fruehauf Corporation of Detroit, the trailer-maker, took over the yard from Koppers' Corporation through an exchange of stock. Fruehauf undertook a $30 million expansion program in 1974. The yard was beset by a series of labor disputes and strained by mounting competition from abroad. In

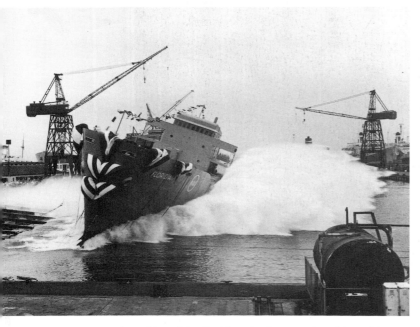

Launching of the *Floridian,* the first container ship, at Maryland Shipbuilding and Drydock, 1960. Peale Museum

July 1984, with business at a standstill, Fruehauf closed the yard.

Kurt Iron and Metal, a company controlled by Pasadena, Maryland, shipbreaker Kerry L. Ellis Sr., purchased 10.5 acres at the northwest corner of the Maryland Shipbuilding and Drydock site. Ellis's operation first came to public attention when the former Great Lakes passenger ship *South American,* brought in for scrapping, broke loose from its moorings one stormy night and drifted toward the Key Bridge, looming out of the mist as a ghostly apparition to small boats in the harbor. The Coast Guard retrieved the vessel before it could damage the bridge. This last lonely voyage of the forlorn hulk was in sad contrast to her days as a gleaming white luxury vessel with pots of red geraniums lining her fantail, her band playing "Anchors Aweigh" every time she left dock at lake ports from Buffalo to Duluth.

An even more famous victim of the Ellis blowtorch, and one that got him into trouble, was the historic U.S. Navy aircraft carrier *Coral Sea.* The 972-foot carrier was commissioned in 1947 and saw duty in Suez, Vietnam, and Lebanon. Rights to the ship were sold in 1993 to Andrew Levy, a New York businessman, for $750,000, with the stipulation that the demolition work be done in the United States, Virgin Islands, or Puerto Rico. Levy hired Ellis's Seawitch Salvage Company to break up the ship in Baltimore.

The task was more daunting than anyone had expected, the Baltimore *Sun* reported in 1995. Toxic PCBs needed to be removed from 10,000 various items aboard and the thick armor plates of the vessel were tough to break through. Levy petitioned the Defense Department to allow him to tow the hull to India. A Chinese tug optimistically stood by, awaiting the assignment. But the government refused—it claimed that consent would have been unfair to others who had bid on the original contract—and Ellis proceeded with the dismantlement.

On September 24, 1996, a federal grand jury indicted Ellis and his Seawitch Company for stripping asbestos from the old aircraft carrier in an improper manner that was unsafe for the workers, and trying to hide what was going on, as well as illegally discharging oil and other pollutants into the harbor. On May 30, 1997, Ellis was convicted by a federal jury, in what the *Sun* described as "the nation's first criminal case involving environmental violations and the ship scrapping industry." He died while serving a two-year prison term. The Maryland Port Administration subsequently bought the land for future expansion and began clearing the property. The yard made the headlines again in May 2004

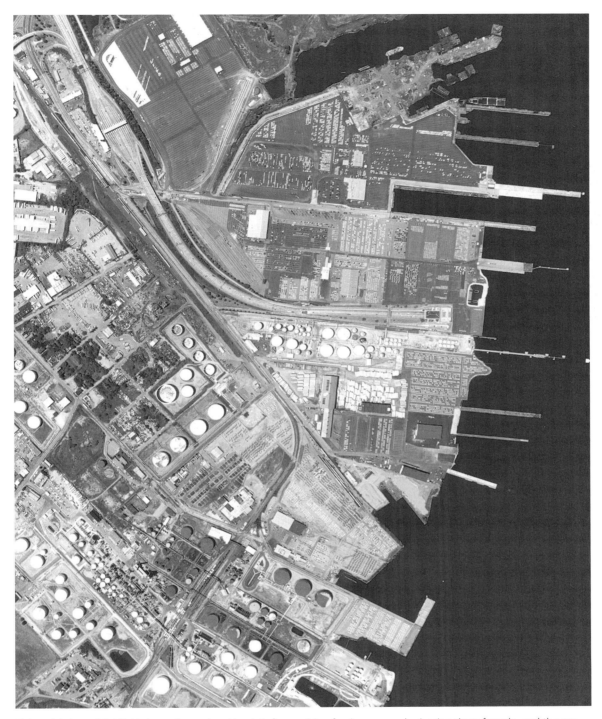

This aerial view of Fairfield shows the vast parking lots for receiving foreign cars and primping them for sale, and the sea of tanks for petroleum awaiting delivery to homes, factories, and service stations. The Baltimore Beltway swoops in from the upper left of the picture, expands at its rank of toll booths, and disappears into the Harbor Tunnel at right center. The tunnel entrance sits in the middle of the site of Bethlehem Steel's World War II shipyard. The yard's outfitting piers remain. Maryland Port Administration

Boats from the Vane Brothers fleet gather at the company's new headquarters in Fairfield, opened in 2003. Barge *DS 15* (DS = double skin) is one of the newest of the company's ecologically top-of-the-line petroleum carriers, designed to move safely behind a tugboat on Chesapeake Bay and the pristine rivers of the Eastern Shore. In moves from Pratt Street to Fells Point to Canton and now Fairfield, Vane Brothers has evolved from a chandler serving sailing ships into a major supplier of petroleum products and safety gear, with operations in Philadelphia and Norfolk as well as Baltimore. Photo by author

when what appeared to be twelve World War II bombs were discovered in a scrap pile there. Authorities closed the harbor to shipping and shut down the Harbor Tunnel for five hours while the missiles were trucked away. They were found to be practice weapons filled with concrete.

AUTOS AND OIL

The Port of Baltimore entered the twenty-first century with a new mission for the abandoned shipyards of Fairfield: to provide vast parking lots for the receipt and shipment of automobiles.

In 1997, Baltimore leap-frogged over Jacksonville, Florida, to become the second largest automobile port on the East Coast after New York. A year later,

the nation's largest automobile processing company, American Port Services (AMPORTS) rededicated its 53-acre Atlantic Marine Terminal on the old Bethlehem shipyard site, with a fresh investment of $4 million in facilities for special services such as coating bodies and undercarriages and installing special components like stereo systems.

The AMPORTS facility handles every Chrysler product shipped overseas, moving 95 percent of the vehicles through Baltimore. Other carmakers using the AMPORTS site include Ford, General Motors, Isuzu, Hyundai, Land Rover, and Mazda. AMPORTS also owns the Chesapeake Terminal on the east side of Fairfield.

In 2000, the Maryland Port Administration opened an $18 million, 40-acre terminal just west of

AMPORTS, on a portion of an undeveloped site known as Masonville, purchased from the Arundel Corporation. Arundel retained 60 acres for its gravel operations, pending future port expansion. The new state-of-the-art terminal is leased to ATC Logistics, of Jacksonville, Florida, which imports Honda and Hyundai vehicles.

Another Fairfield player is Premiere Automotive Services, which handles shipment of heavy agricultural and construction equipment, such as tractors and bulldozers, on a 20-acre site. Additional major auto-handling sites are located at Dundalk Terminal on the north side of the harbor.

City development officers estimated in 2002 that $460 million had been invested in the Fairfield Peninsula over the previous six years. Such upgrading of an industrial area provides a special boost to the city, because it brings not only jobs but increased property taxes that do not need to be returned to that area to fund schools, police, and social services.

In addition to handling autos, Fairfield is a major distribution center for petroleum products—gasoline, diesel fuel, and heating oil. Some of this continues to be brought in by ship, but the majority comes through the Colonial Pipeline, which originates in Texas and spurs off to a cluster of pipes and spigots on Fairfield's east side. Familiar names at Fairfield include BP, Exxon-Mobil, Amoco, Conoco, Hess, and Shell (the last in a joint venture with Saudi Arabia). It is said that 70 percent of Maryland's petroleum comes out of Fairfield.

Other major Fairfield ventures include the industries around Stonehouse Cove and SASOL NA, a South African company that has invested $100 million in a plant to produce a biodegradable ingredient for use in soapmaking, replacing a chlorine product. At Wagner's Point on the northeast edge, the city's Patapsco Waste Water Treatment Plant treats sewage water and pipes it to an open discharge point a few hundred yards off the seawall.

The sewage operation and environmental consequences of the chemical and petroleum industries eventually made life unbearable for the 500 or so residents of two worker communities on the peninsula, Wagner's Point and Fairfield. In the late 1990s, after much legal hassle, the city closed them down and relocated the residents.

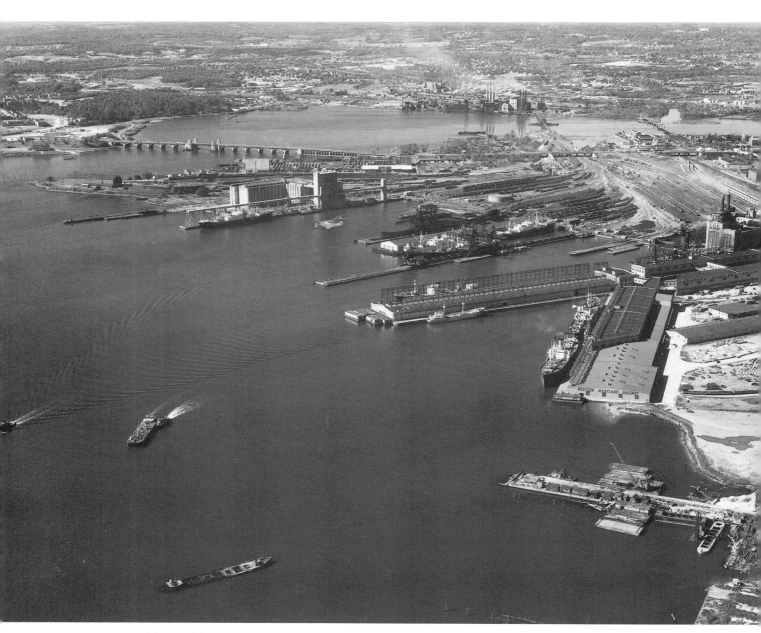

An aerial view of the Patapsco's Middle Branch, looking west, in about 1959. Maryland Historical Society

MIDDLE BRANCH

As you travel west from Fairfield and Fort McHenry toward the Hanover Street Bridge, you are moving away from the Baltimore that *is,* toward the Baltimore that *might have been.* The founders of Baltimore Town initially proposed to locate their community here, on the Middle Branch of the Patapsco, rather than at the shallow, swampy harbor to the north.

If this plan had succeeded, the landscape would be vastly different from the view shown in the photo opposite. In the foreground is the Port Covington terminal complex established by the Western Maryland Railroad in 1903 and eventually taken over by CSX. The huge grain elevator (*above and left of center*), operated by the Connecticut-based Louis Dreyfus Corporation, was built in 1929. It was demolished sixty years later to make room for development. Just beyond the grain silos is Ferry Bar point, one of Baltimore's most popular leisure spots when it was the northern head of the "long bridge" carrying the Light Street streetcar line into Anne Arundel County. The present Hanover Street Bridge to the west was built in 1914. At the upper right, on the far shore, is the Carr-Lowrey Glass Factory, which closed in 2003, despite help from the Abell Foundation to keep it alive as Baltimore's last glassmaker.

The plan to put Baltimore on the Middle Branch was thwarted by John Moale, an English immigrant who arrived in 1719. Moale bought land on the north shore, in what is now called South Baltimore, and apparently also on the south shore, taking in the present Cherry Hill. Moale thought there was more money to be made in the mining of iron ore than in real estate speculation, so he prevailed on the colonial legislature in Annapolis to defeat a bill that would have created Baltimore Town on his own lands. Moale was influenced by the fact that the English-controlled Principio Furnace Company was conducting mining operations on nearby Whetstone Point (now Locust Point) to feed its iron furnaces at the head of Chesapeake Bay. Stockholders of the company included Augustine and Lawrence Washington, father and brother of George. Ore was also being dug nearby by the Baltimore Company, which ran an iron furnace at the mouth of Gwynns Falls which remained in operation until about the time of the Civil War.

Overshadowing the mining operations on this branch of the Patapsco River in those days was the shipping of tobacco and, a little later, the milling of flour. Hogsheads of tobacco were rolled down Rolling Road in Baltimore County (the road bears the name today) to Elk Ridge Landing (now Elkridge) which in the mid-1700s had a customs house, a race track, and a deep channel leading to the open river, making it

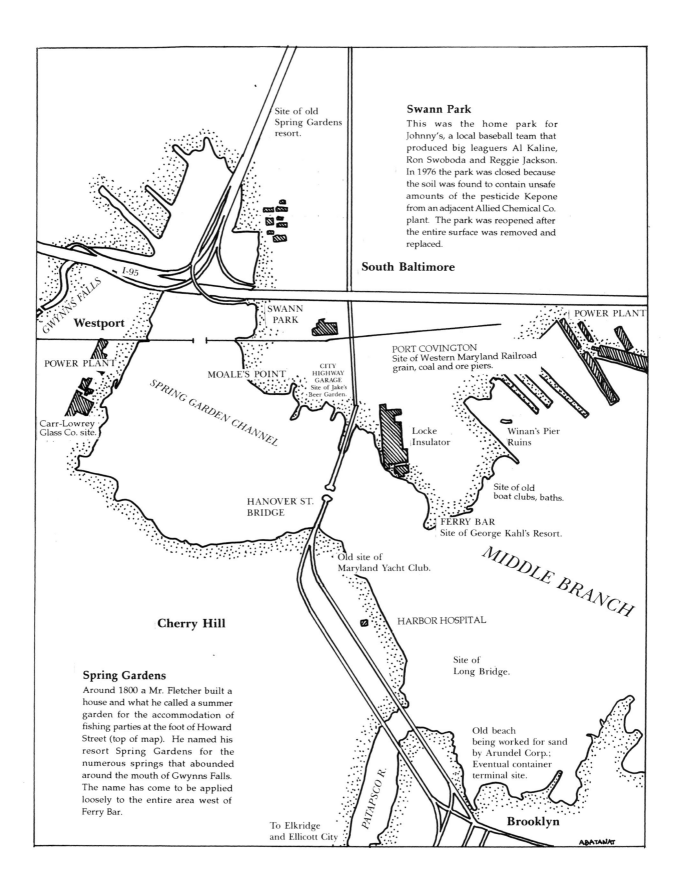

Site of old
Spring Gardens
resort.

Swann Park

This was the home park for Johnny's, a local baseball team that produced big leaguers Al Kaline, Ron Swoboda and Reggie Jackson. In 1976 the park was closed because the soil was found to contain unsafe amounts of the pesticide Kepone from an adjacent Allied Chemical Co. plant. The park was reopened after the entire surface was removed and replaced.

South Baltimore

I-95

GWYNNS FALLS

Westport

SWANN
PARK

POWER PLANT

PORT COVINGTON
Site of Western Maryland Railroad grain, coal and ore piers.

POWER PLANT

SPRING GARDEN CHANNEL

MOALE'S POINT

CITY
HIGHWAY
GARAGE
Site of Jake's
Beer Garden.

Locke
Insulator

Winan's Pier
Ruins

Carr-Lowrey
Glass Co. site.

Site of old
boat clubs, baths.

HANOVER ST.
BRIDGE

FERRY BAR
Site of George Kahl's Resort.

Old site of
Maryland Yacht Club.

MIDDLE BRANCH

Cherry Hill

HARBOR HOSPITAL

Site of
Long Bridge.

Spring Gardens

Around 1800 a Mr. Fletcher built a house and what he called a summer garden for the accommodation of fishing parties at the foot of Howard Street (top of map). He named his resort Spring Gardens for the numerous springs that abounded around the mouth of Gwynns Falls. The name has come to be applied loosely to the entire area west of Ferry Bar.

Old beach
being worked for sand
by Arundel Corp.;
Eventual container
terminal site.

PATAPSCO R.

To Elkridge
and Ellicott City

Brooklyn

ABATANAT

Winans's "cigar ship" at sea, as the builder envisioned it. *Illustrated London News,* Peale Museum

Maryland's second port after Annapolis. In 1772, the Ellicott brothers built the country's largest flour mill further upstream (now Ellicott City). In 1830 this became the first destination of the horse-drawn Baltimore and Ohio Railroad.

A great flood on the Patapsco on July 24, 1868, hastened the end of the milling era. The raging waters destroyed a town (Avalon), engulfed a mail train, killed fifty persons, and wiped out or damaged most of the mills. Many were never rebuilt.

EXPERIMENTAL SHIPS

Inventor and engineer Ross Winans and his son, Thomas, had a pier and shipyard on Ferry Bar point, visible on E. Sachse and Company's 1869 lithograph of the city of Baltimore (see p. 80). Winans's famous "cigar ship" is shown docked at the pier. Ross Winans came to Baltimore in the 1820s to build cars and locomotives at the Mount Clare shops of the Baltimore and Ohio Railroad. He helped Peter Cooper design the Tom Thumb engine. Shortly before the Civil War, he bought land on both sides of the Middle Branch. The property on the west side came to be known as Mount Winans. The property on the east

side included Ferry Bar and the land subsequently developed as Port Covington.

Turning his inventive mind to ships, Ross Winans conceived a hull design that he thought could cross the Atlantic in four days. The ship was built by Thomas Winans and launched in 1858. It was radical for its time in that it was intended to master the open ocean by steam power alone. Freed of the need to support wind-filled sails, Winans reasoned, the hull could be made long, round, and thin, and thus make a streamlined cut through the water. The resultant "cigar ship" was 180 feet long and 16 feet wide. It was propelled by an iron wheel with flanges which circled the vessel at mid-ships and was driven by machinery from the inside. The ship attained a speed of 12 miles an hour on its first trial run in January 1859, but any passenger taking a walk on the deck quickly discovered the flaw in Winans's design, and returned, drenched, to the stuffy confines of the ship. The Winanses lengthened their vessel to 194 feet in February and to 235 feet in October. In November the craft went to Norfolk and made several experimental trips to sea. The Winanses built three other cigar boats, one in Russia in 1861 and two in England in 1864, with conventional screw propulsion, but none was com-

Ferry Bar point shown on part of E. Sachse and Company's bird's-eye view of city of Baltimore. The lithography firm sent out teams of artists during the 1860s to record every building in the city. The project took several years, and the final product, which is 12 feet wide and 5½ feet high, was published in 1869. Maryland Historical Society

mercially successful. The first ship was returned to its Baltimore dock, where it remained until it fell to pieces.

On June 10, 1876, Thomas Winans launched the *Sokoloff,* a 32-foot sailing yacht which, he claimed, would "not upset in the strongest gale," despite a large press of canvas. The reason for the claimed stability was that the 3-foot-deep iron keel was separated from the body of the boat and fastened to it by brass gudgeons fore and aft, so that the body could swing clear. The 36-foot mast was fastened to the keel at the bow. In a gust of wind the mast and keel would go over but the body would remain upright. Success of the vessel is not recorded.

PORT COVINGTON

Soon after the turn of the twentieth century, the Western Maryland Railroad built its waterfront ter-

minal on the lands once occupied by the Winanses' shipyard and, before that, Fort Covington in Revolutionary times. Western Maryland built piers for the export of grain and coal, import of ore, and handling of general cargo, much in the manner of the Baltimore and Ohio with its great Locust Point terminals further to the east. The B&O took over the Western Maryland in 1973 and eventually abandoned the Port Covington piers as it and its successor, CSX, concentrated on use of the original B&O facilities.

BOATING AND BEER PARKS

A number of resorts sprang up along the Middle Branch in the late 1800s, most notably George Kahl's Ferry Bar Resort, beside the wooden bridge that connected Baltimore City with Anne Arundel County. The name derived from a sandbar at the old ferry landing. Here, during the "Gay Nineties," you could

Pacific Mail Steamship Company ships at Port Covington, April 1920. The two-masted boat at left is a Chesapeake Bay bugeye. The railroad cars at the center of the photo are loading onto covered barges, which will be taken alongside the ships. The use of barges to supplement dockside loading and unloading speeded the handling of a ship in port and eliminated the need to get the railcars to the right place alongside the ship at dockside. Maryland Historical Society

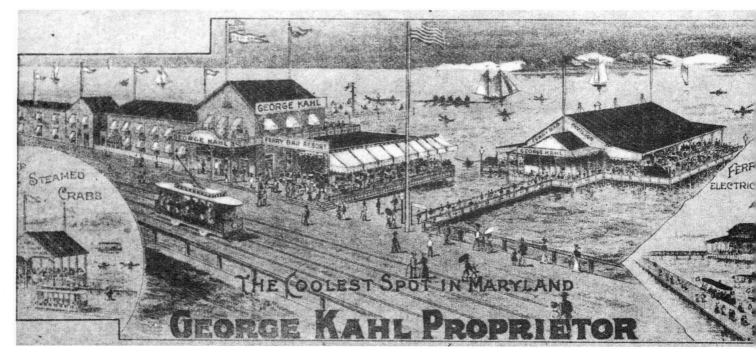

George Kahl's Ferry Bar resort as captured in an advertising piece of about 1890. Enoch Pratt Free Library

Bathing beauties. The rented bathing suits shown in this photograph at the Baltimore Public Baths reflected the modesty of the times—until they got wet. Maryland Historical Society

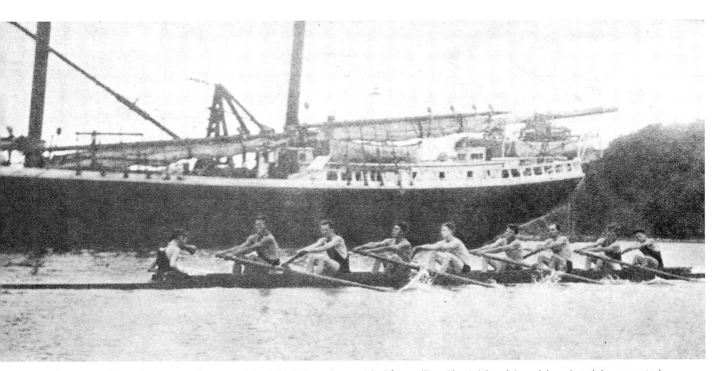

Rowing competition. The protected waters of the Middle Branch were ideal for sculling. The Ariel and Arundel rowing clubs competed with each other and with other mid-Atlantic clubs, and were known as "the Patapsco Navy." *Above,* Ariel club members practice alongside an unidentified four-masted schooner. *At top,* the Ariel team poses for a group portrait. The Ariel club was last heard from in 1927, but a revival of rowing took place in the 1980s at Jackson's Wharf in Fells Point and was reinforced by the city's construction of the Baltimore Rowing Center on Middle Branch in 1987. Maryland Historical Society

A light rail train penetrates the spaghetti of ramps that carry the rail line and Interstate Highways 95 and 395 over the north end of the Middle Branch. Photo by author

get a huge bowl of crab soup for a dime, and for 50 cents you could get a "shore dinner"—half a fried chicken, a soft crab, farm-fresh vegetables from farms across the bridge, french-fried potatoes, hot muffins, and all the coffee you could drink. An electric launch transported patrons to other resorts on the basin.

The area was a mecca for swimmers, fishermen, and pleasure boaters. The Baltimore Yacht Club (now at Middle River) was located upstream from Ferry Bar point, while the Maryland Yacht Club (now at Rock Creek) established itself across the river to the south. Along the northeast shore were the Corinthian Yacht Club (active in Bear Creek until 1955), the Ariel Rowing Club, the Arundel Boat Club, the Baltimore Athletic Club, and a branch of the Baltimore Public Baths. Informal swimming could be found on the south side of the river, where a sand beach stretched all the way from Hanover Street to the Maryland Drydock Company.

BRIDGING THE MIDDLE BRANCH

The first bridge over the Middle Branch was the wooden "long bridge" at Ferry Bar point, built in 1856. The bridge was an extension of Light Street, which ran to the river in those days, and then continued on for a number of miles in Anne Arundel County on the south side of the river. The ornate Hanover Street Bridge, built in 1914, is now officially called the Viet Nam Veterans Memorial Bridge. The City of Baltimore continues to man the bridge around the clock, although few vessels require the raising of its drawspans. A Coast Guard buoy tender that passes through perhaps once or twice a month needs the bridge drawn, and that translates into twenty-one shifts a week on the Department of Public Works' payroll. At least the bridge is well guarded between visits.

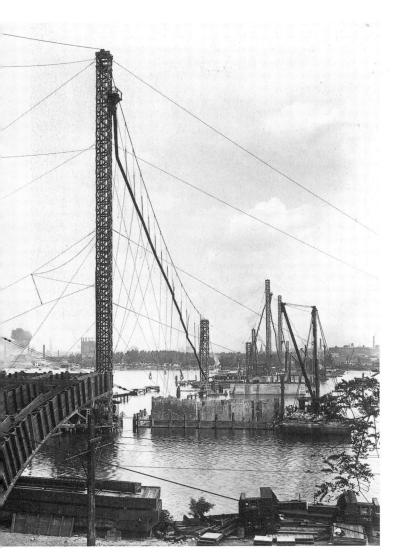

Left: Hanover Street Bridge under construction in 1914, looking north. Maryland Historical Society

Below: The drawspans rise to accommodate the three-masted schooner *William J. Stanford,* making its way up the Middle Branch basin in about 1920. To the immediate right of the bridge is the former Hanover Bridge Marina, now called Baltimore Yacht Basin. Next to it is the Locke Insulator's porcelain manufacturing plant, one of the country's largest. Since 1974 it has been a subsidiary of NGK Industries of Japan. Maryland Historical Society

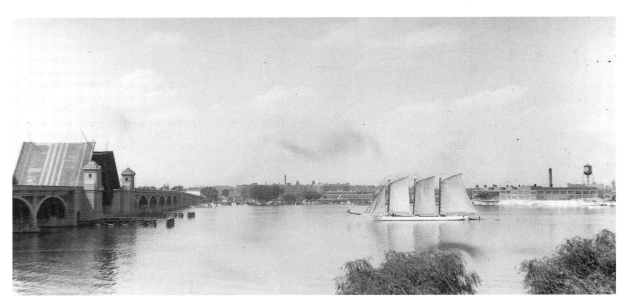

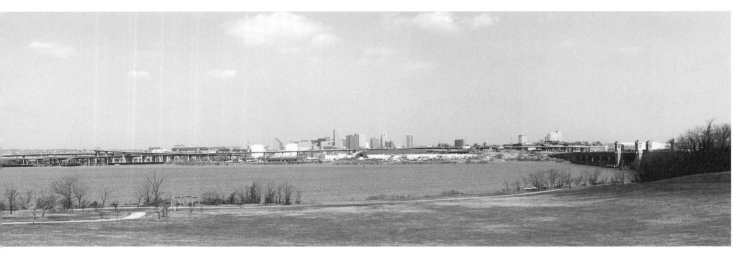

A rare stretch of open green space west of the Hanover Street Bridge (*far right*) may be protected from development. Photo by author.

BALTIMORE'S FUTURE ECOPARK?

For years, Baltimore planners dreamed of transforming the wide shallow basin west of the Hanover Street Bridge into an environmentally protected public green area, contrasting sharply with the urban waterfront of the Inner Harbor. The Baltimore Rowing Center, on the south side, fosters nonintrusive public use of the basin now, as do several marinas. The Rowing Center is owned by the city's Department of Recreation and Parks, which uses it for offices to manage the city's swimming pools. The Baltimore Rowing Club leases the lower level.

Dreams of "green" development of the basin got a boost in 2002 when the National Aquarium in Baltimore disclosed preliminary plans to bring to Middle Branch a 6-acre, multimillion-dollar facility for ani-mal care and breeding in a parklike setting that would be open to the public. The building, the Center for Aquatic Life and Conservation, would be built on the old Corinthian Yacht Club site, just west of the bridge. It will, if built, set the tone for cleanup and wetlands restoration for the entire basin. But as of 2004, the Aquarium was considering other sites.

The entire area, from the Ravens football stadium at the far north of Middle Branch to Port Covington east of the bridge, was ripe for a comprehensive master plan as Baltimore entered the twenty-first century. Meanwhile, the developers were closing in, one purchasing 8.8 acres west of the Rowing Club for luxury housing, while others eyed the Carr-Lowrey and other nearby industrial sites for conversion to homes and offices with sweeping waterfront views.

LOCUST POINT

Almost everyone knows that Fort McHenry, at the tip of Locust Point, played an important role in American history. But how many are aware of the role played by the sprawling commercial establishment west of the fort? Here arose one of the largest rail-sea terminal complexes on the face of the earth.

The Locust Point terminal of the Baltimore and Ohio Railroad, on the north side of the peninsula, was a vital instrument in the nation's export of coal and grain, the movement of general cargo, and the welcoming of thousands of immigrants to participate in the building of America.

Today these piers are under the control of the Maryland Port Administration, and the facilities are geared to handle goods brought to and from the port by truck as well as train. Through these public terminals still flow the goods of international commerce: tires, vehicles, paper products, spices, molasses, latex, almost everything imaginable that can be carried by ship.

Originally, the tip of land Fort McHenry now occupies had the name Whetstone Point. In 1706 Maryland's assembly recognized it as the second official port of entry for ships entering the Patapsco River, mainly to pick up tobacco (Humphrey Creek, which now trickles through the Sparrows Point steel plant, was the first, in 1687). In 1776 patriots con-

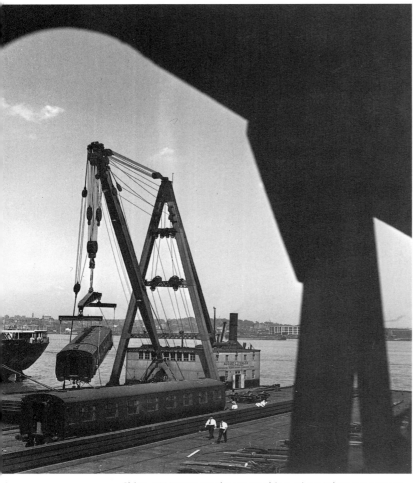

Ships can transport almost anything, given adequate means of on and off loading. Here, in 1946, the Three Brothers derrick lifts a railroad car aboard a ship bound for England. The port's biggest crane today, known as Big Red, can lift up to 300 tons. Maryland Historical Society

structed a defensive position here, Fort Whetstone, to defend against possible British attack. It did not come—during the Revolutionary War.

FORT McHENRY

Shortly after midnight on Tuesday, September 13, 1814, after putting an invasion force ashore on North Point the previous day (see p. 212), British naval forces began their famous bombardment of Fort McHenry.

"Baltimore is a doomed town," the British had proclaimed, but events proved otherwise. The total failure of the naval operation is attributed to the inability of the British fleet to get close enough— either to support the land forces or to inflict serious damage on the fort. The ship channel was tricky at best, and Gen. Sam Smith, a Revolutionary War officer who was in charge of the city's defense, had made things more difficult for the British by blocking the way with sunken ships. Anticipating that some British ships might slip through and attack Fort McHenry from the rear, General Smith set up batteries at Forts Babcock and Covington on the Middle Branch. Thorough preparations paid off when on Tuesday night militia repulsed a 1,200-man landing force off Fort Covington.

The ineffectual bombardment continued into the early hours of Wednesday morning. One of the witnesses, a lawyer from Georgetown, Francis Scott Key, had sailed out to the enemy fleet under a flag of truce, seeking the release of a Maryland physician whom the

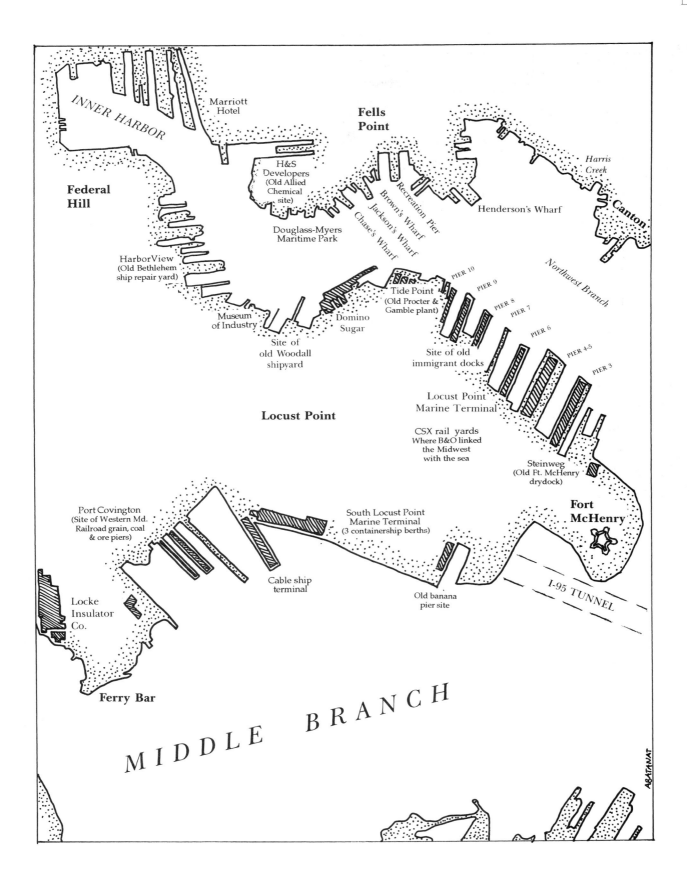

INNER HARBOR

Marriott
Hotel

**Fells
Point**

*Harris
Creek*

**Federal
Hill**

H&S
Developers
(Old Allied
Chemical
site)

Recreation Pier

Brown's Wharf

Henderson's Wharf

Canton

Jackson's Wharf

Douglass-Myers
Maritime Park

Chase's Wharf

Northwest Branch

HarborView
(Old Bethlehem
ship repair yard)

PIER 10

PIER 9

Tide Point
(Old Procter &
Gamble plant)

PIER 8

PIER 7

Museum
of Industry

Domino
Sugar

Site of old
immigrant docks

PIER 6

Site of
old Woodall
shipyard

PIER 4-5

PIER 3

Locust Point

Locust Point
Marine Terminal

CSX rail yards
Where B&O linked
the Midwest
with the sea

Steinweg
(Old Ft. McHenry
drydock)

Port Covington
(Site of Western Md.
Railroad grain, coal
& ore piers)

South Locust Point
Marine Terminal
(3 containership berths)

**Fort
McHenry**

Locke
Insulator
Co.

Cable ship
terminal

Old banana
pier site

I-95 TUNNEL

Ferry Bar

M I D D L E B R A N C H

ABATANAT

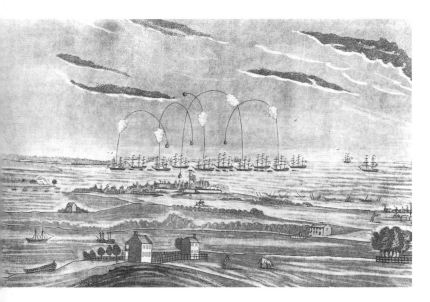

A sketch of the bombardment of Fort McHenry in 1814, when the British expected to punish Baltimore for being "a nest of pirates." The fort was one of the first constructed to defend the new republic. It carried the name of James McHenry, a Revolutionary War veteran, Maryland congressman, and President John Adams's secretary of war. Maryland Historical Society

This 1865 etching published by E. Sachse and Company shows the fort during the Civil War. Confederate prisoners march under guard toward a prisoner-of-war compound at middle left of the drawing. The other barracks housed federal troops. Maryland Historical Society

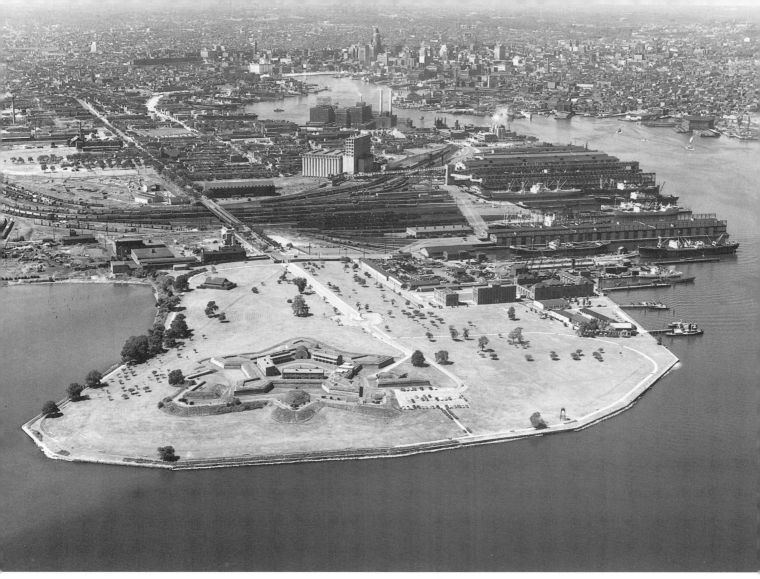

Fort McHenry and behind it the Locust Point peninsula in about 1950. Maryland Historical Society

British had earlier captured. The British received Key well but refused to let him and a companion return during the bombardment.

When dawn came Wednesday, Key was so elated to see the American flag still flying over the fort that he began writing a poem on the back of a letter he had in his pocket. He finished the effort that evening in Baltimore, and the following day his uncle, Judge Joseph H. Nicholson, had it struck off in handbills at the office of the *Baltimore American*. Judge Nicholson also discovered that the verses could be sung to the tune of an English drinking song, "Anacreon in Heaven." Key's "Star-Spangled Banner" rapidly be-

came popular, but Congress did not officially adopt it as the national anthem until March 4, 1931.

The spot where Key is thought to have anchored and watched the bombardment is marked by a red, white, and blue Coast Guard buoy, just west of Key Bridge near Dundalk Terminal. The flag that inspired Key was made by Mary Pickersgill, whose home on East Pratt Street is preserved as Flag House.

THE *ARGONAUT*

An event of possibly greater long-range military significance than the bombardment of Fort McHenry

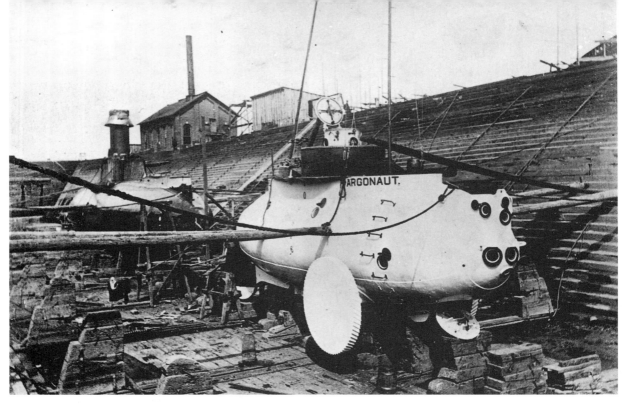

The *Argonaut* under construction, with rival *Plunger* visible at left. Maryland Historical Society

The new owner of the Fort McHenry graving dock filled it with earth and gravel but left the gates operable—in the event anyone ever wants to reopen a service station for small ships. Photo by author

took place just west of the fort about eighty years later. This was the construction of Simon Lake's submarine, the *Argonaut,* at the Columbian Iron Works drydock. The little vessel, 33 feet long and 9 feet wide, was built on a shoestring budget alongside the *Plunger,* a rival submarine, well-funded by the Navy Department as an experiment and being built by John P. Holland.

Lake's submarine was operated by a 30-horsepower gasoline engine whose exhaust fumes were vented to the surface by a 20-foot pipe. A similar pipe brought in fresh air. In deep water the pipes could be extended by hoses and floats. The sub was propelled along the bottom by two large cog wheels forward and one in the rear. Lake quietly tested it off Fort McHenry in August 1897, then treated ten nervous reporters to a demonstration ride off Ferry Bar in December. It later made trips to Norfolk and up the Atlantic Coast, prompting a congratulatory telegram from Jules Verne.

Lake's sub introduced features that have endured to present times: it used ballast water to submerge; it

carried a dynamo and storage batteries and could stay under for ten hours without air; it sported a search-light and a chamber in the bow where divers could go in and out to a bell to perform salvage work, which was the craft's principal intended purpose. Simon Lake is rightfully recognized as father of the modern submarine. His concepts were used by the Germans for their World War I U-boats. Holland's model ulti-mately failed.

The Columbian Iron Works drydock was one of three on Locust Point. A drydock next to Fort McHenry, built in 1879, remained in service until recent times. It was taken over by Bethlehem Steel and eventually sold to developer Richard Swirnow as part of a deal for revitalization of Bethlehem's ship repair yard on Federal Hill. The last use of the dry-dock (called a graving dock in the industry) was for the restoration of Baltimore's historic tall ship, the *Constellation,* which was towed to another site in 1998 for completion of the preservation work. After the departure of *Constellation,* the drydock was filled in by a new owner, C. Steinweg (Baltimore), a subsidiary of Steinweg Handlesveem BV, a worldwide cargo handling service founded in Rotterdam in 1847.

Steinweg's Baltimore operation focuses on the im-port, storage, and domestic shipment of nonferrous metals: aluminum from Russia, copper from South America, lead from China, and zinc from Australia. The company also handles "soft" cargoes: pepper, cocoa, spices, peanuts, and lumber, and even offers to process and repackage the raw materials so that cus-

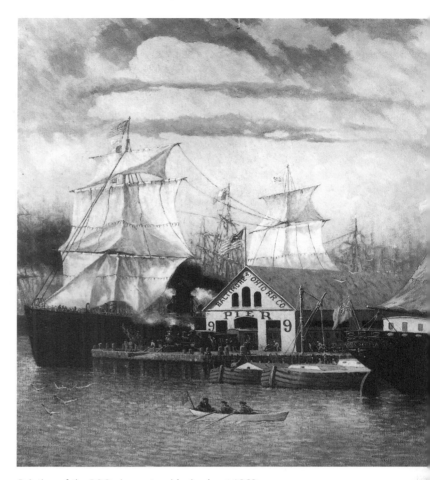

Painting of the B&O pier, water side, in about 1860. B&O Railroad Museum

tomers can receive them ready for marketing. Much of the cargo is destined for companies in the Midwest.

According to Rupert Denny, president of the Bal-timore operation, the company invested $10 million in land, infrastructure, and improvements in Locust Point. Steinweg purchased a former Southern States property west of Fort McHenry in 1998 and the dry-dock site in 2000. Steinweg's aluminum imports, along with those at the Rukert piers in Canton and aluminum ores brought to Eastalco on Hawkins Point, have made Baltimore the leading aluminum port on the East Coast.

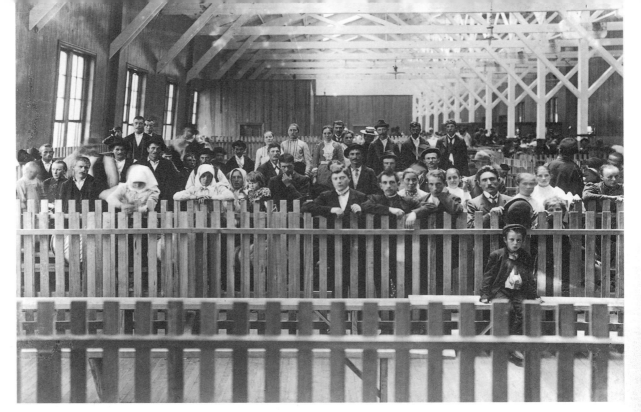

Immigrants waiting patiently to be processed through the immigration facility at Locust Point in about 1900. Peale Collection, Maryland Historical Society

THE B&O AND THE IMMIGRANT EXPERIENCE

Past Fort McHenry, one sees the shoreline of Baltimore harbor's Northwest Branch where the Baltimore and Ohio Railroad brought its rail line to the water in 1845. The nation's first commercial railroad built its ocean terminal in the area just east of the present sites of Domino Sugar and the former Procter and Gamble soap plant. In those days, Locust Point referred only to the protrusion of land in the docks area. As the B&O complex expanded eastward, the entire peninsula came to be known as Locust Point, and the name was also taken by the workers' town which arose south of the rail yards.

Tobacco, cotton, and grain exports were the staples of the B&O's nineteenth-century trade, but the most interesting "cargo" was inbound: thousands upon thousands of immigrants, particularly from Germany. In the 1830s and 1840s, Baltimore had especially strong ties with Bremen, whose records show that 57 sailing vessels, with 5,967 passengers, were cleared for passage to Baltimore in 1839, compared to 38 ships cleared for New York. They were joined by a heavy influx of Irish after the potato famines of the 1840s. Then came Czechs (1860s and 1870s), Poles (1860s through the 1880s), Italians and Prussians (1880s and 1890s), and Russians and Russian Jews (1860s to 1914).

The earlier immigrants landed at Henderson's Wharf in Fells Point. Sailing ships could not keep up with the demand for passenger space, so steamers were added. After briefly operating a steamship line of its own, the B&O Railroad made arrangements with the North German Lloyd Line to establish a strong steamship passenger service terminating at Locust Point. A huge crowd gathered at the new B&O pier on the morning of March 24, 1868, to see the *Baltimore* steam in from Bremen, inaugurating the service. The guns at Fort McHenry roared out a salute. At that time, Baltimore was a heavily German city. A

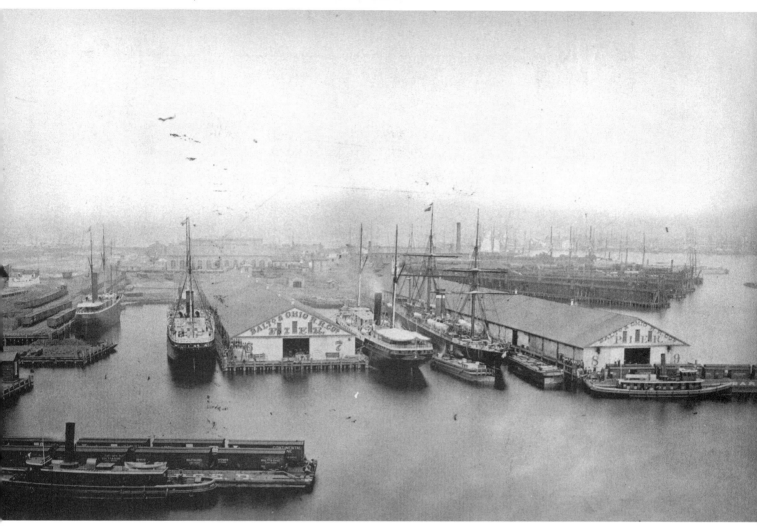

The B&O immigrant piers on Locust Point in the late 1800s. Maryland Historical Society

fourth of her 160,000 white inhabitants had been born in Germany and half of the remainder were of German or mixed-German descent.

Not all of the immigrants remained in Baltimore. Many boarded trains inside the pier sheds and immediately headed west. For a time Baltimore ranked second only to Ellis Island in New York in numbers of immigrants received, with ships arriving regularly from Scandinavia and the British Isles, as well as Germany. A new immigration station (the present Naval Reserve Center) was built near Fort McHenry in 1916. But World War I brought suspension of the Bremen service. Although the North German Lloyd Line resumed its service in 1926, Baltimore never recovered her position as an important passenger port.

The B&O operated its Locust Point facility until 1964, when the port authority took a forty-year lease on the terminal (except for the grain elevator), radically improved truck access, and reconstructed the piers, creating seventeen modern berths. The complex at piers 4 and 5 is now the largest pier space in the port for non-containerized general cargo. The Maryland Port Administration purchased the terminal outright in 2001, while CSX, successor to the B&O, continued to control the 3,750-railcar holding yard with exclusive rail access to the docking ships and their cargoes.

At South Locust Point, near Fort McHenry, the Port Administration put a new three-berth container terminal into service in 1979. It was placed just west of a banana dock where, from 1958 to 1981, the sleek

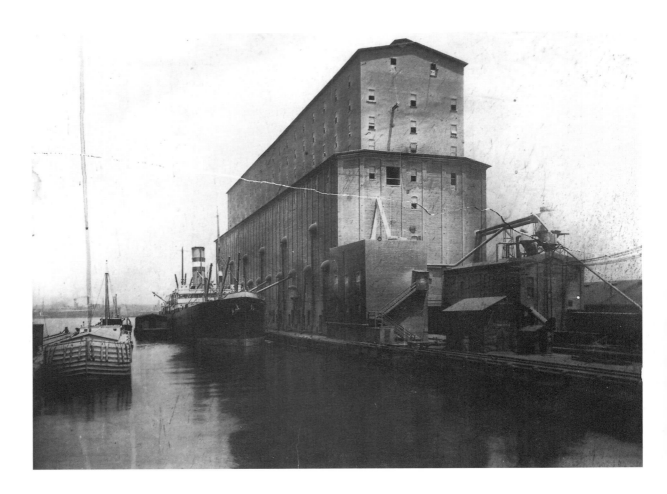

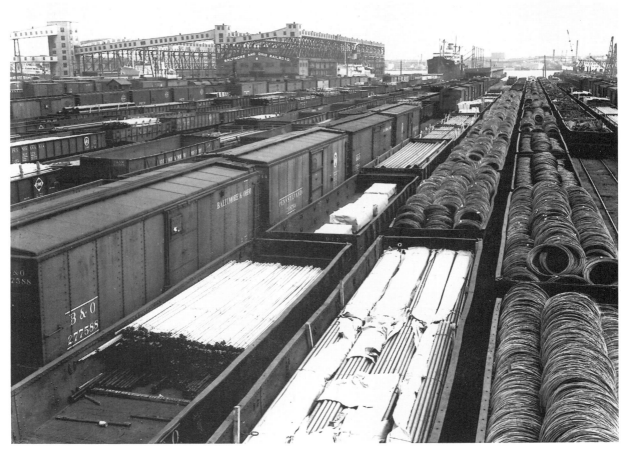

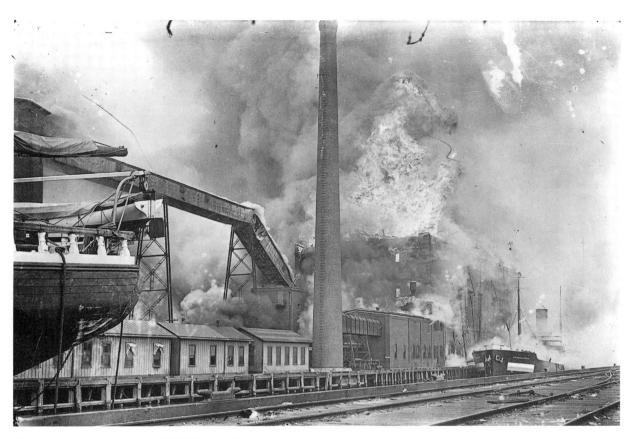

Facing page top and above: The B&O's Elevator C put grain aboard ocean-going ships at Locust Point from 1891 until 1922, when it was destroyed by a spectacular fire, caught by local news photographer Eugene McPhee. Maryland Historical Society

Facing page bottom: Railcars at Locust Point, before pier reconstruction. Railroads dominated the port until the mid-1960s. Maryland Historical Society

white ships of United Brands unloaded up to 8,000 bunches an hour. The dock was later torn down to make way for container storage.

THE GRAIN TRADE

Baltimore was built by its port, and its port was built by the grain trade. As the nation expanded westward, the Mississippi River eventually became the pathway for export of Midwest grain, through New Orleans. Baltimore's grain export volume sank from 6.7 million tons in 1979 to 1.8 million tons in 1987, with most inland shippers turning to Baltimore only when the New Orleans terminals became clogged or the Mississippi froze. Part of the conveyor belt apparatus of the Locust Point grain loading pier, the last operating grain pier in the port, collapsed into the water after a storm in June 2001. The event, probably signaling the end of the city's earliest major trade, passed with-

The Age of Sail persisted alongside the Age of Steam well into the twentieth century. Here in about 1930 the freighter *Zitella* loads at Locust Point's grain terminal, as does a three-masted bark on the other side of the pier. The grain was conveyed overhead to the pier from an adjacent 3.8 million-bushel storage elevator and fed down long chutes into the cargo hold. Maryland Historical Society

The Archer Daniels Midland grain complex, as recently seen from Fort Avenue. Photo by author

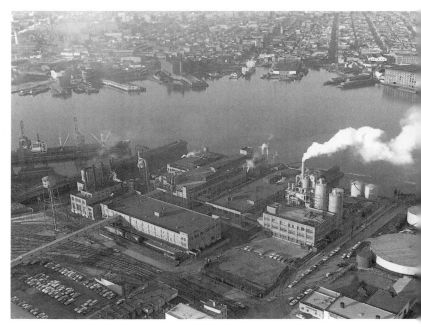

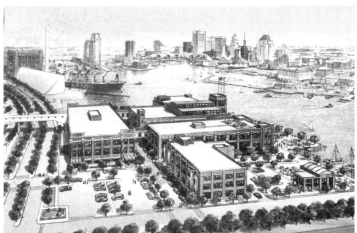

The Baltimore Procter and Gamble plant in its heyday (*top*) and as an adaptive reuse project (*bottom*). Courtesy of Struever Brothers, Eccles and Rouse

out notice in the local press. Unhappy Maryland farmers began shipping their grain through more distant ports when neither the elevator and conveyor owner, Archer Daniels Midland Company, nor the Port Administration, which had purchased the pier just three days before the collapse, stepped forward to make what would have been costly repairs.

In May 2003, Baltimore developer Patrick Turner announced plans to turn the old 276-foot-tall grain elevator into luxury condominiums, served by parking in the adjoining 110-foot-tall grain silo building. The $200 million project, to be called Silo Point, includes possible office space above the grain silos and street level residences between the elevator and Fort McHenry. Turner purchased the 15-acre site from Archer Daniels Midland for $6.5 million. The city's Planning Commission backed the plan in May 2004, and the City Council heard overwhelming citizen support the same day, assuring city approval.

The Maryland Port Administration will continue to own the pier holding ADM's grain loading structure, leaving the future of this pier and remnants of two others west of it a puzzlement, since, without the ADM site, there is little adjacent land to serve them.

SUGAR AND SOAP

Built in 1929, Procter and Gamble's Locust Point soap plant produced some of the nation's best-known soaps and detergents until its closure, as a result of corporate financial decisions, in 1995.

Korean interests purchased the sturdy buildings for $7 million in 1996 with the intention of turning them into a distillery for the popular Far Eastern drink called SoJu. This plan fell through. But by 1999, the plant was coming to life again, under the baton of new owners, Baltimore developers Struever Brothers, Eccles and Rouse (SBER). Vats and giant tanks were hauled away and reconstruction began with a goal of

The steamer *Domino* unloading raw sugar at the Locust Point refinery in 1931. An old Fells Point–Locust Point ferry boat, believed to be the *Howard W. Jackson*, can barely be seen crossing the harbor behind the *Domino*. Maryland Historical Society

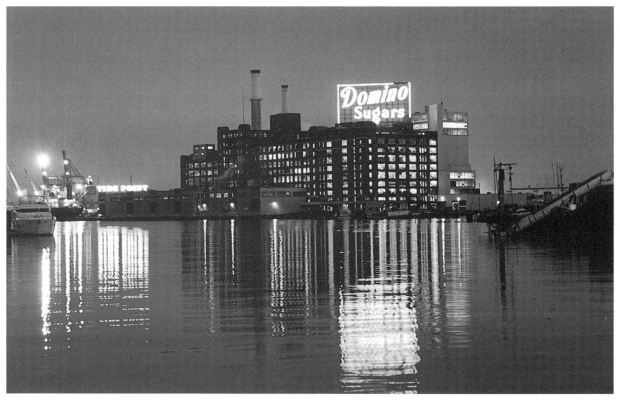

The Domino Sugars sign, with its 32-foot-high "D," costs its owners $70,000 a year to maintain, even though the plant produces its own power. Writing for the Baltimore *Sun* in 1996, Rafael Alvarez ticked off the specifics: The sign is "a 120-by-70 foot neon Polaris that has cast its blood-orange radiance across the Patapsco since April 25, 1951—650 neon tubes searing a 760-amps-per-hour image into the psyche of Charm City." It may be the second largest neon sign in America east of Las Vegas. "The red—like heat, like sugar, which is energy—gives the harbor a warm glow," said the director of the nearby Museum of Industry; "I stare at it all the time." To its devotees, the sign spells Baltimore, and if it ever goes, it will represent the passing of much that was Baltimore. Photo by author

A view looking forward on the four-masted schooner *Edward L. Swan,* tied up at the Woodall docks in 1935. The bow of the four-master *Katherine May* can be seen at right. Maryland Historical Society

400,000 square feet of office space and parking for 1,000 cars.

SBER named the development Tide Point (a reference both to the well-known P&G detergent and to the twice daily rise and fall of river level) and further honored the P&G legacy by giving the buildings such names as Ivory, Dawn, Cascade, and Joy. The developer's primary target was the raging "dot.com" market of those times, but when that bubble burst and SBER looked for other tenants, the site, with its spectacular water-level views, proved attractive to such diverse tenants as law firms, architects, and Mercy Health Services. In 2002, the Westway interests of New Orleans, America's largest molasses distributor, signed a lease for use of the tanks that insures nothing but sweet smells from the site for the next twenty years. Industrial molasses provides an important ingredient of animal feeds.

Inside the P&G buildings, Struever Brothers replaced the soap vats with prime office space, which was quickly snapped up. Tenants found a day care center, transport by water as well as by car, and some of the best views on the waterfront.

Tide Point is but one of several historic waterfront structures saved by Struever Brothers, Eccles and Rouse. Two others are Tindeco and American Can in Canton. SBER built Bond Street Wharf new from the ground up in Fells Point, but at least the original warehouse building, demolished by a subsidiary of the Baltimore Gas and Electric Company, was mimicked in size and footprint.

In 2000, SBER's successes in saving original structures and maintaining the diversity of the nearby neighborhoods won Struever the Baltimore *Sun*'s Marylander of the Year award.

The ten-story sugar refinery with the big Domino sign opened on Locust Point in 1922, then the largest and most modern sugar plant in the world, capable of turning out a billion pounds a year. Inside, the refinery is reminiscent of the engine room of a great ship, with catwalks among the pipes and conduits, boilers, and vats, and a hum of machinery running smoothly

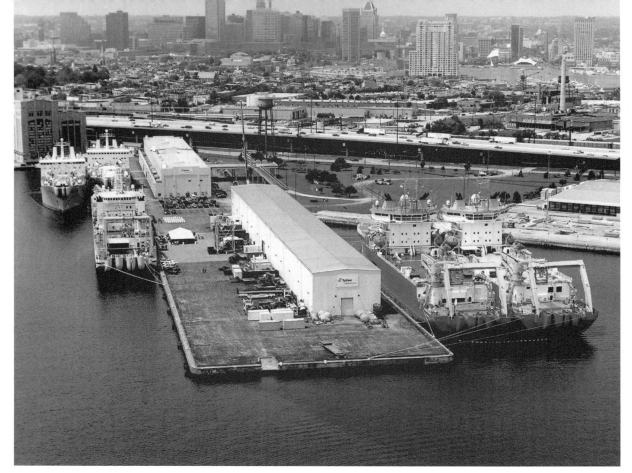

Five ocean-going cable-laying ships, with their distinctive bow and stern rollers, are shown here assembled for the christening of the *Tyco Decisive* at the TyCom company's south Locust Point pier on May 31, 2003. Airland Industrial Photo Company

around the clock. The essential purpose of the plant is to receive brown raw sugar from the West Indies and Central and South America and transform it into the snow-white crystalline sugar that Americans buy in the grocery store.

Raw sugar is grabbed from the ships with two giant bucket cranes and cleaned through a series of washing and heating methods that allow the refinery to turn it into a variety of final products, including molasses and animal feed.

British sugar giant Tate and Lyle North American Sugars purchased the plant in 1989 and invested $30 million in plant upgrades and construction of a 370-foot barge to transport liquid sugar to Brooklyn, New York—attesting to their determination to keep the plant open "for many years to come." Their managers described Baltimore as a "perfect" location, with "sixty percent of the population east of the Mississippi

within a day's drive by truck." Tate and Lyle boosted production of refined sugar to 3,000 tons a day, restoring the plant's dominance as the largest sugar refinery in North America. This optimism did not deter a sale: American Sugar Refining Company purchased the property in 2001 for a reported price in excess of $165 million.

WOODALL SHIPYARD

Next to the sugar plant once stood a harbor institution that now only old-timers remember—the William E. Woodall and Company shipyard. This yard built and repaired a number of Baltimore's passenger steamers, including the *Emma Giles*. It also looked after the big cargo schooners. Tidewater Marina now occupies the site. William Easley Woodall arrived in Baltimore from Liverpool in 1853, at age

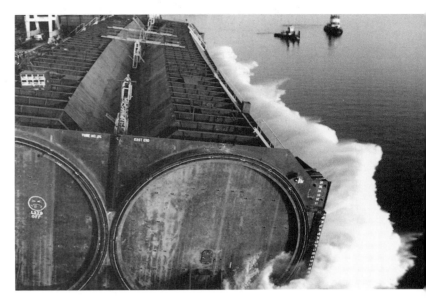

Launching a tunnel. The Wiley Manufacturing Company of Port Deposit, Maryland, on the Susquehanna River, manufactured the tunnel sections—each one 340 feet long, 82 feet wide, and 42 feet high. They were towed on barges for twelve hours down Chesapeake Bay to the job site. It took thirty-two sections to complete the more than mile-long underwater portion of the tunnel. The sections under the freighter channel needed to be buried deep enough to allow fifty feet of clearance for passage of ships overhead. The sections were laid side by side in two rows to provide eight lanes of traffic. City of Baltimore, Rick Lippenholz, photographer

15. The yard he created had the harbor's first drydock, a floating affair built at the Reeder wharf on Federal Hill in 1874. The 270-by-60-foot drydock was a harbor landmark for 62 years. It could be sunk in 30 minutes to pick up a ship in need of paint or repair, and handled 50 or more vessels a year. When the Woodall operation closed in 1929 the drydock first moved to Locust Point, then in 1934 to the Norfolk Dredging Company in Norfolk, Virginia.

THE INTERSTATE AND THE INTERNET

The largest project in the history of the National Interstate Highway Program got underway in 1981 when a hydraulic dredge began excavating a trench under the Patapsco River between Locust Point and Canton. In 1982 workers began lowering giant steel and concrete tubes into the trench, and by 1985 the connected tubes were open to traffic, carrying the eight lanes of Interstate-95, the main roadway between New England and Florida, under Baltimore harbor. The tunnel came in under its $825 million budget, and the federal government picked up 90 percent of the tab.

The same year work began on the I-95 tunnel, South Locust Point became home port to ships laying and repairing telephone cables on the East Coast and Atlantic Ocean, even in the waters of Asia. The unique vessels lay fiber-optic cables, consisting of bundles of hair-thin fibers, to carry pulses of light beams. These can transmit hundreds of millions of phone calls simultaneously, without echos or delays.

The fibers are surrounded by steel wire and copper, with polyurethane insulation. The copper carries electricity to power repeater stations, set every twenty-five to thirty miles, that recharge the light beams. With the diameter of a quarter, the cable is sufficiently small that enough can be stored aboard to reach Europe on a single trip. The ships are owned by Bermuda-based TyCom, which also makes the cable. TyCom, formerly a division of AT&T, was aquired by Tyco International in 1997.

CHAPTER EIGHT

FEDERAL HILL

When the first known European explorer, Capt. John Smith, sailed up the Patapsco River in 1608 (some writers speculate that Spanish adventurers may have preceded him by several decades), he took note of the large hill that bounds today's Inner Harbor to the south. The hill's red clay reminded him of a substance known in Europe as bole Armoniac, used in cosmetics, and because of this he named the river Bolus. Historians agree that Smith's Bolus and the

Indians' Patapsco are the same river. For a long time the promontory carried the name John Smith's Hill, but on December 22, 1788, Baltimoreans staged a great parade through the city, culminating in food and fireworks on the hill, all in honor of the Maryland General Assembly's ratification of the federal Constitution. Since that day, the hill and surrounding neighborhood have carried the name Federal Hill. The panoramic view below includes, on the far right, the Maryland Science Center, built on the site where Thomas Morgan opened the hill's first shipyard, in 1773, and on the far left, Bethlehem Steel's Key Highway ship repair yards, where work was performed on everything from tugboats to supertankers more than 1,000 feet in length.

Federal Hill from the World Trade Center, 1981.
Photo by Eileen P. Kelly

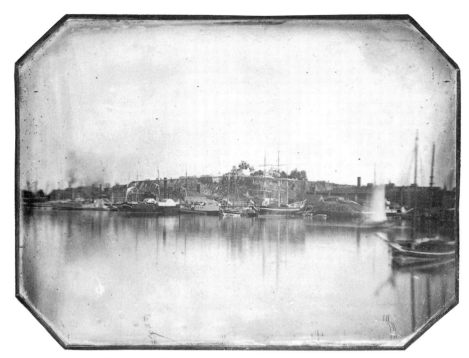

Federal Hill was not always the manicured park one sees today. It was a rough cliff of red clay and sand when Capt. John Smith found it and was still so in about 1851 when H. H. Clark made this daguerreotype, looking south from the northern shore of the basin. Peale Museum

STEAMBOATS AND ENGINES

Baltimore's first steamboat, the *Chesapeake,* was built at McElderry's Wharf, on the north side of the harbor. The engine was fabricated and installed by Charles Reeder, who came down from Pennsylvania and established a shop on Federal Hill. The 130-foot paddlewheel steamer was put on the run to Frenchtown, at the head of the bay, from which her passengers could be taken overland to Philadelphia.

The appliances for her navigation were simple and crude. A pilot stood at the bow who called out a course to a man amidships, and he to the helmsman. There were no bells to signal the engine, but the captain conveyed his commands by word of mouth or by stamping his heels on the woodwork over the engine. The boat had been running six months when the engineer accidentally discovered that he could reverse the engine and back her. (Johnston's *History of Cecil County*)

Federal Hill became the center for steamboat construction. Charles Reeder's company built engines for eighty vessels, including five built keel up by the company itself. A Reeder launching was marked by a touch of class. The *Susquehanna* was christened in 1898 with a flask of water from the river of her name. The *Queen Anne* was christened the following year by release of four doves from a cage in her bow, Japanese style.

Another pioneer engine builder at Federal Hill, John Watchman, did not fare as well as Charles Reeder. His engine in the Baltimore Steam Packet Company's *Medora* exploded on the ship's trial run

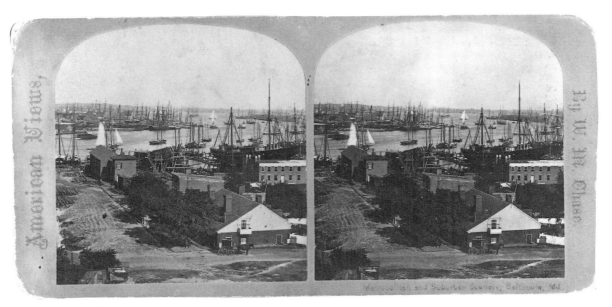

By the time of the American Revolution, small shipyards were springing up at the base of Federal Hill, followed by engine shops, breweries, small iron and steel mills, fertilizer and chemical plants, ice storage houses, canneries, glass factories, and other enterprises. This view, looking east from the hill about 1870, was part of a series sold for enjoyment on the home "stereo" (stereoscope)—a hand-held device that gave a three-dimensional effect when the cards were viewed through the binocular-like eyepiece. Maryland Historical Society

Charles Reeder, pioneer builder of steam engines

A nineteenth-century ad for oysters canned at the base of Federal Hill. Maryland Historical Society

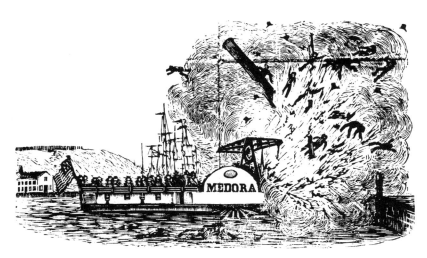

The explosion of the *Medora* as captured in a contemporary woodcut. Maryland Historical Society

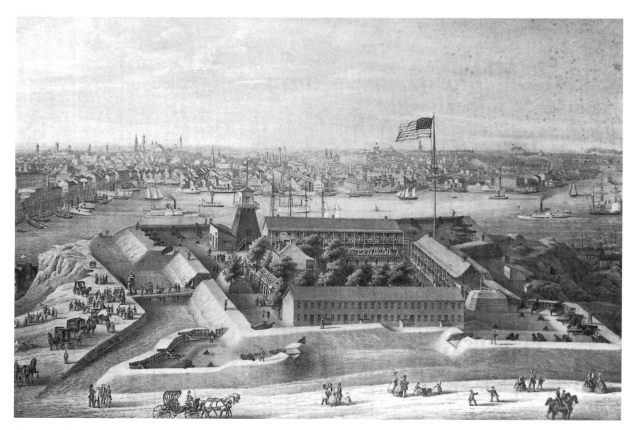

Capt. David Porter's observation tower can be seen in this view of Federal Hill during the Civil War. The sympathies of Baltimore were divided during this conflict. In an effort to maintain control, Federal forces occupied the hill in May 1861, building barracks and external fortifications and aiming cannons at the heart of the city. Maryland Historical Society

The second observation tower gave way in a squall in the summer of 1902. Maryland Historical Society

April 14, 1842, and twenty-six persons died, including the passenger line's first president, Andrew F. Henderson. *Medora* was rebuilt, given a Reeder boiler, and rechristened *Herald*. She remained in service for forty-three years, lastly as a tug on the Hudson River.

OBSERVATION TOWER

For more than a century, from 1797 until 1902, Federal Hill was topped by a tall observation tower, used to signal the appearance of ships heading up the bay to Baltimore harbor.

Capt. David Porter obtained 300 subscriptions from local businessmen to construct the first wooden tower, which was augmented by lookout stations at North Point and Bodkin Point. Ships carried flags of their owners, and when these flags were spotted through the powerful telescopes at the stations, an identical flag was flown from Porter's observatory, where it could be seen by all the merchants and chandlers in the harbor. This advance notice of ship arrivals meant important savings of time and money to shippers and suppliers.

In 1888, nine years after Federal Hill was designated a public park, the park commission built a new tower, with an ice cream stand at its base, to replace Porter's sturdy observatory. The ungainly Victorian edifice rocked in high winds, and a summer squall of 1902 knocked it over. It was not replaced. Telephone and telegraph, and then radio, supplanted the signal flags in giving advance word of ship arrivals. Today the information comes through the Baltimore Maritime Exchange in Canton, and the Baltimore *Sun* carries a record of ship arrivals and departures each day.

THREATS TO THE HILL

Federal Hill has survived three human threats to its very existence.

In 1838, Dr. Thomas H. Buckler proposed to level the hill and use the sand and clay to fill the inner harbor basin. This plan, he maintained, would rid the city of the pestilential water of the shallow basin, admit fresh air from the river, and greatly facilitate transportation within the city.

In a second threat to the hill, private interests in the nineteenth century began burrowing into the hill to obtain sand for glass-making and building purposes, and clay for pipes and pottery. As a consequence, the hill is riddled with deep unmapped tunnels, some of which occasionally are exposed. Brewers

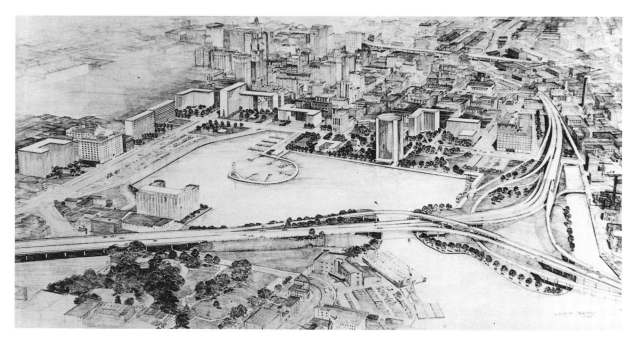

The Inner Harbor bridge proposed in 1962 would have wiped out Federal Hill and plowed through Fells Point.

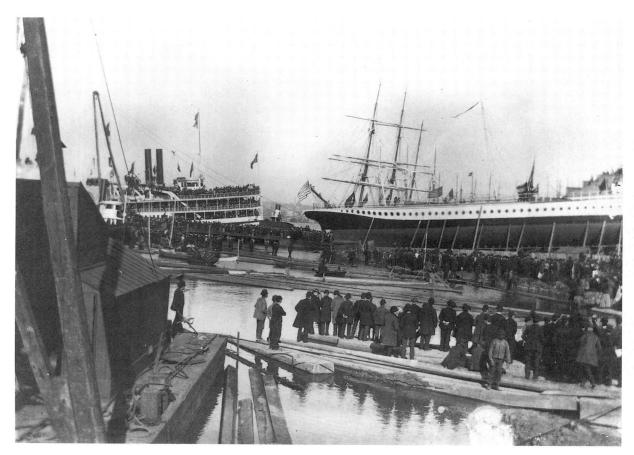

A crowd on shore and hundreds aboard the *Columbia* watch curiously on November 6, 1890, for the launch of the *Howard Cassard*. Maryland Historical Society

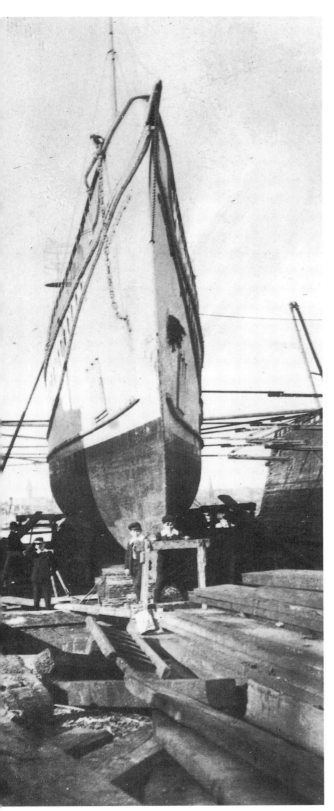

The *Howard Cassard,* suffering from a fatally flawed design, managed only a single brief and frightening voyage. Maryland Historical Society

used the tunnels to store kegs of beer and whiskey. Federal troops stored ammunition and supplies in them during the Civil War. Interesting details about the tunnels can be found in Norman G. Rukert's 1970s book *Federal Hill.*

Then in 1962, state and federal highway officials proposed construction of a superhighway through Federal Hill, with a low bridge across the neck of the Inner Harbor leading to the docks of East Baltimore. The plan would have destroyed Federal Hill and Fells Point and turned the Inner Harbor into a downtown lagoon, inaccessible to tall ships.

It is a tribute to the feistiness of Baltimore residents that these schemes, despite powerful backing, ultimately suffered defeat.

THE THIN SHIP OF 1890

Half the town turned out, including hundreds aboard the S.S. *Columbia,* to watch the launching of the *Howard Cassard* at Federal Hill on November 6, 1890. The *Cassard* was perhaps the most improbable vessel ever put together by grown men. From the side it looked reasonable enough: 222 feet long, 18 feet from deck to keel, and portholes to light every stateroom. But head-on the vessel was only 16 feet wide! It looked like one of those skinny fishes in an aquarium. Robert M. Freyer, who designed the ship, was not a naval architect, and neither was Howard Cassard, the Baltimore lard mogul who agreed to back him. The idea was that with virtually no bow wave to push aside, the vessel could cross the Atlantic in a few

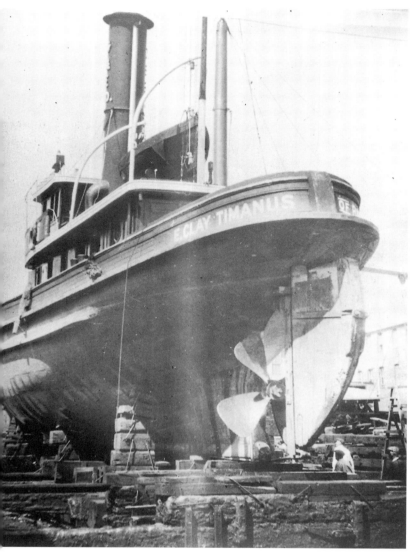

Tug *E. Clay Timanis* in a drydock for repairs in the early 1900s. Maryland Historical Society

days. The narrow cabins were set up like Pullman berths, with an aisle between. A 34-ton iron keel was provided for stability.

The launch of the *Cassard* did not occur on schedule. The ship stuck on the ways. But Freyer tried again the following day, and, with the tug *Britannia* pulling, managed to get his strange ship afloat. The flaw in the *Cassard*'s design showed itself instantly: unlike the aquarium fishes, the *Howard Cassard* had no means of holding itself on an even keel. The vessel leaned on its side and its mast struck and carried away the smokestack of another assisting tug, the *Baltimore*. Undaunted, Freyer had the ship taken to Woodall's shipyard for repairs, after which he invited guests for a trial run. This too, ended in failure. The *Cassard* again listed alarmingly, the guests panicked, and the ship's only voyage was cut short after a mile. It returned to dock, where it remained for twelve years until sold for scrap.

THE SHIPYARDS OF FEDERAL HILL

For many years, the largest Federal Hill shipyard was the Skinner yard at the foot of Cross Street. Barks and brigantines were built here for the coffee trade, and between 1860 and 1890 the yard turned out nine Chesapeake Bay steam packets. Just to the north were the Booz Brothers yard, which moved to the hill from Canton in 1879, and Redman and Vane, which was founded in 1917 and specialized in repair of wooden sailing ships.

The present Francis Scott Key Highway was cut

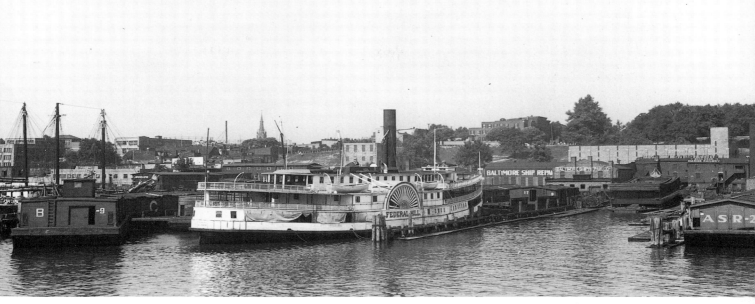

The sidewheeler *Federal Hill* (formerly the *Avalon*) at Booz Brothers yard, July 1939. A year later she was cut down to a barge.
Maryland Historical Society

through the area in 1913. A year later the Skinner yard went into receivership. It was renamed Baltimore Dry Dock and Shipbuilding Company and was acquired by Bethlehem Shipbuilding Corporation in 1921. The Booz and Redman and Vane yards were absorbed by Bethlehem Steel immediately after the outbreak of World War II, when Bethlehem needed more space to fulfill war contracts. Bethlehem's Key Highway repair yard handled more than 2,600 ships during the war years, installing armor plate and gun platforms on merchant ships, converting passenger ships to troop transports, and repairing ships that were damaged.

METAMORPHOSIS OF A SHIPYARD

Bethlehem Steel closed its Key Highway yard on New Year's Eve 1982. Developer Richard Swirnow struck a $26.5 million purchase deal that included a promise to put the yard back in business by spring of 1984. When that plan failed, he negotiated one far more controversial: use the view and harbor frontage to create what the Baltmore *Sun* called "the biggest residential

project ever planned in Baltimore." Mayor Schaefer fumed and state senator George Della complained that "the community was rolled over." But Swirnow, described by the *Sun* as a "rough-cut millionaire" and "pit bull," pressed ahead, finding financing first in Maryland and then, after a squabble, from Parkway Holdings in Singapore in an eleventh-hour rescue from foreclosure in December 1986.

A $5 million sales center and yacht club opened first, to draw attention to the HarborView project. Then, in 1993, came a 27-story, 248-unit tower, designed as three buildings in one, with less expensive units on the bottom, larger and more expensive units in the middle, and penthouses on top. The building was placed atop the drydock of the old shipyard, using the drydock for underground parking. A five-story apartment unit called Pierside and 76 townhouses were later added on the south side. In November 2002, Swirnow announced his next step: a $60 million plan to fill the old shipyard piers north of his tower with 88 townhouses.

The last remnant of Swirnow's shipyard tract—the

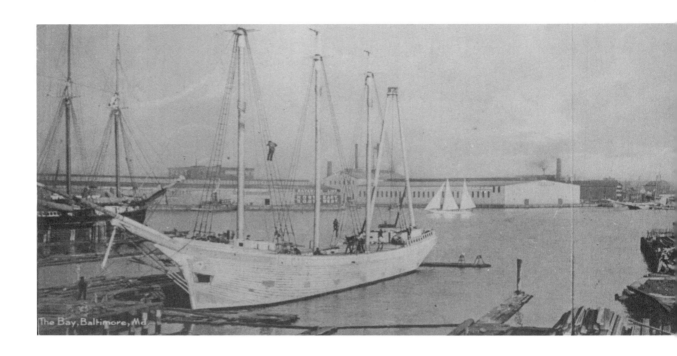

The Bay, Baltimore, Md.

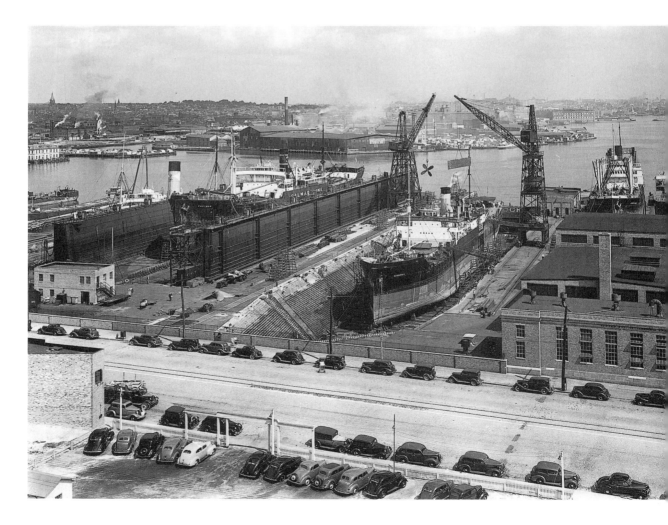

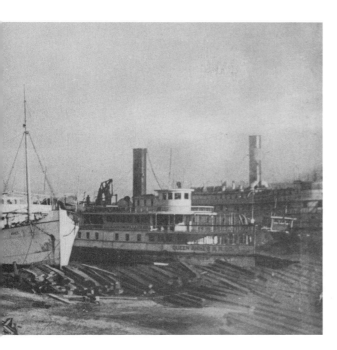

Left: The view from the eastern base of Federal Hill in about 1900. Maryland Historical Society

Below: The same view in the late 1930s, when Bethlehem's Key Highway ship repair yard dominated the scene. This sweeping view takes in Fells Point, Canton, and Locust Point. A large warehouse occupies Fells Point behind the ships at left, preceding the Allied Chemical chrome plant which expanded onto the site in 1950. The Hughes Company Collection, Maryland Historical Society

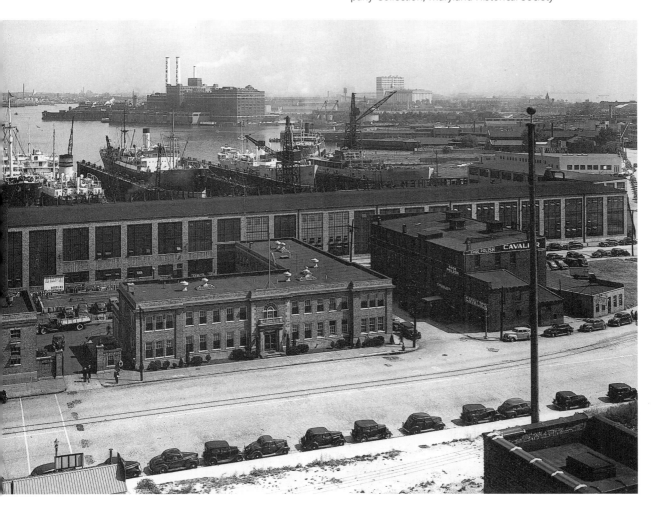

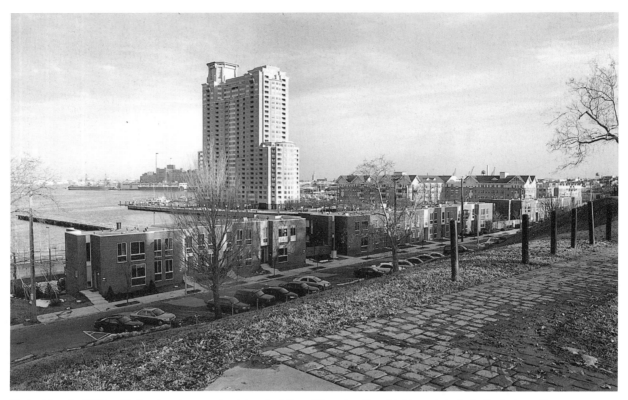

HarborView in 2003, with the signature condominium building sitting atop the old shipyard drydock. Photo by author

northernmost parcel, holding the old propeller storage building—was given its new mission in life May 19, 2004, at a ceremony where dignitaries launched a project called Ritz Carlton Residences, a complex of 165 luxury condos, to be enhanced by a five-star restaurant, a 15,000-square-foot spa, a marina, a gourmet food market, meeting rooms, and a private movie theater. Mayor Martin O'Malley hailed the developer, Edward V. Giannasca II, for his persistence in moving the $155 million project forward in the face of various disputes, and without asking for tax breaks or other financial support from the city. Ritz Carlton will pay for bulkhead repairs and a public promenade, unlike several developers who had recently gotten $10 million in state and city relief from those costs in Fells Point. Andrew Frank, executive vice president of the quasi-public Baltimore Development Corporation, called the hundred percent private investment "a testament to where Baltimore is today compared to where it was five years ago."

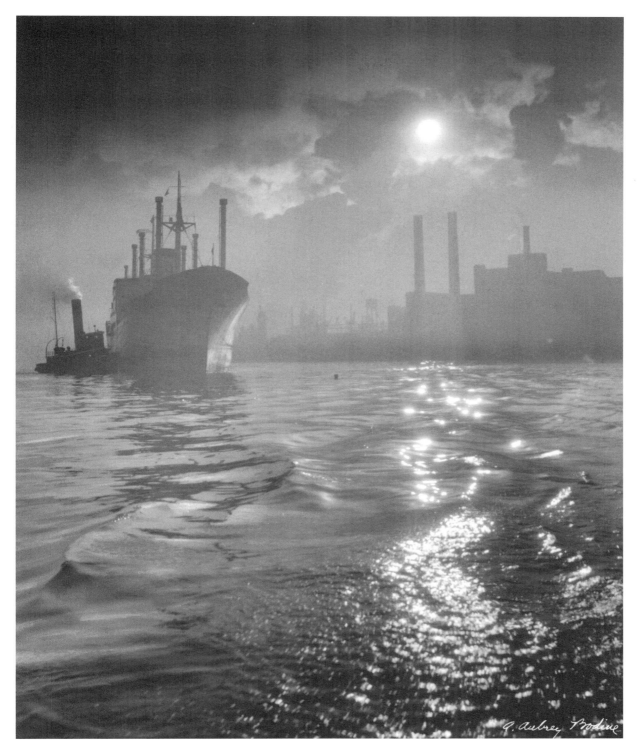

Her cargo holds emptied, a ship passes the Domino Sugars plant with tug assistance, most likely heading for the Key Highway repair yard in this classic ghostly photo taken by *Sun* photographer A. Aubrey Bodine. ©Jennifer B. Bodine.

CHAPTER NINE

INNER HARBOR

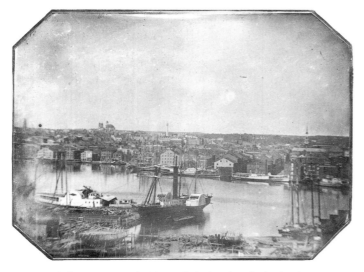

A daguerreotype by H. H. Clark showing the harbor in about 1851 from the south shore of the Inner Harbor. The new steamer *Bertha Harassowitz* sits in the foreground. Peale Collection, Maryland Historical Society

After passing the general cargo piers of Locust Point, a traveler to Baltimore's Inner Harbor could, until not long ago, almost navigate by smell. First, to port, came the unmistakable scent of Ivory and other famous soaps being made at the Procter and Gamble plant, opened in 1930. Then came (as it still does) the pleasant smell of raw sugar, being unloaded almost any time, day or night, at the Domino Sugars plant. Beyond the sugar refinery, one steered northwest, between sounds and odors of the Bethlehem ship repair yards, to the left, and the Allied Chemical chrome plant, to the right, into the aromatic embrace of the McCormick spice plant at the head of the harbor. Some of the scents are gone, but the Inner Harbor continues to beckon as one of the premiere tourist attractions on the East Coast.

After the bay steamers passed into history and the commercial freight services moved to the outer harbor, city fathers had the vision to tear out the rotting piers and convert the waterfront into a public place, appealing to locals and visitors alike. Virtually a cesspool in the early 1900s, the harbor became Baltimore's enchantress, with a magical shoreline that won national attention.

This new incarnation of the harbor is traced to 1963, when Abel Wolman, a prominent local water resources engineer, returned from a visit to Europe

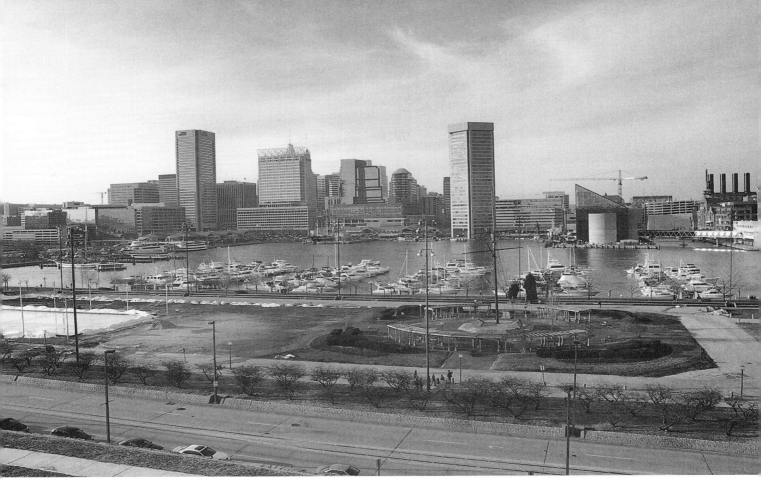

The Inner Harbor at the dawn of the twenty-first century from the same vantage point. Photo by author

with glowing tales of Stockholm's harbor. Wolman urged Mayor Theodore R. McKeldin to develop a similar plan for Baltimore. The mayor appointed the Philadelphia designer David A. Wallace, who had planned the city's Charles Center renewal project in 1959, to the job. Wallace credits his partner, Thomas A. Todd, with the resultant master plan, which drew this comment from *Progressive Architecture* magazine in April 1965: "Inner Harbor . . . emerges as a candidate for the best use of water and open land in postwar U.S. urban renewal. Instead of cutting the water off from the city, as almost all our cities do, Baltimore—if this plan is followed—will thrust the living, 24-hours-a-day city into intimate and vivacious contact with the harbor whence it sprang."

For the next two decades, under the leadership and watchful eyes of Charles Center–Inner Harbor Management, the harbor was developed, largely in keep-ing with Todd's plan. But the dynamics of harborside activity eventually began to change. Baltimore residents began to stay away as the tourist trade mounted and prices rose to match the clientele. Local shop owners and restaurateurs left, unable to pay the premium rents and still compete against national chains.

The city sensed some loss of momentum after the departure in 1986 of the fabled "Do it now!" mayor, William Donald Schaefer, and his entourage of "Do it right" lieutenants. Schaefer headed to the State House as governor, leaving his friend, the durable City Council president, Clarence "Du" Burns, as anointed successor. When election time came, Burns suffered defeat at the hands of the Yale- and Harvard-educated attorney Kurt L. Schmoke.

As the first elected black mayor of a predominantly black city, Schmoke put his focus on schools and neighborhoods. In 1991 he folded the harbor's inde-

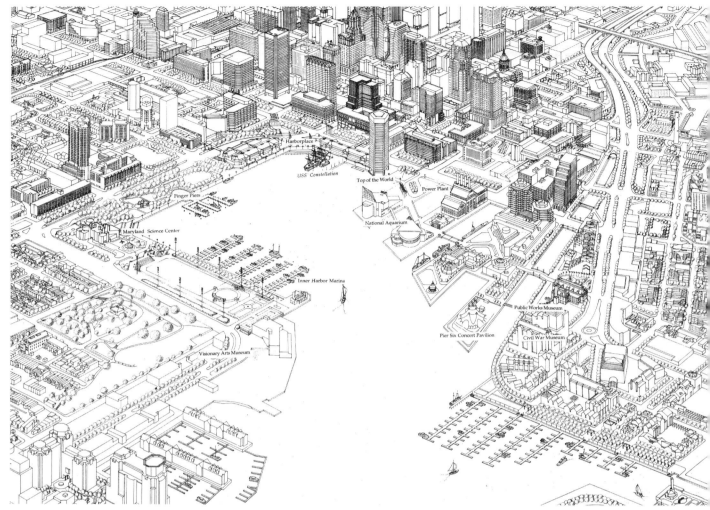

Detail of 1989 plan for Baltimore Harbor. Baltimore City Department of Planning

pendent management authority into his citywide development arm—the Baltimore Development Corporation—whose core mission is to improve the tax base, not to ponder issues of image and style. Four years later he shook up the Baltimore Area Convention and Visitors Association (BACVA) and put in his own people. Meanwhile, oversight of daily operations in the harbor passed into the hands of the Public Works Department. Observers counted six agencies having a say, with none holding a firm grip.

In this setting, retail and entertainment began to dominate the harbor scene, sometimes at the expense of open space and museum growth, which appealed to families. New buildings were sited without reference to a plan or to a code for size and placement of the inevitable neon signs. There were no clear signals from City Hall. A report in November 1995 from the Downtown Partnership, a nonprofit business group, warned: "While Baltimore led the trend in the first generation, the festival marketplace, it missed out on the next generation of entertainment projects. . . . Baltimore is also behind, and could lose out, on the third generation of themed environments."

In recent years, despite a $151 million expansion of

facilities, convention business began to plateau or even taper off. The September 11, 2001, terrorist attacks certainly slowed the convention business, in Baltimore as elsewhere. Also, to some extent Baltimore was bitten by its own early success. An evergrowing number of rival cities followed the pioneer city's example and created alternative sites to entice convention planners.

Critics contended that, in this competitive scene, Baltimore's marketers were too focused on trying to land the megaconventions rather than the moderate-sized ones the city is better equipped to handle in terms of floor space and hotel capacities. BACVA's chief executive for seven years, Carroll R. Armstrong, stepped aside in January 2003. His successor, Leslie R. Doggett, vowed to bring more accountability to the agency as well as to rebrand Baltimore for marketing purposes.

While convention business continued to slump in 2003—a turnaround takes several years—BACVA reported a nearly 50 percent increase in hotel room use and a 35 percent increase in visitors to the city in the first three months of 2004. Tourism was up in the state and nation as people regained their confidence to travel. In May of that year, Baltimore reached out to its visitors by opening a $4.5 million visitors' center on the west shore of the Inner Harbor, replacing a converted construction trailer that even lacked bathrooms. With glass walls and a wavy roof that suggests the sea, the 8,000-square-foot pavilion is the place to go for information about restaurants, hotels, and attractions nearby and elsewhere in the city. A short, tightly edited film called *The Baltimore Experience* is a pleasure to watch even for Baltimoreans.

While the promotion people struggled to build the crowds, attractions managers continued to struggle with the harbor's visual and cultural identity. On the east side, developer David Cordish rescued the old city power plant after a Six Flags Corporation family entertainment center failed. Cordish came up with a multiuse plan more in tune with the times: an ESPN Zone restaurant and sports center on the Pratt Street side, a two-level Barnes and Noble bookstore in the main chamber, and a Hard Rock Cafe to the south. In June 2003 the Cordish Company opened a virtual reality attraction in a new building next door, called PassPort Voyage of Discovery. ESPN managers celebrated their fifth anniversary in July 2003, proclaiming a "home run" with a consistent patronage of a half-million persons each year, about 60 percent of whom lived within a 30-mile radius.

North of Pratt Street, the Cordish family brought life back to the old Market Place where successive developments called the Brokerage and Fish Market had failed. With more than a dozen bars and restaurants, a license allowing patrons to carry drinks on the public plaza, and giant neon signs designating the area as "Power Plant Live," the Cordish project quickly drew huge crowds, from 18-year-olds on "college night" to professionals in their forties.

The company raised eyebrows among neighboring attractions and other harbor observers when it obtained permission to replace one of the Power Plant structures with an office building and service it with a

waterfront garage, rather than locate such structures north of Pratt Street, away from the prime tourism area.

With this issue raised, and with the Maryland Science Center, Harborplace, the National Aquarium, and the Power Plant all providing strong public draws that needed to be encouraged and protected, the Baltimore Development Corporation in 2002 commissioned the firm Cooper, Robertson and Partners of New York to recommend a new master plan to address existing issues and set the tone for the Inner Harbor of the twenty-first century.

Drawing on Cooper, Robertson's recommendations and a 2003 study by the Greater Baltimore Committee, Mayor Martin O'Malley in May 2004 announced a plan that would address management issues and, more specifically—and subject to funding—tame the traffic on the harbor's "ring road," composed of Key Highway and Light, Pratt, and President streets. The plan would turn them into pedestrian- and bicycle-friendly boulevards, reduce clutter and provide more shade trees on the western shore along Light Street, and make more parking for the Science Center, in a two-deck garage beneath an elevated Rash Field. The mayor asked BDC's executive vice president, Andrew Frank, to coordinate implementation of the plan over the next eighteen months and report back with recommendations regarding the idea of putting harbor management under a single, new entity.

The challenge to the harbor could prove to be more political than architectural. *Baltimore Business Journal* editor Joanna Sullivan alerted her readers in the paper's September 19, 2003, issue of "whispers" about a "growing, albeit quiet force that envisions the Inner Harbor as a mid-Atlantic Las Vegas." It "doesn't make sense," she wrote, "to ruin the Inner Harbor's thriving family atmosphere" at a time when "the momentum for people to live, work and play around the city's waterfront has never been stronger." Time will test the validity of her concerns.

Its intermittent marketing problems notwithstanding, Baltimore's harbor and surrounding area offer a host of outstanding and successful attractions, from the National Aquarium to the temporarily storm-damaged B&O Railroad Museum to the pioneering Science Center that began drawing family visitors long before the builders of Harborplace broke ground. The photographs and descriptions on the following pages provide a tour of public attractions along the Inner Harbor basin, starting on the south side. Locations can be seen on the map. With the exception of the Museum of Industry, all points of interest are reasonably accessible from one another by foot. For the footsore, a refreshing respite can be found by walking one way and returning by water taxi or shuttle.

BALTIMORE MUSEUM OF INDUSTRY, 1415 Key Highway. This unique museum—a popular destination for school field trips—was organized on a shoestring in 1981 and has witnessed a stunning growth in offerings and clientele. Demonstrations include a belt-driven machine shop, a loft garment shop, a

working print shop, a port cargo–handling exhibit, and a make-believe hands-on oyster cannery that shows that "Kids Can." A new exhibit covering vintage paint manufacture opened in 2004, and two others, on transportation and glassmaking, were in the planning stage.

On a pier behind the museum is the S.S. *Baltimore,* a turn-of-the-century steam tugboat restored to operating status by volunteers after several years under water on the other side of Chesapeake Bay. The Maryland Port Administration once used the *Baltimore* for public tours. Half-submerged near the tug pier is the metal hull of the *Governor McLane,* a patrol boat the state used to keep the peace between Maryland and Virginia oyster harvesters during the Oyster Wars of the 1880s. The museum can be reached by shuttle boat from Harborplace. Phone 410-727-4808.

AMERICAN VISIONARY ART MUSEUM, 800 Key Highway. Opened in 1995 under the guidance of Rebecca Hoffberger (clearly an inspired person herself), this popular facility has been designated by Congress as a "national museum, repository and education center for the best in original, self-taught artistry." Its seven galleries offer changing displays of imaginative creations by farmers, mechanics, housewives, retirees, the disabled, the homeless, and others. A "new world cuisine" café overlooks the harbor. On July 4, 2003, Hoffberger broke ground for a $10 million expansion, to be called Jim Rouse Visionary Center. She and her colleagues are making over an old whiskey warehouse adjacent to the original museum, creating displays

Steam tug *Baltimore,* shown under way in 1987, has a home and loving keepers at the Baltimore Museum of Industry. C. H. Nichols, photographer

Whirligig, a permanent installation at the Visionary Art Museum. Photo by author

and meeting rooms that sustain the warehouse as a place where spirits soar. Phone 410-244-1900.

RUSTY SCUPPER AND INNER HARBOR MARINA, 400 Key Highway. This glass and wood-beam structure, opened in 1982, does double duty as a restaurant and home for the Inner Harbor marina. The marina offers 158 boat slips, including water and electricity hook-ups and showers. Eighty of the slips are devoted to daily rentals by transient boaters. Reservations are taken, but Saturday nights may be booked up months in advance. Phones: Rusty Scupper, 410-727-3678; Inner Harbor Marina, 410-837-5339.

MARYLAND SCIENCE CENTER, 601 Light Street. The original $7.2 million brick structure was built by the Maryland Academy of Sciences in 1976 as one of the first public attractions in the harbor. A decade later the fortress-like exterior was given a facelift, and a spectacular IMAX big-screen theater was added to keep in step with the harbor's tourist boom. In May 2004 museum officials opened a new wing as part of a $36 million program of expansion and renovation intended to put the Science Center on a par with the National Aquarium in terms of fascination and patronage. The new Earth Science and Dinosaur Hall features fifteen dinosaur displays and dozens of hands-on activities that explain anatomy, evolution, and climate change. One area of the center is designated as the National Visitor Center for the Hubble Space Telescope, with live links to NASA. Other areas feature the city, geology, the Chesapeake Bay, and computers. The Davis Planetarium offers

Architect's rendering of the new face of the Maryland Science Center from Light Street. Design Collective

daily shows on astronomy. Open some evenings. Phone 410-685-5225.

SEAWALL AND FINGER PIERS. Dockage at the finger piers and alongside the lively seawall promenade is open to boaters on a first come, first served basis, with a minimum $5 fee for the first four hours (as of 2004) and no reservations accepted. In theory, boaters can pull in and walk to Harborplace for a snack or meal; but space is at a premium on summer weekends, and it may be necessary to anchor in the mucky bottom between Constellation Pier and the Aquarium or head for the piers to the east. The dockmaster keeps office just off the finger piers. Power and water hookups are available. Phone 410-396-3174.

HARBORPLACE, Pratt and Light Streets. Some 160 shops, restaurants, and food stalls of every shape, size, and ethnic origin are packed into two glass and metal pavilions on the water and the four-story Gallery opposite, on the north side of Pratt Street. The complex ranks among the world's liveliest retail operations in sales per square foot.

In December 1978 the City of Baltimore struck a deal with developer James W. Rouse under the terms of which the Rouse Company built the Pratt Street shopping pavilion and Light Street food pavilion on 3.2 acres of city-owned land. The pavilions opened to great fanfare on July 2, 1980, though their conception was not without controversy. Some Baltimoreans felt they would intrude on the tranquility of the harbor promenade. Mayor William Donald Schaefer successfully engineered a referendum to assure construction

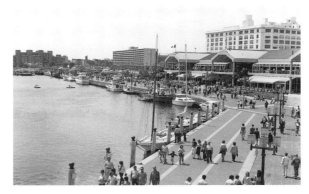

Harborplace, 1982, before demolition of the McCormick spice building (*background at right*). Photo by author

of the buildings, and the objections have largely been forgotten as hordes jam the popular pavilions.

The 1978 agreement required the Rouse Company to pay the city an annual basic rent of $100,000 plus 25 percent of cash remaining after deducting a 10 percent operating profit, 10 percent on equity investment, and other expenses. Individual entrepreneurs were asked to pay, depending on location, anywhere from $48 to $96 a square foot annual rent, plus utilities, to operate in this prime commercial space.

Phone 410-332-0060.

U.S. SLOOP *CONSTELLATION*, Constellation Dock, Pratt Street. The original frigate *Constellation* was built in Baltimore by David Stodder in 1797. That vessel defeated the French ships *L'Insurgente* and *La Vengeance* in her first five years of service, engaged pirates off the Barbary Coast in 1802, fought the British in the War of 1812, and opened U.S. trade with China in the 1840s.

In 1852 the Navy dispatched the water-worn *Constellation* to the Portsmouth, Virginia, Navy shipyard for a rebuild as a sloop of war, which carries a different gun complement than does a frigate. The vessel that emerged from the repair yards had a new keel and somewhat different hull configuration and a questionable number of original timbers.

For years, a controversy has been swirling among maritime buffs and Navy brass as to whether the refurbished ship is really the *Constellation* or a new ship with the same name. To philosophers, the argument is akin to John Locke's question If you patch a

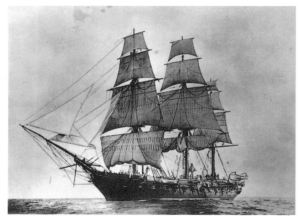

U.S. Sloop *Constellation*. Collection of William Jackson, Constellation Museum

pair of socks until there is nothing but patches, is it still the same pair of socks? To naval buffs, if the present *Constellation* dates back to the original build, she can rightly claim to be the oldest ship in the navy, upstaging Boston's *Constitution,* which was launched and commissioned a month after the *Constellation.*

Whatever her genesis, the *Constellation* that emerged from the yard has a history of her own. She helped break up the slave trade off Africa in the early 1850s, transported food to Ireland during the famine of 1880, served as a training ship at the Naval Academy, and was commissioned by President Franklin D. Roosevelt as flagship of the Atlantic Fleet, moored at Newport, Rhode Island, in World War II. She underwent a down-to-the-waterline $8 million reconstruction between 1996 and 1999 at the skilled hands of local shipbuilders using a novel method of encapsulating and strengthening the upper hull with laminated planking, and no one has claimed that she is yet a third ship. Visitors can tour the magnificently renovated vessel from spar deck to orlop. Phone 410-539-1797 (a number that reflects the building year of the original ship).

WORLD TRADE CENTER AND TOP OF THE WORLD, 401 E. Pratt Street. For a stunning perspective on where you are going, or where you have been, no public place matches the observation floor of the World Trade Center, dubbed Top of the World, which features exhibits, a gift shop, and giant windows on five sides. The $22 million Trade Center was designed by I. M. Pei and opened in 1977. It is home to the

Baltimore's World Trade Center. Photo by author

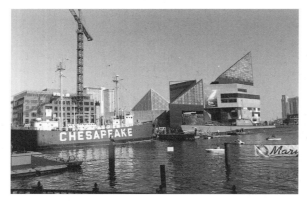

Lightship *Chesapeake* (a beacon ship) and the decommissioned U.S. Navy submarine *Torsk* docked alongside the National Aquarium. Photo by author

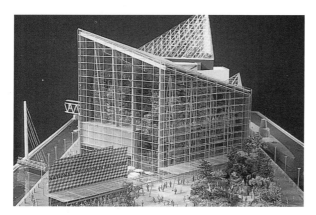

Architect's view of the expanded National Aquarium in Baltimore. Photo by George Grall

Maryland Port Administration and many of the ship lines and agencies. Phone 410-837-VIEW.

NATIONAL AQUARIUM IN BALTIMORE, Pier 3, Pratt Street. The crown jewel of the Inner Harbor, the $21.3 million National Aquarium, has had a waiting line snaking to its dramatic tetrahedral entrance almost every day since it opened in August 1981. Marine biologists and engineers control the environment of over one million gallons of water to care for and display some 5,000 creatures in natural-looking settings. Highlights of the main building include a giant pool of rays, a 335,000 gallon Atlantic coral reef (largest in the U.S.), a 220,000 gallon shark tank, a tropical rain forest, and displays showing aquatic life from mountain stream to seashore. Ramps, bridges, and escalators carry visitors over, around, and through the gigantic glass-walled tanks and displays while recorded fish sounds and gurgles play overhead. In 1991 the Marine Mammal Pavilion was opened on neighboring Pier 4 with additional classrooms and popular dolphin shows. Groundbreaking took place in September 2002 for a $61.8 million, 12-story glass addition out front that replicates an Australian river canyon, with aboriginal art, freshwater crocodiles, and a range of hardy animals not found outside Australia. The project also includes a waterfront park with Chesapeake Bay area plants. Open daily. Phone 410-576-3800 (but expect a recorded human sound).

BALTIMORE MARITIME MUSEUM, Pier 3. One can walk through a submarine and a lightship alongside the Aquarium and a 327-foot Coast Guard cutter

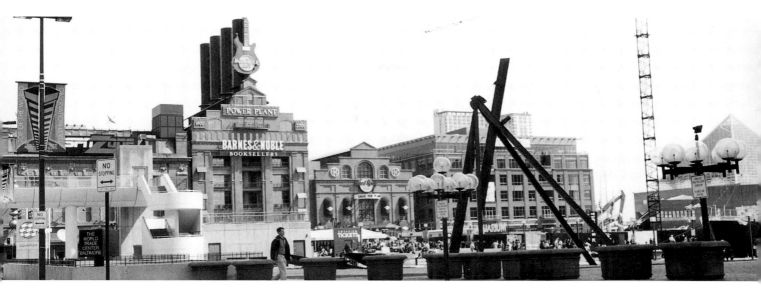

Power Plant with a new mission. In 1900, when built, it powered city streetcars and provided steam heat for downtown buildings. Photo by author

at Pier 5, all of historical significance. The 311-foot submarine *Torsk,* built in 1944, fired the last torpedo and sank the last Japanese combatant ships of World War II. Later, as a training ship, it set an all-time world record of 11,884 dives. The 133-foot lightship *Chesapeake,* really a floating lighthouse, served for twenty-nine years to mark the entrance to Chesapeake Bay off the Virginia Capes. The cutter *Taney* is the last warship afloat to survive the 1941 attack on Pearl Harbor. It was decommissioned in 1986 after fifty years of service.

Sevenfoot Knoll Lighthouse, now installed at the end of Pier 5, makes up another offering of the Maritime Museum. It was barged into the harbor on the end of a crane in 1989, after serving for 133 years as a beacon for vessels turning into the Patapsco River from Chesapeake Bay. It is the bay's oldest "screw pile" light, using cast iron supports that were screwed into the soft mud, eliminating the need for a stone base. Phone 410-396-3453.

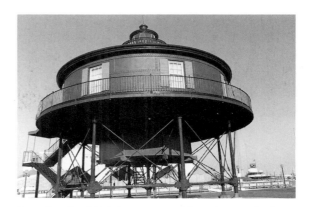

Sevenfoot Knoll Lighthouse, moved from the mouth of Chesapeake Bay to new quarters. Photo by author

CUSTOM HOUSE CALL ROOM, 103 S. Gay Street. For an unadvertised maritime and architectural wonder, visit the Call Room of the U.S. Custom House at

Lombard and Gay streets, a block north of the Aquarium. The classic granite structure dates to 1903, at a time when captains from arriving vessels were still carrying manifests and clearing their papers at the Custom House before unloading their ships.

The giant Call Room, where the captains brought their papers, is 50 by 95 feet, with a 35-foot-high ceiling decorated by a huge canvas showing ten sailing ships entering Baltimore harbor on a summer morning. There are twenty-eight smaller paintings and five lunettes. All are by marine artist Francis D. Millet, who went down with the *Titanic* in 1912. The room and its paintings were restored for the 1976 Bicentennial, but few uses have been found for it. The public may view it during working hours.

PIER SIX CONCERT PAVILION, Pratt Street. This imaginative tentlike structure has been a popular attraction on summer evenings since 1981. Its fare has ranged from Ella Fitzgerald and the Preservation Hall Jazz Band during the first season to Linda Ronstadt and Hootie and the Blowfish in 2004. Seat prices vary, down to nothing at all for those who come by boat or find a place on the seawall across Jones Falls. Phone Visitors' Center, 410-837-4636.

PUBLIC WORKS MUSEUM AND SEWAGE PUMPING STATION, President Street at Eastern Avenue. The Public Works Museum was opened in 1982 at the ornate brick-and-copper Sewage Pumping Station. The museum features a $500,000 streetscape demonstrating the below-ground marvels at a typical street intersection.

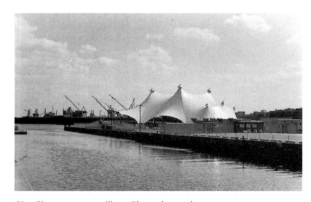

Pier Six concert pavilion. Photo by author

The Sewage Pumping Station, built in 1911, is a marvel in itself. Until that time, Baltimore had one of the worst sewage systems of any American city. Cesspools abounded; all piped sewage drained directly into the harbor, including vegetable refuse from shoreside canneries. The noxious odors wafted well up into the heart of the city. "You could smell the harbor for miles and new paint on vessels coming into the harbor was oxidized," one observer recalled.

To set the situation right, the city built what for that time was the largest "trickling filter" sewage treatment facility in the world, at a site on Back River, east of the city. At the same time, throughout the city, sewage outlets were diverted from the storm drains and connected to lines leading to Back River, culminating in a gravity drain 11 feet high and 12 feet wide and five and a half miles long.

In areas where the ground was too low to drain to Back River by gravity—about a third of the city—the pipes were led to the pumping station. At the Sewage Pumping Station, three steam-driven pumps, again the largest of their kind in the world, were installed to force the sewage up a 60-foot rise to Bond and Fayette streets, a mile to the northeast, and into the tunnel to Back River. The giant steam pumps were replaced by five low-profile electric pumps and one diesel pump in 1959 and the early 1960s, negating the need for such an elaborate building and spacious pump room.

The pumping station includes a screen room (to protect the pumps from debris), a boiler room and coal bin (no longer used because of the conversion to diesel), and an emergency bypass into the harbor

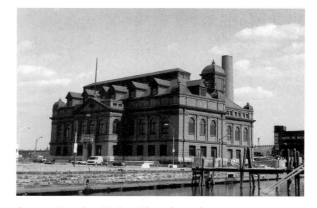

Sewage Pumping Station. Photo by author

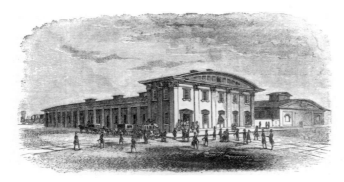

President Street Station railroad terminal as it appeared at the time of the Civil War. Maryland Historical Society

which, fortunately, has been used only on rare occasions, such as during hurricane rains when the Back River plant cannot handle the input.

The Back River plant had major upgrades in the 1980s to handle the needs of a growing metropolis. But disputes have arisen over the discharging of water into Back River and the disposal of sludge on nearby farms. An engineering report in 1928 suggested that the material worked well as a fertilizer for white potatoes, cabbage, and corn. Phone 410-396-5565.

CIVIL WAR MUSEUM, 601 President Street. President Street Station, once the southern terminus of the Philadelphia, Wilmington and Baltimore Railroad, has been transformed into a first-class Civil War information center, focusing especially on Baltimore's role in the conflict. The museum also explains the role of the railroad in slave escapes from bondage—notably the escape of Frederick Douglass. Unfortunately dwarfed by a recently built waterfront hotel, the museum operates under the umbrella of the Maryland Historical Society. Phone 410-385-5188.

SEE IT FROM THE WATER

More than a half-dozen attractions offer an opportunity to go out on the water yourself.

The most popular is the Water Taxi, which departs from Harborplace and follows a fixed route that takes you to Fells Point, Fort McHenry, and many points between. For a single fare ($6 as of 2004) you can get on and off all day.

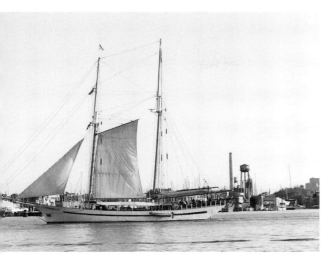

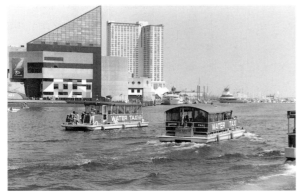

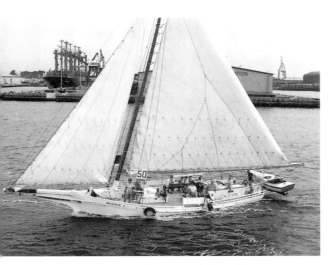

Top: The *Clipper City* offers tours of the harbor. Photo by author

Middle: Water taxis pass each other on a bright summer day. Photo by author

Bottom: The skipjack *Minnie V.* on one of its summertime harbor cruises. Photo by author

Top: Dinner boats lined up on the Light Street seawall. Photo by author

Bottom: Harbor shuttle landing at Fells Point, Photo by author

This privately owned service was founded in 1977, after discussions between two local visionaries, Mayor Shaefer and businessman Ed Kane, both of whom saw the taxis as a way to draw pedestrian activity to the harbor. At the end of the 2004 season, the nonprofit Living Classrooms Foundation (see p. 156) closed down its competing Seaport Taxi service and formed a partnership with Water Taxi under which the latter

provides transportation for the foundation's National Historic Seaport tour of selected historic waterfront attractions. These moves coincided with a plan by the city, announced in October 2004, to offer a single taxi service exclusive landing rights at city docks in return for expansion of operations to serve weekday commuters. Phone 410-563-3901.

Four water transport operations offer extended tours:

CLIPPER CITY. Designed after a Lake Michigan lumber schooner, this 140-passenger open-air vessel offers private and public tours of the harbor from the Finger Piers. Phone 410-539-6277.

HARBOR CRUISES LTD. The 600-passenger showboat *Bay Lady* and her 500-passenger companion vessel, *Lady Baltimore*, provide lunch and dinner cruises from the Light Street seawall. The two vessels alternate in providing a day-trip to Annapolis each Wednesday. A third vessel, *Prince Charming*, offers 60-minute narrated harbor tours. Phone 410-727-3113.

DUCKS. You can board one of these 39-passenger World War II amphibious vessels on Light Street for an 80-minute tour of the harbor area by land and by sea. Phone 410-727-DUCK.

MINNIE V. This city-owned Chesapeake Bay skipjack offers narrated tours of the old harbor under sail from the Ceremonial Steps, between the two Harborplace pavilions, and is under management of the Liv-

ing Classrooms Foundation. Until oyster harvests plummeted in the 1980s, the classic vessel earned its keep by winter dredging. Phone 410-685-0295.

Two concessions let you be captain:

PADDLEBOATS. You can fantasize walking on water by renting one of the fifty leg-powered conventional paddleboats or sixteen that resemble dragons, maintained by Living Classrooms Foundation next to Constellation Pier. Phone 410-385-2733.

TRIDENT ELECTRIC BOATS LTD. For those less athletic, this fleet of twenty-three battery-powered boats operates from a dock just east of the World Trade Center. Phone 410-539-1837.

THE STEAMBOAT ERA

The Inner Harbor lagged behind Fells Point as a mooring site for deep-draft ocean vessels, but it was ideally suited to the shallow-draft paddlewheel steamboats that began to ply the Chesapeake Bay in the early 1800s. For more than a century, until trucks, highways, and the distractions of war brought their eclipse in the early 1940s, steamboats dominated the Inner Harbor.

Baltimore's steamboat expert, H. Graham Wood, classified the boats that carried passengers and freight from the Light Street and Pratt Street piers in four general categories. The Baltimore-Philadelphia steamboats were the first in operation, beginning in 1813—a year when the young American nation, and

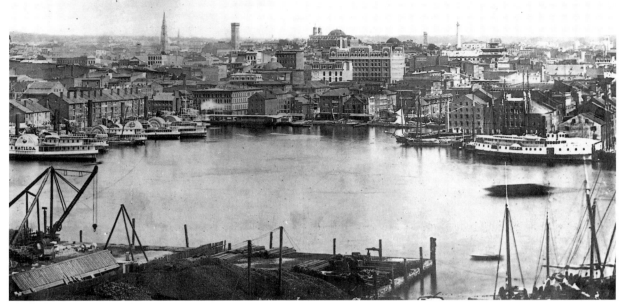

The harbor as it looked about 1872. Maryland Historical Society

Baltimore in particular, was still at war with the British. The first Philadelphia boats ran up the bay to Frenchtown, at the head of the bay, and their passengers were then taken overland by stagecoach to the Delaware River for an additional water journey. Later, a rail line connected Philadelphia to the head of the bay and there picked up boat passengers. In 1829, a narrow canal was cut through from Chesapeake Bay to Delaware Bay, enabling the slender ships of the Ericksson Line (named for the man who invented the type of propeller they used) to provide overnight through service.

The second category of steamboat service, between Baltimore and Norfolk, began in 1817. For many years this service was monopolized by the Baltimore Steam Packet Company, but at the time of the Civil War a New York–based company came in, advertising itself as the "new" bay line. The Baltimore Steam Packet Company countered by reminding patrons it was the "Old Bay Line," a nickname that was to last for a hundred years.

The Old Bay Line was presented with more durable competition when the Chesapeake Steamship Company began service to Hampton Roads, at the

The walking beam, a distinctive feature of the early sidewheelers. Their great steam pistons were set upright, and the walking beam was used to transfer the reciprocating (up and down) thrust of the pistons to the rotary motion of the paddlewheel crankshaft. In later vessels the pistons were laid on their side so that their power could be applied to the crankshaft directly. For excitement and drama, there was nothing in the world that could quite match the sound, smell, and sight of the engine room of a paddlewheel steamer. Maryland Historical Society

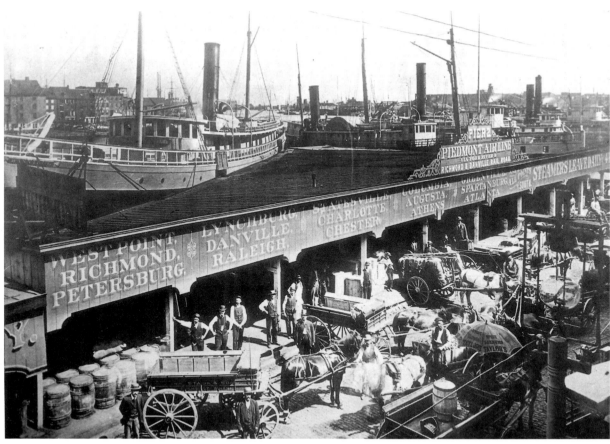

The Light Street docks about 1885. Peale Collection, Maryland Historical Society

mouth of the bay, in 1896. The competition lasted until 1941, when the U.S. Government took over boats of both lines for the war effort. The Old Bay Line then bought out its rival and continued the bay service for another two decades with two boats the government left them, the *City of Norfolk* and the *City of Richmond,* both already thirty years old at the time.

The Norfolk boats were large and swift, traveling 17–18 miles per hour on the 185-mile overnight run. A third category of steamboats were slower and smaller but followed schedules infinitely more interesting and romantic. These were the river steamers, which left Baltimore with goods and passengers for all parts of the bay and might not return to Light Street for two or three days or even a week. Graham Wood counted

100 old steamboat landings on the eastern shore of the Chesapeake and 150 on the western shore. Baltimore was the outside world to the waterfront communities served by these landings, their source for fertilizer, farm machinery, and supplies. In return, they shipped strawberries, potatoes, tobacco, grain, livestock, and seafood back to Baltimore for sale. In those days, given the local geography, the bay steamers and smaller sailing craft were the only practical means of transportation between these calling points and Baltimore.

A fourth category of Baltimore steamer was the excursion boat. Day-long outings to Tolchester Beach, Betterton Beach, Chesapeake Beach, and other resorts were enjoyed by hundreds of thousands. Across the bay, the ferry docks at Love Point received

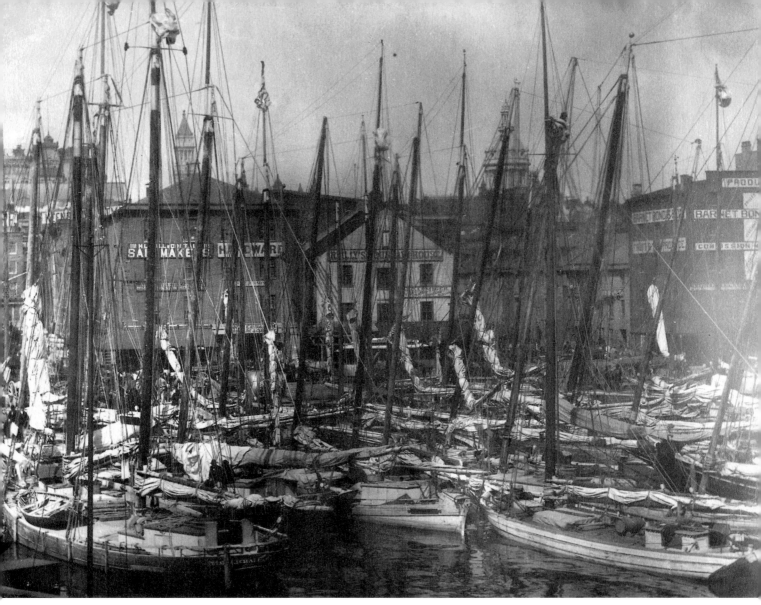

Pratt Street was long a receiving center for Chesapeake Bay produce. Here bugeyes, pungies, sloops, and schooners cluster at the old piers in about 1890. Smithsonian Institution

passengers for the rail trip to Rehoboth, Delaware, on the Atlantic Ocean, while further south the Claiborne docks were the railhead for service to Ocean City, Maryland. In 1923 the Rehoboth service was dropped, and Love Point became the terminus of the Ocean City line, with a steamer nicknamed "Smoky Joe" providing the waterborne leg from a Light Street pier.

The peak of steamboat operations on the bay came around 1910. The Pennsylvania Railroad alone, through operating companies, owned thirty-one bay steamers. The Pennsylvania abandoned all its river lines in 1932, dismissing captains and crew without pension. Other railroads followed suit, one by one. The rail service from Love Point ended in 1947, as more and more people went to the ocean by car. The bridge across the Chesapeake Bay was opened in 1952, so that even the automobile ferries became obsolete. The Old Bay Line finally ended its Norfolk run in 1962 (see p. 57).

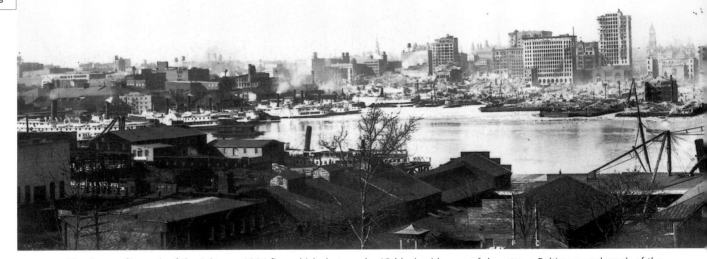

The dreary aftermath of the February 1904 fire, which destroyed a 13-block wide area of downtown Baltimore and much of the inner harbor waterfront. The Pratt Street wharves and the buildings on them went up in flames, and only a valiant fire-fighting effort and shifting winds kept the inferno from spreading to Fells Point. Smoke rises from the ashes in this panorama. Even those buildings shown standing were gutted. A giant reconstruction effort got under way immediately. J. William Schaefer, photographer, Maryland Historical Society

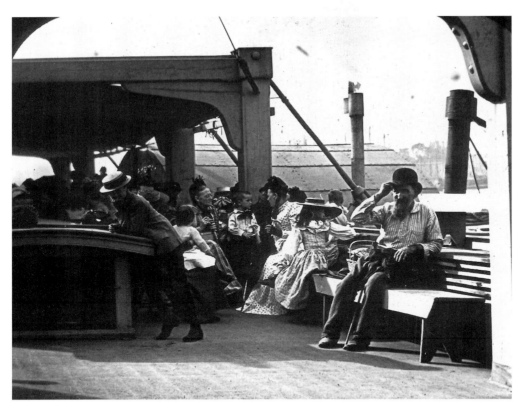

In the Gay Nineties the icebreaker *F. C. Latrobe* regularly carried summertime excursionists down the Patapsco. This group, cooling off in 1893, passes Federal Hill. Laura F. Brown Collection, Steamship Historical Society, University of Baltimore

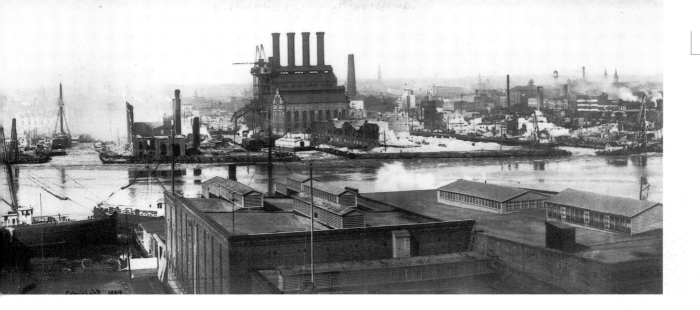

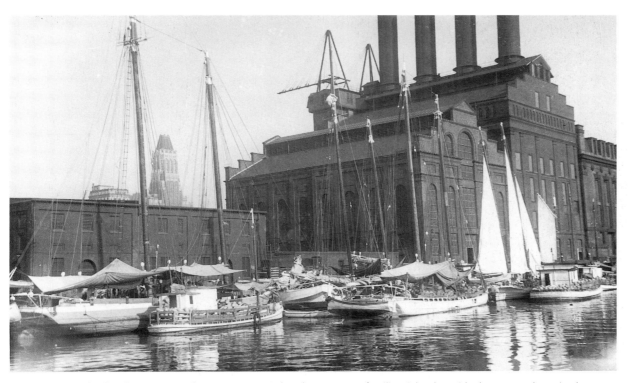

Boats wait to unload in the 1920s. Until recent years, produce boats were a familiar sight alongside the power plant pier, known as Long Dock. The boats brought oysters from the Chesapeake Bay, watermelons from the Eastern Shore, and vegetables from Curtis Bay truck gardens. They helped service Marsh Market to the northeast, the name harking back to the days when the market was on land filled in over the Jones Falls marsh. A wholesale fish market remained there until the 1980s, when the market area, like the Power Plant, was given over to entertainment, retail, and office use. Maryland Historical Society

The fireboat *Cataract* tends a blaze aboard the passenger steamer *Annapolis* in 1931. Maryland Historical Society

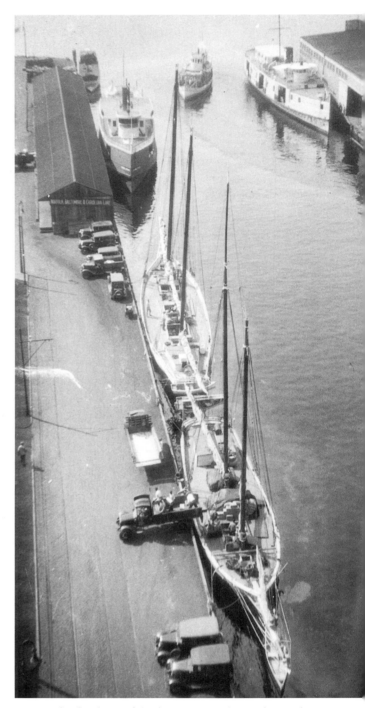

Unloading bay craft in about 1930 at Pier 4, where today the Aquarium marine mammal pavilion stands. Maryland Historical Society

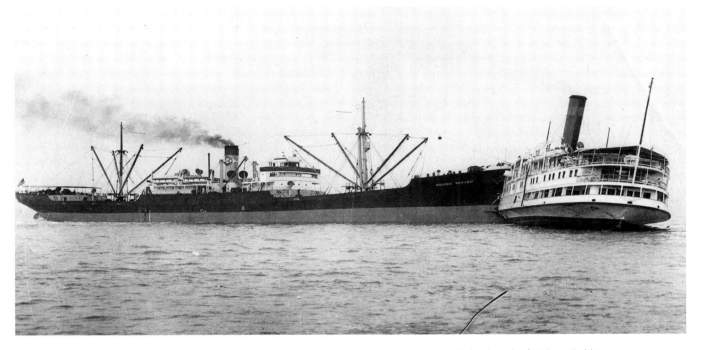

Maryland governor Harry W. Nice, along with other city and state officials, was thrown to the deck when the freighter *Golden Harvest* collided with the *State of Virginia* on July 14, 1936. The accident occurred off Sevenfoot Knoll, at the entrance to the Patapsco, with 263 persons aboard. No one was hurt seriously. Sunpapers

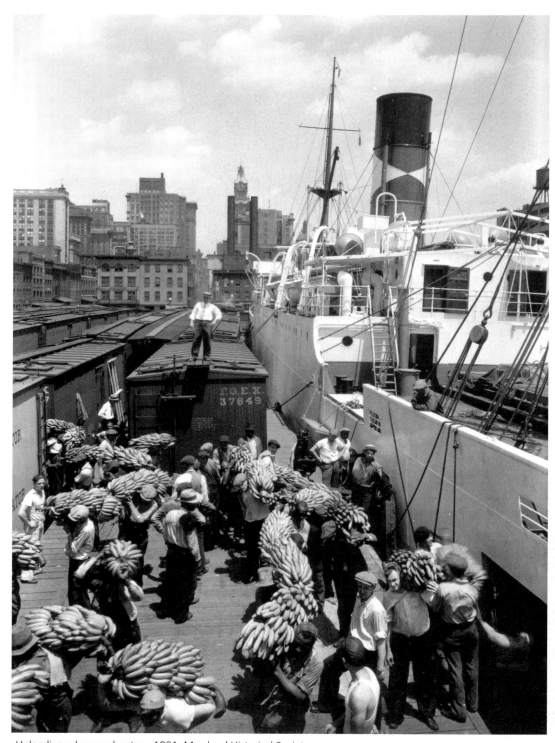

Unloading a banana boat ca. 1901. Maryland Historical Society

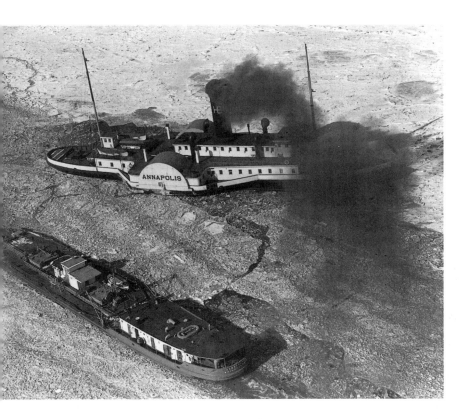

Belching smoke and soot, the *Annapolis* helps a small tanker move through the winter ice in 1942. Ice breaking used to be an annual chore on Chesapeake Bay. According to one old-timer, the winter of 1918-1919 was the worst. "We had a battleship breaking ice all through the Bay and 10 miles out to sea. All we went was two miles a day." Maryland Historical Society

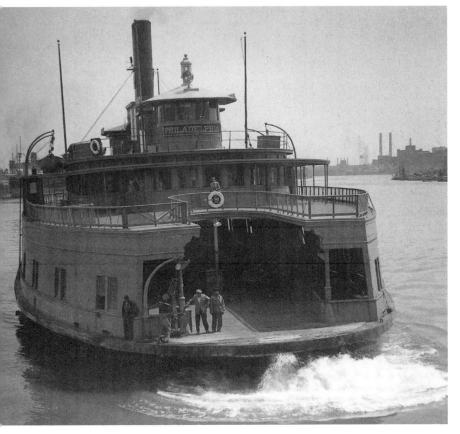

Love Point ferry *Philadelphia,* known as Smoky Joe, reverses engines to brake as she approaches her Light Street pier, in the mid-1940s. She made three trips a day, covering the 24-mile run across Chesapeake Bay in 2 hours and 20 minutes. Round trip fare was 79 cents. A small restaurant— twelve seats around a horseshoe-shaped counter—on the upper deck served fresh seafood from Kent Island and pie from a Baltimore bakery. Collection of John Showers

Right: The famous *Exodus,* a Baltimore steamship that caught the attention of the world. As the *President Warfield* of the Old Bay Line (named after the company's president and introduced to the Baltimore-Norfolk run in 1928), the *Warfield* made transatlantic voyages under the War Shipping Administration during World War II. Afterward it quietly became the property of Baltimore Jewish interests—one of four vessels secretly outfitted in the city as part of the campaign to establish a viable Jewish homeland in then-British-ruled Palestine. Designed for 400 passengers, the vessel again went to Europe,

was renamed *Exodus 1947,* and took on 4,554 Jewish refugees and Holocaust survivors, all of them determined to breach the British blockade and go ashore in the "new land" of Palestine. On July 18, 1947, British warships fired on the vessel, rammed it, and escorted it to Haifa. There the passengers were put aboard three other ships and taken to detention camps in British-occupied Germany. The world outcry over the episode was instrumental in winning United Nations support for the partitioning of Palestine and later the creation of Israel as an independent state. Meantime, the *Exodus,* left in Haifa harbor to become a floating museum, caught fire in 1952 and sank. In Baltimore, the story of *Exodus* appears on a bronze plaque at the World Trade Center. Thousands pass it daily, but few notice. Her original brass bell and steam whistle and a 5-foot ship's model are in the care of the Jewish Museum of Maryland on Lloyd Street. Steamship Historical Society

When the steamboats died, the Inner Harbor almost died with them. Mayor Thomas D'Alesandro Jr. had the rotting Light Street piers torn down in 1950. The street was widened, and the Sam Smith waterside park was created on a 200-foot-wide strip of landfill. This view dates to 1967. Three years later, dumping rock and granite behind seawalls, the city added 100 feet to the western shoreline and created the promenade one sees today by placing pylon structures over an additional 30 feet of water. Maryland Historical Society

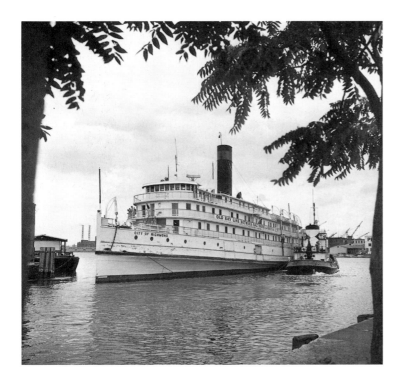

Left: The Baltimore-Norfolk steamer *City of Richmond* leaves her Pratt Street pier for the last time, on August 13, 1964. Plans called for adapting her for use as a restaurant at St. Thomas in the Virgin Islands. Unfortunately the southward journey extended into the hurricane season. A big storm hit as she was being towed off the Outer Banks of North Carolina, and she went to the bottom, seven weeks after this photo was taken.

FACING PAGE:

Bottom: General cargo freighters were a common site at the Pratt Street piers before expansion and modernization of port facilities downriver in the 1950s. Eight large vessels appear in this 1948 photo. Maryland Historical Society

A port for the people. Baltimore's Inner Harbor waterfront is now devoted exclusively to public activities—shopping, strolling, eating, boating. It is the focal point of the city. Here the tall ship *Danmark* pays a visit in 1981.
Baltimore *Sun*

The following passage, written about a voyage in 1926, captures the flavor of travel in the steamboat days. The little steamboat *Northumberland* has cast off her lines for a voyage down Chesapeake Bay to various landings along the Potomac River. Her ultimate destination is Washington, D.C., about 180 miles by water, 50 minutes by express train. Along the way she will drop off automobile tires, groceries, paint, cement, sugar—whatever supplies are needed by the communities she visits.

As the boat travels along, the passengers begin making guesses as to her chances of winning a race that started when she left her pier, at which time three other ships got the same notion. If you have ever been in Baltimore's inner harbor, you will recall the congestion there, with fussy little steamers coming in from and starting out for various points on the Chesapeake and its rivers and creeks.

The *Talbot* has made good headway and the others string along behind. The *Eastern Shore* is second, but the *Northumberland* passes her. Puffing along in the rear is the *Potomac*. But she gains foot by foot and eventually is abreast of us, within speaking distance. For a few minutes it is a bow-and-bow race, the Negro crew calling taunts to each other across the intervening stretch of water.

Slowly the *Potomac* pulls ahead and from her crew come bursts of triumphant laughter and yells of delight, mixed with expressions of amused contempt. Finally, one of the fellows produces a rope and shakes it in the direction of our crew. This is the crowning reproach. For every sailor knows that to "shake a rope at 'em" is the last word in insult—meaning, of course, that a ship at which a rope is shaken is in sore need of being taken in tow.

Fourteen miles from the city the river loses itself in the bay. And about here the passengers who have been on deck eagerly observing tramp steamers, schooners, bugeyes and other harbor craft realize that evening has stolen on them unawares, and that darkness is fast blotting out the distant shores. But inside the boat there is plenty of light and activity, and downstairs in the dining room a hot chicken supper awaits appetites sharpened by salt sea breezes. (Oliver Martin, *The Chesapeake and Potomac Country* [C&P Telephone Company, 1928])

THE JONES FALLS

A fast-flowing stream that cuts down from the north through the heart of Baltimore, the Jones Falls played a dramatic role in the development of the city and its harbor. Before electricity, mills upstream from the harbor used its flow to make sailcloth and other textiles. Normally peaceful, at times of extreme rainfall the stream carries mud, debris, and dead trees into the harbor.

In the early 1800s, the swampy, mosquito-ridden mouth of this stream separated the original Baltimore Town from Fells Point, its newly acquired appendage to the east. Travelers from Fells Point needed to go north to what is now Lombard Street to cross the Falls. Within a few decades the marshy banks had been filled and a drawbridge built at Block Street on the original Fells Point "hook," as shown on the 1869 Sachse map on page 148.

As the twenty-first century opened, the entire area east of the Jones Falls outlet was undergoing rebirth as "Harbor East," crowned by the largest, tallest, and perhaps most controversial hotel ever built in Baltimore. The twenty-acre, half-billion-dollar mixed-use waterfront development extends from Pier Five Hotel in the Inner Harbor to Central Avenue on the west side of Fells Point. The financing comes from bakery magnate John Paterakis through his H&S Properties

Development Corporation, working in partnership with Struever Brothers, Eccles and Rouse.

The buildings were put in place one by one, with the ultimate goal of three million square feet of office and retail space as well as 400 residential units, three hotels, and 3,300 parking spaces. Paterakis's proposal for a 750-room, 44-story waterfront hotel exploded onto the scene in 1997, when the city was seeking a hotel to serve the Convention Center. Mayor Schmoke championed the plan, and the City Council agreed to overturn an established 180-foot height limit to achieve it. The Baltimore *Sun*, which had earlier railed against the mayor's support of the hotel, reported in May 2004 that the place had become a booming success—not in serving the Convention Center, as it supposedly was built to do, but in hosting smaller conventions on its own, offering the convenience and economy of having hotel and meeting rooms all in one building. During the hotel's first three years, the Baltimore Area Convention and Visitors Association booked 110 groups into the Marriott rather than the publicly owned Convention Center, and BACVA's new president, Leslie R. Doggett, was philosophical. "It's a win for the city because it's filling rooms; in the long run it raises the appeal of the destination," she told the *Sun*.

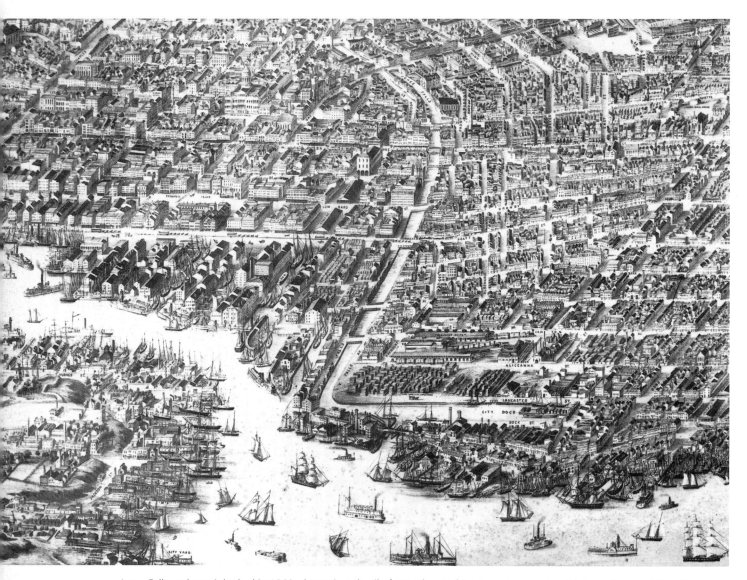

Jones Falls outlet as it looked in 1869, shown in a detail of E. Sachse and Company's sweeping "birds-eye" view of the city. Maryland Historical Society

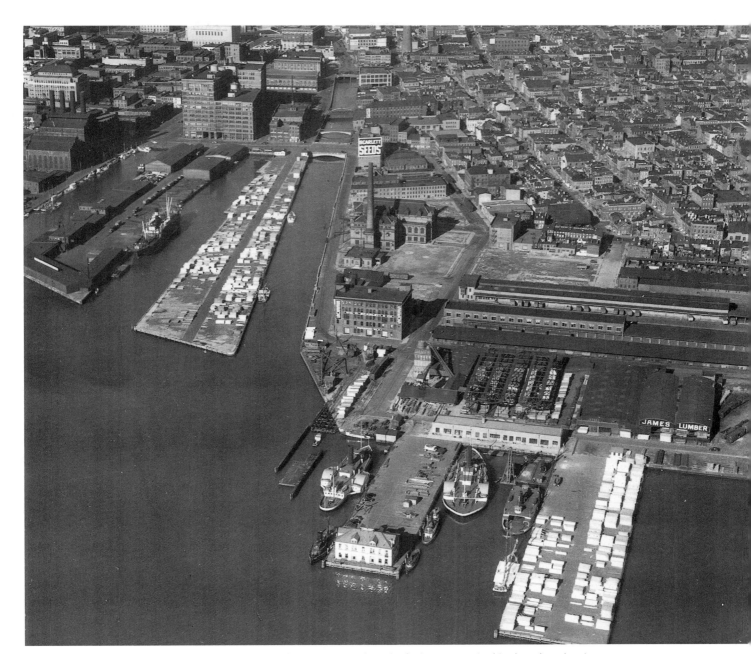

Jones Falls outlet in 1950. Marked changes had occurred since 1869, and much of what appears in this photo has also since vanished. The icebreakers *Annapolis* (*left*) and *F. C. Latrobe* (*center*) and the ferry *Howard W. Jackson* (*right*), looking like bugs at their piers, have been scrapped. The large, gabled firehouse at the end of the left pier in the foreground burned May 16, 1980. A pleasure boat marina replaced the pier on the right. Maryland Historical Society

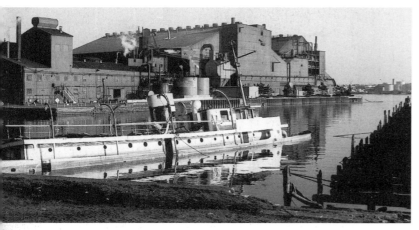

Allied Chemical's Fells Point chrome plant dominated the entrance to the Inner Harbor until its demolition in the late 1980s. The sunken yacht in foreground is the 50-year-old *Felicia*, once owned by the Association of Maryland Pilots. Its steel hull flooded and sank during the harsh winter of 1981-82. Photo by author

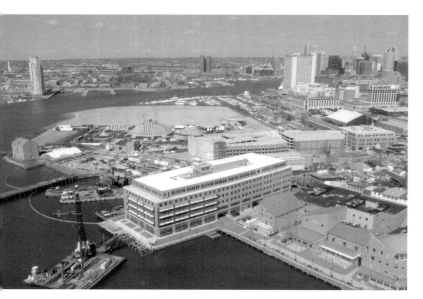

The cleared Allied Chemical site as it looked in 2003, before Struever Brothers and H&S Properties began the conversion to parkland, offices, and other nonresidential uses. The old warehouse on Chase's Wharf stands on the far left, the barren site of the chrome plant occupies the center, and the emerging Harbor East project looms at the upper right. The new Bond Street Wharf juts past the seawall at lower right. The striped tents belonged to Cirque de Soleil, which was performing on the area east of the remediation cap. Struever Brothers and H&S Properties

Harbor East's structure, scaled back to 32 stories and called the Baltimore Marriott Waterfront Hotel, opened February 15, 2001. A second, lower-end hotel called the Courtyard Marriott, was in place by 2002, and a third, a $130 million Four Seasons hotel and residence project described as an "urban resort," is expected to open in 2006.

Although other aspects of Harbor East have been controversial, no one objected to a sculptural feature of the plan—the Katyn Memorial, a 44-foot work of art resembling a flame, honoring more than 20,000 Polish military officers massacred by the Red Army in 1940.

THE CHROME WORKS

Just south of Harbor East, across a small canal, lies the choice—but environmentally daunting—27-acre waterfront tract freed up in 1985 by the closing of the Allied Chemical chrome plant. This single site produced 70 percent of Maryland's hazardous wastes. Under federal and state supervision, Allied carried out a $100 million "remediation," clearing the site and entombing and capping the carcinogenic chrome residues. The site passed into the hands of Honeywell Corporation in 1999, but it continued to lie barren, pending completion and testing of the remediation measures.

The Allied chrome plant occupied the hook of land of William Fell's original purchase, making it the "point" of Fells Point. To the east on Philpot Street, within the site but just off the remediation cap, once

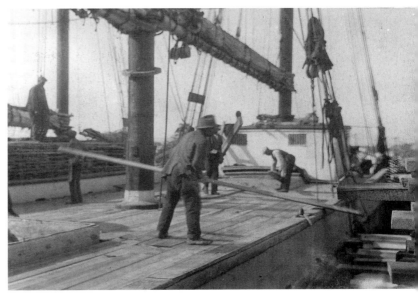

Offloading lumber in Baltimore in about 1930. Lumber has long been a major business in Fells Point. In the schooner days, it was unloaded by hand, board by board. Vessels lay at dock many days while their cargoes were transferred. Maryland Historical Society

stood a string of nineteenth-century brick buildings, including Grafflin Bag and the Lacey Foundry, all lost in recent years to fire or demolition by would-be developers in the name of progress.

The chrome operation went back more than a century and a half. In 1845 a Quaker geologist, Isaac Tyson Jr., established the Baltimore Chrome Works on the north side of the hook, using local chromite ore from around the area—Bare Hills just north of Mount Washington, Soldiers Delight near Owings Mills, and several mines near Jarrettsville.

For more than a decade Tyson controlled the world chrome market. Then high-grade ore was found abroad, destroying his monopoly and forcing him to import. Mutual Chemical of New York took over the plant in 1908; they enlarged it several times to keep up with the expanding uses of chromium, including steel production. It became the largest multipurpose chrome plant in the world, employing 400 persons. The plant produced chrome chemicals responsible for the yellow of a Yellow Cab, the green of pressure-treated lumber, the shiny silver of an auto bumper. Other familiar uses include solar heat panels and video tape. The Allied Chemical and Dye Corporation acquired the plant in 1954 and operated it for three decades, finally succumbing to foreign competition.

In 1993, Struever Brothers assisted Allied Chemical in obtaining rights from the city for future development of the property and subsequently teamed up with H&S Properties to manage and finance the development. Honeywell Corporation agreed to honor

these arrangements when it became owner of the site, but stipulated that there would be no residential use. In 2002, Struever Brothers, working with H&S, announced plans for a $250 million development, initially called Harbor Point. Honeywell would remain owner of the land and be responsible for any environmental issues. "Total build out could include a signature waterfront public building, office space, retail stores, restaurants, at least 2,000 parking spaces, and a six-acre waterfront park," according to a promotional leaflet. Plans were afoot in 2004 for construction of the first office building, on the waterfront next to Living Classrooms Foundation's Maritime Park.

NEW MUSEUM HONORS BLACK AMERICANS' FREEDOM

In the early nineteenth century, before the coming of the chrome operations, the Fells Point hook provided the sad scene of slave transportation to the lower South. Mostly moving at night, the notorious slave trader Austin Woolfolk and other slave mer-

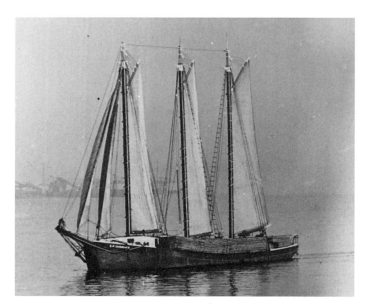

The ram *B. P. Gravenor* passes Sparrows Point with a load of lumber. Rams were bulky, straight-sided schooners, most of them built at Sharptown, Maryland, or Bethel, Delaware, both on the Eastern Shore, with dimensions that allowed passage through canals at either end of the bay. Enoch Pratt Free Library

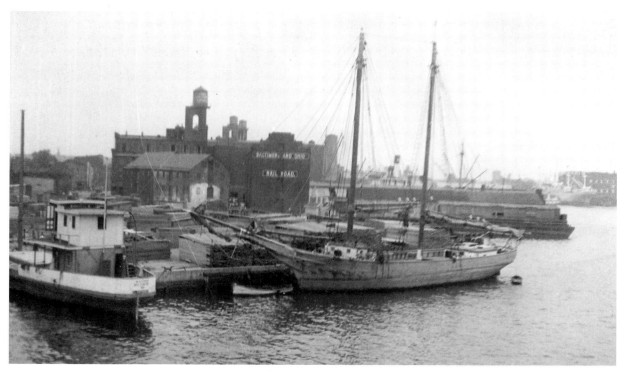

The B&O's terminal at Chase's Wharf, which received lumber into the 1940s. The barge at left, the *B. S. Ford,* once served as a passenger steamer. Converted, it brought lumber to Baltimore from the Carolinas. The schooner is the *Charles G. Joyce,* built in Baltimore in 1882. Maryland Historical Society

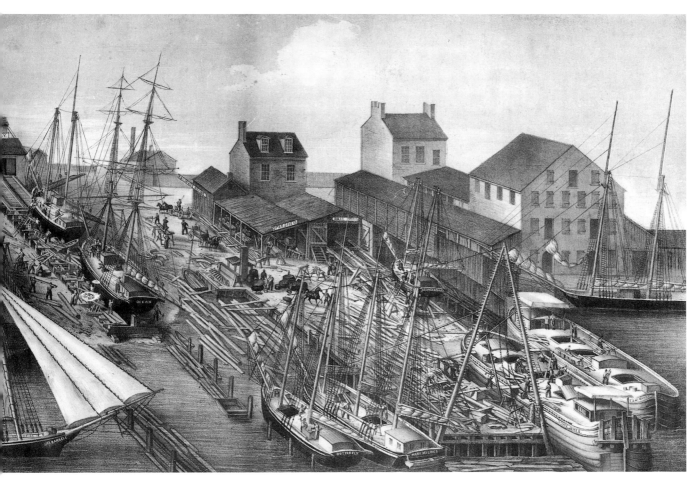

The site of this marine railway, which African Americans operated between 1866 and 1884, lies around the bend from the chrome works, just before Chase's Wharf. Peale Museum

chants marched their human cargo—men in chains, their wives and children following along—from imprisonment in holding pens on the west side, across Pratt Street, down West Falls Street, over the then-existing Block Street drawbridge, south to Philpot and then to the docks. From there the captives were rowed to ships waiting at anchor to carry them to New Orleans and other Deep South ports. The abolitionist Frederick Douglass wrote of his experience living on Philpot as a young slave in the 1820s, "I have often been aroused by the dead heavy footsteps, and the piteous cries of the chained gangs that passed our doors."

Successors to Woolfolk used horse-drawn omnibuses to lessen the odium, but from 1808, when the

Constitution banned the further importation of slaves from abroad, to the outbreak of the Civil War, Maryland slaves were thus "sold South." The growing southern cotton industry needed more labor; after turning from tobacco to corn and grain, Maryland and Virginia growers had an excess of enslaved mouths to feed.

Slave dealers like Woolfolk thrived. They purchased and transported an estimated 500,000 to 1,000,000 people to southern markets during the decades before the Civil War. Family members could be auctioned off separately after their arrival, never to see each other again. In addition to maintaining their holding pens for slaves on the way to market, Baltimore's slave merchants, for 25 cents a day, would

Frederick Douglass

board slaves temporarily—dog kennel style—for owners traveling through Baltimore or going away on vacation.

In 1826, after five days at sea, thirty-one of Woolfolk's Baltimore slaves, being transported to New Orleans aboard the vessel *Decatur*, threw the captain and a navigator overboard and took over the ship. Lacking naval or navigational skills, they were seized by the crews of two other ships. The whaling ship *Constitution* delivered seventeen of the captives to Boston, and no record has been found of their fate. Fourteen others arrived in New York aboard the *Rooke* and managed to escape into the city. Police there recaptured one and tried and executed him for the murder of the captain (see Ralph Clayton, *Cash for Blood: The Baltimore to New Orleans Slave Trade* [Bowie, Md.: Heritage Books, 2000], pp. 71-74).

In 2003, Baltimore's Living Classrooms Foundation broke ground for the nation's first museum of black maritime history, at the east end of the Allied Chemical site. Comprising a marine railway, renovated warehouse, and educational center, it commemorates two of Baltimore's most prominent African Americans of the nineteenth century, Frederick Douglass and Isaac Myers.

Frederick Douglass, born a slave in Talbot County in about 1817, landed at Fells Point in 1826. His master expected him to train as a caulker of ships, but he learned to read and eventually escaped to freedom, disguised as a white man on board a Philadelphia, Wilmington, and Baltimore train heading north. He soon published his life story and thereafter gained national and world attention as a spokesman for the abolition of slavery. Among many callings, he was an adviser to President Lincoln and served President Benjamin Harrison as minister to Haiti.

Isaac Myers, born in Baltimore in 1835, the only son of free-born black parents, attended a private day school, and, like Douglass, learned to caulk ships. He also learned the ins and outs of the industry and the constant rivalry between black and white workers over jobs. In 1868 Myers participated in the founding of the black-owned Chesapeake Marine Railway and Dry Dock Company, which operated for sixteen years on Philpot Street, just west of the new Maritime Park, and employed white labor as well as black. He devoted himself to African-American labor causes, serving as first president of the Colored National Labor Union.

Douglass and Myers, one born slave and one born free, epitomize the ironies of being a black person in Baltimore in the 1800s. By the time of the Civil War, even though Maryland as a whole had more enslaved than free blacks, in Baltimore free blacks outnumbered slaves ten to one. Blacks dominated the cargo handling trade on the waterfront. But until emanci-

Isaac Myers

pation, free blacks could never feel totally secure. They knew the risk of being kidnaped and sold south; they often kept certificates of freedom concealed in their clothing in case proof was needed.

Douglass's eloquence in his writings and oratory made him a major figure in the antebellum abolitionist movement. The hypocrisy of the slaveholder supplied a leading theme in his *Narrative of the Life of Frederick Douglass,* which first appeared in 1845 and went through several editions:

I assert most unhesitatingly, that the religion of the south is a mere covering for the most horrid crimes,—a justifier of the most appaling barbarity—a sanctifier of the most hateful frauds,—and a dark shelter under which the darkest, foulest, grossest, and most infernal deeds of slaveholders find the strongest protection. . . . of all slaveholders with whom I have ever met, religious slaveholders are the worst. I have ever found them the meanest and basest, the most cruel and cowardly, of all others. It was my unhappy lot not only to belong to a religious slaveholder, but to live in a community of such religionists.

His lyrical call for freedom, inspired by boats under sail on the Chesapeake, appeared in the same memoir:

Our house stood within a few rods of the Chesapeake Bay, whose broad bosom was ever white with sails from every quarter of the habitable globe. Those beautiful vessels, robed in purest white, so delightful to the eye of freemen, were to me so many shrouded ghosts, to terrify and torment me with thoughts of my wretched condition. . . . My thoughts would compel utterance, and there with no audience but the Almighty, I would pour out my soul's complaint. . . . You are loosed from your moorings, and are free; I am fast in my chains, and am a slave! You move merrily before the gentle gale, and I sadly before the bloody whip! You are freedom's swift-winged angels, that fly round the world; I am confined in bands of iron! O that I were free! O that I could also go! . . . God, deliver me! Let me be free! Is there any God? Why am I a slave? I will run away.

Evil will always be with us, but the law can address evil. When Frederick Douglass was born, the evil of slavery was condoned and protected by the law. By the time he died, it was banned by law, and the dynamics of race relations in America were changed forever. Frederick Douglass played no small part in influencing that change.

Creating the education center at the Douglass-Myers Maritime Park necessitated painstaking renovation of a nearly two-hundred-year-old fire-ravaged warehouse on Chase's Wharf. There, in the 1800s, Capt. John Chase and his descendants operated a fleet of tea and coffee clippers, including the *Severn, White Wings, Josephine,* and *Good News.* After the Civil War,

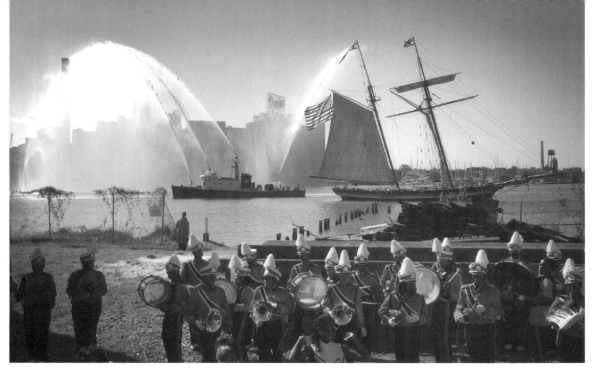

A city fireboat and the *Pride of Baltimore II* salute and the City College marching band prepares to perform at the ground-breaking for the nation's first museum of black maritime history on September 30, 2003. Baltimore *Sun*

the warehouse served Levering and Company, the largest coffee roaster south of New York. Eventually the building became a general warehouse for the B&O Railroad.

One block inland from the Maritime Park site, alongside a canal that once served the lumber trade, the Living Classrooms Foundation has established its 2.5-acre headquarters and East Harbor Campus. The foundation's headquarters building, the Weinberg Center, sits atop an overhanging steel structure where trucks once brought the city's garbage to be dumped onto waiting barges for transport to hog farms in the outer harbor. Living Classrooms teaches more-modern methods of recycling as part of good citizenship.

The foundation had its origins in 1985 with construction of the pungy schooner *Lady Maryland* by two teachers, Dennis O'Brien and Tom Shouldice, from McDonogh School in northwest Baltimore County. The Lady Maryland Foundation built programs around the vessel, using maritime-related activities, from navigation to carpentry, to enhance the outlook and skills of inner-city youth. One project in

1989 was rehabilitation of the century-old Sevenfoot Knoll Lighthouse, barged to Pier Five in the Inner Harbor. The foundation took on its current name in 1992 as it broadened its programs and geographic reach. It expanded its fleet of historic Chesapeake Bay vessel types to include the skipjacks *Minnie V.* and *Sigsby,* oyster buyboats *Mildred Bell* and *Half Shell,* and draketail *John Gregory.*

Impressed with the fundraising and organizational prowess of its president and CEO, James Piper Bond, and his staff, city leaders also entrusted the foundation with oversight of the museum ships *Constellation, Torsk, Chesapeake,* and *Taney.* In addition, Living Classrooms operates a paddle-boat concession in the Inner Harbor and managed the National Seaport tour program aboard a fleet of pontoon shuttle boats to help support its programs. The foundation suffered a tragic blow on March 6, 2004, when a fast-moving windstorm overturned the smallest of its pontoon vessels, the *Lady D,* off Fort McHenry, causing five passengers to lose their lives. The foundation's shuttle boat operations were discontinued in November 2004 (see p. 133).

FELLS POINT

Fells Point was Baltimore's deep-draft ocean port of the eighteenth and nineteenth centuries. This waterfront community was born in the age of sail, and her world-renowned shipyards helped bring that age to perfection. The ships and shipyards are gone now, but visitors to the square at the foot of Broadway still find an authentic maritime flavor. Tugboats whistle and wheeze from their base at Recreation Pier. The old Anchorage Hotel—the seaman's YMCA— saw service as a vinegar works in the 1950s and was subsequently reincarnated as the Admiral Fell Inn. A tale, perhaps apocryphal, is that Fells Point's last waterfront "shanghai" took place at the YMCA in 1948 when a local seaman went to sleep in his hotel bed and woke up on a Chinese freighter bound for the African coast.

Fells Point merchants display goods from around the world. Restaurants with such names as Bertha's, Waterfront Hotel, Admiral's Cup, and bars like the Cat's Eye, Dead End, Whistling Oyster, and The Horse You Came In On serve a diverse clientele. Ethnic meals—French, Japanese, Chinese, Egyptian, Latin American, Slavic, and Greek—can be found along the waterfront or within an easy walk. Produce and fast food stalls in the two buildings of the Broadway Market cater to the neighborhood and are not as pricey as those at Harborplace. When the water taxis

The Moran Company tugboats residing at Recreation Pier are used almost exclusively for the docking and undocking of ships coming in and out of the harbor. Here tugboat captain Samuel J. White directs the docking of a tanker at a ship repair yard in 1947. Put aboard by the tug company, the docking pilot gives signals from the ship's bridge by whistle, hand signals, or radio, and the tugs alongside acknowledge each command by repeating the signal. The number of tugs required to place a ship alongside its pier depends on the weather. Strong winds can necessitate several tugs before and aft, particularly if the ship is heavily loaded. Maryland Historical Society

Fells Point waterfront, about 1941. Robert F. Kniesche Collection, Maryland Historical Society

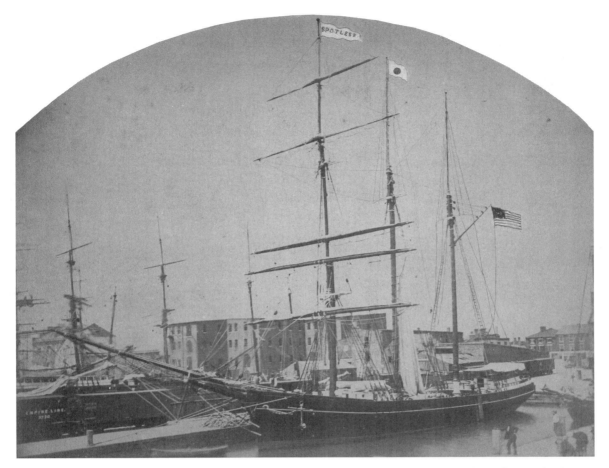

The bark *Spotless* docks at Jackson's Wharf at the foot of Bond Street in October 1878, a time when Fells Point dominated the nation's coffee market and the aroma of roasting coffee beans permeated the waterfront. The warehouse at nearby Chase's Wharf, in present times about to become the centerpiece of the Living Classrooms' Maritime Park, can be seen at the left, behind the tip of the bowsprit. At center is the Miller's Wharf "zig-zag" building, which was torn down by the Baltimore Gas and Electric Company's real estate subsidiary in the 1990s, over fierce neighborhood opposition. On July 1, 2004, developers Struever Brothers, Eccles and Rouse treated the community to a party on this site, dedicating a large park to be called Bond Street Landing. Collection of Robert Marks

began serving Fells Point in 1990, shoppers found bargains that helped make up for the cost of the boat ride.

Fells Pointers have always felt somewhat detached from the rest of Baltimore. In the early days, when Fells Point and Baltimore Town were negotiating amalgamation, they sought—and won—an assurance that their taxes would not be used to dredge the downtown harbor. Some locals still sense that Baltimore has the best side of the deal financially. "Fells Point does not really consider itself a part of Baltimore," marine artifact merchant Stevens Bunker

wrote in 1991. "Baltimore is considered to be like a boorish or dull-witted relative."

Fells Point's independent spirit was demonstrated in the late 1960s when the state and city teamed up to ram an expressway through the community, a plan which would have gutted its historic core. Barbara Mikulski, now a U.S. senator, was among the local activists who stopped the road. "The British couldn't take Fells Point, the termites couldn't take Fells Point, and . . . the State Roads Commission can't take Fells Point," she correctly proclaimed.

William Fell, an English carpenter and shipwright,

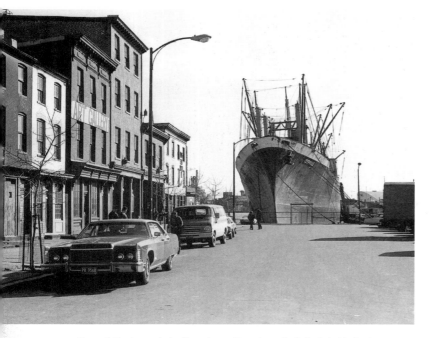

One of the joys of strolling down Broadway in Fells Point is that you never know who, or what, you will find—filmmaker John Waters manning a flea market table, actress Michael Michelle asking permission to pet your dog, No. 1 boxer Mohammed Ali sitting at the counter in Jimmy's restaurant. This freighter showed up at the foot of Broadway in 1975, catching the attention of photographer C. H. Echols.

Stevens Dana Bunker, proprietor of the North Atlantic and Orient Trading Company, outside his Fells Point marine artifacts store in 1982. Captain Bunker moved to Maine in 1999 and the Ann Street Wharf store became a French patisserie. Photo by author

purchased over 1,000 acres of land here between 1730 and 1745. His son, Edward, laid off the town of Fells Point in 1763, giving it the English street names found today: Thames (pronounced as it is spelled), Lancaster, Bond, Fleet, Shakespeare, and such colorfully named alleys as Strawberry, Apple, Happy, and Petticoat.

Waterfront lots were snapped up quickly for development of wharves, warehouses, and shipyards. Access to tracts of white oak, locust, and red cedar made Fells Point a natural center for shipbuilding. Deep water made it a terminus for maritime commerce. The community was annexed to Baltimore Town in 1773, about five years after the latter had replaced Joppa, Maryland, as the seat of Baltimore County. Fells Point grew rapidly over the next several decades. Saloons and dance halls sprang up, and prostitutes frequented the hook of land at the west end of the community, a circumstance to which some historians attribute the origin of the term *hooker*.

This hook was the "Point" of Fells Point and was the site of the chrome works and several shipyards and other industries. To the east, Chase's Wharf, Jackson's Wharf, Brown's Wharf, Belt's Wharf, and Henderson's Wharf had their heyday in the 1800s, thriving on the flour, coffee, and tobacco trades. Full-rigged large sailing ships carried bags of Maryland flour to Rio de Janeiro, returning with bags of coffee for Baltimore merchants, who distributed it by rail, riverboat, and covered wagon to an expanding nation. The Fells Point waterfront was "permeated by the pleasant aroma of roasting coffee," an old-timer wrote.

The coffee trades shifted to New York in the early

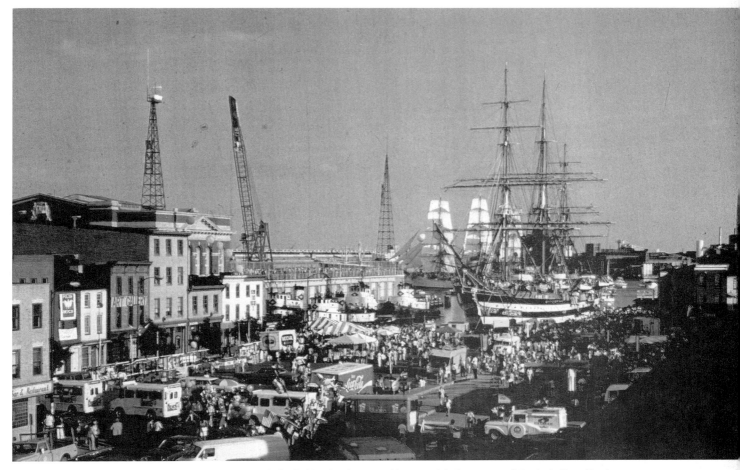

The foot of Broadway explodes into life with the arrival of tall ships for the 1976 bicentennial. The owner of Bertha's, Tony Norris, caught this view from the roof of his restaurant.

1900s. Belt's remained a busy warehouse until developers took it over in 1987. Chase's and Henderson's Wharves served the B&O railroad, Jackson's served the Pennsylvania, and Brown's, built in 1822, was used by the Western Maryland. As at Canton and the base of Federal Hill, canneries sprang up among the docks, shipyards, and warehouses to handle incoming produce.

Loss of the coffee trade, and the introduction of larger ships requiring deeper water and longer piers, signaled the doom of Fells Point as a commercial port. The last coffee clipper unloaded at Brown's Wharf in 1890. Prior to World War II, lumber schooners stopped bringing their loads to Lancaster Street yards, giving way to trucks.

During the 1930s, intercoastal freight services operated out of Fells Point, Lykes Lines using Henderson's Wharf and Southern Pacific Steamship Lines using Jackson's Wharf. This activity also ended with the outbreak of World War II, when the Federal Maritime Commission took over the vessels. By the late 1980s, most of the old brick warehouses had either been demolished or undergone a facelift, and the shoreline was springing back to life, with shops, restaurants, apartments, and condos replacing the departed commercial firms.

Bond Street Wharf. Struever Brothers, Eccles and Rouse

BOND STREET WHARF

This 2002 building is hard to miss. Its identity is proclaimed by the largest name sign in the city of Baltimore, if not the world, painted on the brick. The size and shape of the building almost exactly mimic the brick, steel, and wood-beamed Terminal Warehouse built on the site in 1906 by the Northern Central Railroad, soon after the invention of elevators enabled the construction of warehouses more than a few floors tall. The original building was demolished in 1992 by Constellation Properties, the real estate arm of the Baltimore Gas and Electric Company. The BGE affiliate had purchased the property for speculative waterfront development but decided, after testing the market, that the structure was not suited for new uses.

The demolition was one of two major BGE demolitions of historic Fells Point waterfront properties which were approved by Mayor Kurt L. Schmoke and his administration, despite his consultant's recom-

mendation that they be saved from the wreckers' ball. The other was the Miller's Wharf building a block west of the terminal building. The consultant, George Notter, urged retention of the buildings, in a $220,000 urban design plan commissioned by the mayor to address citizens' concerns.

Both buildings had been saved as part of a 1984 "memorandum of agreement" between the previous owner of the properties, Baltimore developer Michael Silver, and J. Rodney Little, the state's historic preservation officer. The combined effect of the destruction of historic buildings by Silver, BGE, and several big fires left the west side of Fells Point with few buildings to preserve. A practical case can often be made for razing a decaying old building within the Fells Point National Historic District, but the cumulative effect, preservationists point out, is to gradually erode the historic look of the neighborhood. Fells Point is one of the few old port communities in the nation that has been able to retain its character, and that can be

Alexander Brown came to Baltimore from Ireland in 1800 and founded what became one of the world's foremost investment houses, now an affiliate of Deutsche Banc. He built his fortune on imports and shipping, by 1825 operating a fleet of eleven vessels. His son George acquired the Brown's Wharf complex in 1840. A cautious man, Brown advised his sons, "Prudence and reflection are always more valuable than impulsive action." In business deals, he warned, "Get your money first." *Baltimore Biography*

attributed almost entirely to citizen intervention in development proposals. Filmmakers have frequently used the community's streets as locations for movies set in the 1800s, but they complain that this has become increasingly difficult to do as more and more modern features mar the streetscape.

BROWN'S WHARF

Located just east of Bond Street Wharf, this complex is a mix of new structures and warehouses that go back to the 1840s, when sons of respected entrepreneur Alex Brown used them to dry sails and store sugar, coffee, and the like for their shipping business.

The buildings now house offices and retail stores, and have two large spaces for waterfront restaurants. The $12.5 million development, applauded by the community for adhering to existing heights and massing, was a joint venture of Constellation Properties and Historical Developers of Pennsylvania.

CITY PIER

This splendid waterfront structure, with its 315 × 132 foot open-air deck and big sign with light bulbs spelling out "City Pier Broadway," has been the heart of the Fells Point community since its doors opened to the public on August 20, 1914. It is also commonly known as Recreation Pier. Mayor James Preston and the president of the Children's Playground Association were among the speakers at the pier's dedication.

The British steamship *Rosario* pulled alongside a month later to pick up a load of oats for France, and commercial and public users have shared the structure ever since. On the second floor, a large ballroom was used for dances, social events, and volleyball. The adjoining open deck had swings and courts for basketball and tennis. Other activities included clay sculpture classes, aerobics classes, guitar lessons, and table tennis. On the lower floor, ships tied alongside, the most controversial being the German light cruiser *Emden,* which paid a ten-day visit in April 1936, flying swastikas from its forward and top masts. Anti-Nazi groups were outraged.

For many years the pier was the control center for the port. The Baltimore Maritime Exchange kept

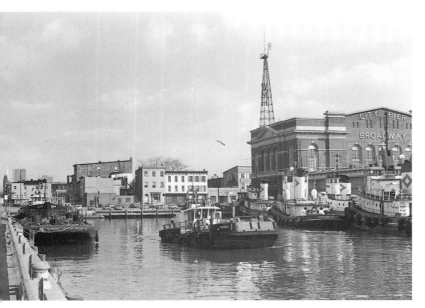

City Pier, 1981, with its venerated tugboats. Photo by author

Sketch of the newly opened Maritime Museum.
Chris White Design

track by radio of all ships entering and leaving the harbor, and the Association of Maryland Pilots kept its launch alongside. The Baker-Whitely and Curtis Bay towing companies also kept their tugs here. Moran Towing Company retained the pier as its base under long-term lease after taking over the Curtis Bay Company as a subsidiary in 1955, absorbing the company fully—and putting Moran's distinctive big "M" on the smokestacks of its boats—in 1988.

The City Pier gained national fame when for seven years it posed as police headquarters for the NBC television series *Homicide.* When that series went off the air, community leaders expected to get the building back for public use, as promised in a personal commitment by Housing Commissioner Daniel P. Henson III. Instead, because of structural deterioration in pilings under the southern half of the parking deck, the Housing Department offered it to developers, in hopes that a plan would emerge that would retain the tugboats and satisfy community wishes while relieving the city of an estimated $3 million in underwater repairs. Five proposals were received, from ferris wheel to hotel, offices, shops, and public use. With the neighborhood divided, Mayor O'Malley and his housing commissioner, Paul T. Graziano, settled the issue in December 2004 by designating local developer J. Joseph Clarke, in partnership with HRI Properties of New Orleans, to convert the property into a three-story European-style boutique hotel.

MARITIME MUSUEM AND
THE ROBERT LONG HOUSE

Across Thames Street from the Recreation Pier is the Maritime Museum, which the Maryland Historical Society opened in 2003 in a former trolley barn leased from the Preservation Society of Federal Hill and Fells Point. The new museum highlights Fells Point's role in the design and construction of the world's fastest sailing ships and is part of a complex that includes the Preservation Society's historic Robert Long House and a community visitors center.

HENDERSON'S WHARF

The massive six-story brick structure at the end of Fell Street, east of Recreation Pier, is the old Baltimore and Ohio warehouse, built in 1898 to accommodate the railroad's tobacco trade. Since 1991 it has beckoned the public with 142 residences (all but 12 of them rental units), a 38-room inn, and a 250-slip marina. There was to be a swimming pool as well, but as it turned out, the original investors were the ones who took a bath. After the Gaylord Brooks Investment Company defaulted on a loan, Carley Capital Group was picked in 1983 to move forward with the renovation. Carley renegotiated its deal with the city after a multialarm fire gutted the building in June 1984.

The wharf's history goes back to long before the construction of the warehouse. It was Fells Point's receiving place for European immigrants in the days of sailing ships. After the Civil War, B&O president John W. Garrett based a shipping line here, using three small wood-hulled steamers, the *Somerset, Carroll,* and *Worchester,* with sailing rigs to aid the screw propellers. The *Somerset* inaugurated the service on September 30, 1865, sailing to Liverpool with cotton, tobacco, corn, oilcake, and several passengers.

After three years, Garrett moved his shipping operations from Henderson's Wharf to his Locust Point piers, which could accommodate larger ships. He negotiated an agreement with the North German Lloyd Line to handle both freight and passengers on its iron-hulled steamers. (See p. 94.)

THE RAILROADS

The railroads did not run literally through the middle of anyone's house in Fells Point in the 1800s and 1900s, but they did run down the middle of many of the streets. The Philadelphia, Wilmington and Baltimore ran its main freight and passenger line through Boston and Fleet streets to reach President Street in 1838. Coming from the west side, the B&O immediately extended its Pratt Street line to President and Fleet in order to meet the PW&B and make a crosstown connection. And the Baltimore and Susquehanna (later the Northern Central) made a similar connection to the north by extending its service from Calvert Street to Fleet Street via Central Avenue. This convergence of services induced the PW&B to open its President Street Station in 1850; this classic structure served passengers until 1873. That year the PW&B and Northern Central shifted their passenger

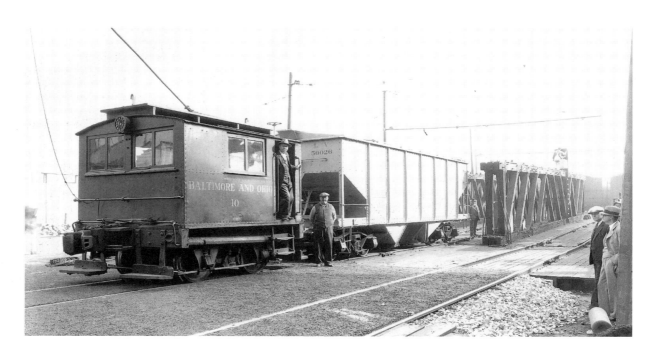

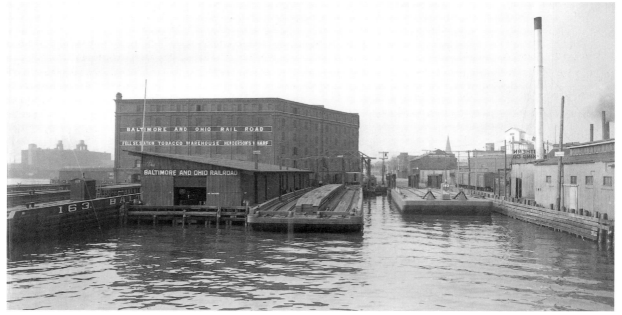

Electric motor car No. 10 (sometimes 150) (*top*) worked the Fells Point streets from 1910 to 1954. Here, in about 1932, it pulls a hopper car from a barge towed from Locust Point to the B&O carfloat terminal at the foot of Fell Street. The lower photo shows the terminal from the water, when Henderson's Wharf was a tobacco warehouse. The railcar carries cement for the Arundel-Brooks concrete plant on S. Wolfe Street. No. 10 survives as an exhibit in the B&O Museum on Pratt Street. B&O Railroad Museum Collection

operations north to the tunnels opened by the Pennsylvania Railroad, which soon took over both lines. Later, the Pennsy opened its giant freight terminal on Clinton Street (still standing as Pier 1), as its freight business expanded to roomier quarters in Canton. The B&O, meanwhile, made its Fells Point activities an adjunct to its expanding Locust Point operations, with a "carfloat" operation that barged railcars to and from Henderson's Wharf. This continued until 1969 when the terminal was condemned.

In addition to the main lines, Fells Point played host to what railroad historian Herbert H. Harwood Jr. called the "most obscure and oddest railroad" to be found anywhere. This was the switching operation for railcars reaching waterfront customers via Bond, Thames, Wolfe, and Fell streets. Steam and diesel locomotives brought the cars in and out on Fleet, Aliceanna, and Boston streets, but the tight turns on the other streets required alternate locomotion. For many years that was provided by Percheron horses, usually in teams of eight. Then came small electric trolleys, and finally, diesel tractors with huge rubber tires, until the final major customer, Allied Chemical, closed its plant in 1985.

THE SAILING SHIPS

Of all the sailing craft developed on Chesapeake Bay, none attracted more attention worldwide than the Baltimore pilot schooner, later popularly known as the "Baltimore clipper." These swift vessels emerged at the time of the American Revolution and played a

The ultimate clipper, the largest (143 feet) and one of the fastest and most beautiful sailing vessels ever built in the world, was the *Ann McKim,* launched at the Kennard and Williamson yard, Philpot and Point streets, on June 4, 1833. Baltimore merchant Isaac McKim spared no expense constructing this vessel, which carried flour around Cape Horn to Peru, returning with copper ore. She carried a "ship" rig, so was unique in her design, possibly influencing the larger "American clipper" that was to come a decade or two later. The *Ann McKim* had the one drawback common to the Baltimore clipper: inadequate cargo capacity for economical peacetime operation. Because of this handicap, the Baltimore clippers eventually gave way to larger ships.
Maryland Historical Society

decisive role in the War of 1812. Many of them came from Fells Point shipyards.

The Baltimore schooner was a relatively small boat, usually 75-100 feet on deck, lightly built and generously canvassed. Her sharp bow and V-shaped bottom allowed for maximal hull speed, while her tall masts and schooner sail rig enabled her to sail within about 60 degrees of the direction of the wind. Because of these features she could outdistance and outmaneuver most other vessels of her time.

The "American clipper" came along in the 1850s, spurred by the discovery of gold in California in 1848 and Australia in 1851. A primary requisite for these ships was the ability to carry cargo around the treacherous Cape Horn. Fourteen of these handsome clippers were built in Fells Point in the 1850s. *Flora Temple* was the largest, at 1,916 tons. Fastest was the *Mary Whitridge,* shown here, built by Hunt and Wagner, on Fells Street south of Thames, in 1855. Her first passage that year, from Cape Henry to the English Channel, 2,962 miles, made in 12 days and 7 hours, was never equaled by any sailing vessel. Maryland Historical Society

During the War of 1812, Baltimore schooners roamed the Atlantic and Caribbean as "privateers"—privately owned vessels armed and manned at their owners' expense for the purpose of capturing and destroying enemy merchant craft in time of war. By posting bond to assure adherence to rules and regulations, the ships obtained a government commission, called a letter of marque. The most famous of these vessels was the *Chasseur,* launched by the Thomas Kemp shipyard, at Washington and Aliceanna streets, December 12, 1812. "She sat as light and buoyant on the water as a graceful swan," wrote one admirer.

Chasseur captured eleven vessels on its first transatlantic voyage, under Capt. William Wade.

On the second major voyage, in 1814 under Capt. Thomas Boyle, it conducted an audacious single-ship "blockade" of the entire English coast, capturing fourteen merchant vessels and embarrassing the British Admiralty. A third expedition brought additional successes in the Caribbean as the war ended. *Chasseur* returned to Baltimore in 1815 in triumph, and was hailed as the "Pride of Baltimore."

When hard times fell after the War of 1812, Fells Point shipping interests found a new use for the Baltimore schooners and a new source of work for the shipyards: adaption of the vessels for use as slavers. The Congress of Vienna outlawed the international slave trade in 1816, and only the swiftest vessels could

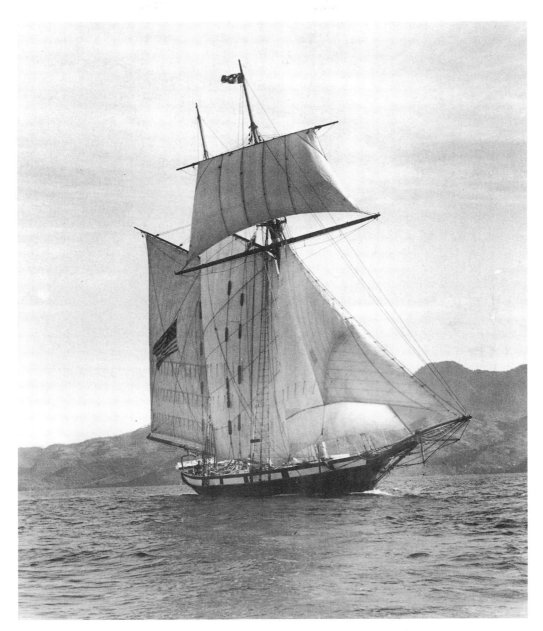

The first modern-day pilot schooner, named *Pride of Baltimore* after the nickname for the *Chasseur*, was built in the Inner Harbor and commissioned by the city in 1977 to serve as a goodwill ambassador and promoter of the port and city. The 90-foot vessel traveled more than 125,000 miles in her nine-year life, visiting ports from the Great Lakes to the West Coast, South America, and Europe. She was tragically lost in a sudden squall off Puerto Rico on May 14, 1986. Capt. Armin Elsaesser, who took this photo, and three other crew members perished. A successor ship, *Pride of Baltimore II,* was launched in 1988. Armin E. Elsaesser III

elude the British fleets posted off Africa to enforce the treaty. The Baltimore schooner was an ideal vessel for this sordid mission. Platforms were installed in the already cramped space below decks, and the human cargo were packed in "spoon fashion"; many died during the voyage. A historian wrote in 1941, "The decline of the Baltimore clipper and her gradual perversion to unworthy ends is perhaps the most melancholy chapter in all the history of Baltimore" (Hamilton Owens, *Baltimore on the Chesapeake,* Doubleday, Doran, Garden City, N.Y., 1941).

Letitia Stocket recalled the mood of the clipper ship days in her book, *Baltimore: A Not So Serious History* (Baltimore: Norman, Remington, 1928):

If in your imagination you will clear away the railroad terminals, the practical and no doubt excellent docks on Fells Point, you will be able to re-create the old Point as she was in those clipper days. Up the river, gliding as proudly as swans, came ships from China, from Cuba, from Peru. And ever new ships were upon the ways. There was a good reek of tar and paint and oakum. There was the clink of hammer on steel and the smell of shavings. There was a stir of activity, a constant coming and going, the arrival and departure of vessels. To see a ship make ready for a voyage is even today a thrilling sight. But to see a clipper ship get under way was a picture never to be forgotten. Everywhere on deck and in the rigging there was hurry and excitement, the creak of ropes and the rattle of chains. Voices shouted orders sprinkled liberally with sulphur and brimstone. But over and above the hubbub rose the voice of the chanty man, the leader of the songs, without which no clipper was complete. Often the chanty man was drunk but that made him troll the merrier:

"In eighteen hundred and forty-six I found myself in a hell of a fix"—and the *Shooting Star* is off to the Horn!

CANTON

Peter Cooper, exhibiting some of the seriousness that made him a leading investor and manufacturer of his day.

The fast-changing shoreline stretching from Harris Creek around to Lazaretto Point and then east to the Dundalk Marine Terminal is part of a section of Baltimore known as Canton. Canton traces its roots to Capt. John O'Donnell, member of a powerful Irish family, who made a celebrated arrival in Baltimore in 1785, bringing his ship *Pallas* directly from China. The cargo of teas, china, and silks and satins attracted the attention of George Washington, who dispatched his friend Col. Tench Tilghman to Baltimore with money and a list of purchases to be made, but only "if great bargains are to be had."

Captain O'Donnell decided to settle in Baltimore. By the time of his death in 1805 he had amassed an estate of 2,500 acres. He called it Canton, apparently in honor of the Chinese city whose goods contributed to his wealth. In 1829, his son Columbus, along with New York capitalist and inventor Peter Cooper and others, formed the Canton Company, with the object of bringing commercial development to the Canton estate and adjoining acreage. Essentially a real estate operation, the company was authorized to lay out streets and build wharves, factories, and houses, with the hope of capitalizing on the success of the Baltimore and Ohio Railroad. As it turned out, Canton became the Baltimore terminus of the Pennsylvania Railroad, and for about thirty years in the twentieth

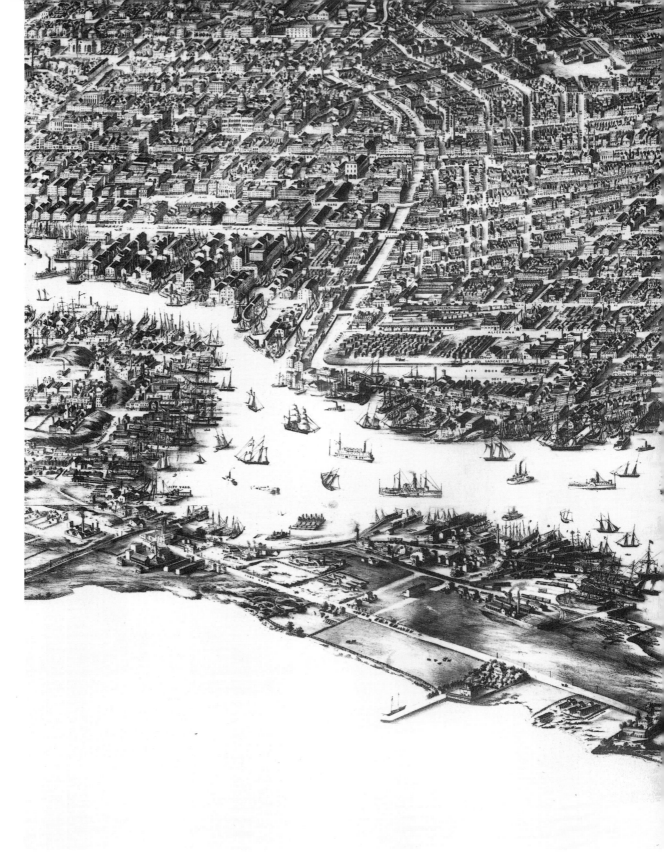

The vitality of the harbor in the nineteenth century is captured in this section of the 1869 Sachse lithographed map of Baltimore. The distinctively shaped Fort McHenry is at the tip of Locust Point in center foreground. Canton extended from Lazaretto Point, opposite the fort, up along the shoreline, around the bend toward the city. Continuing along the water's edge, the busy wharves

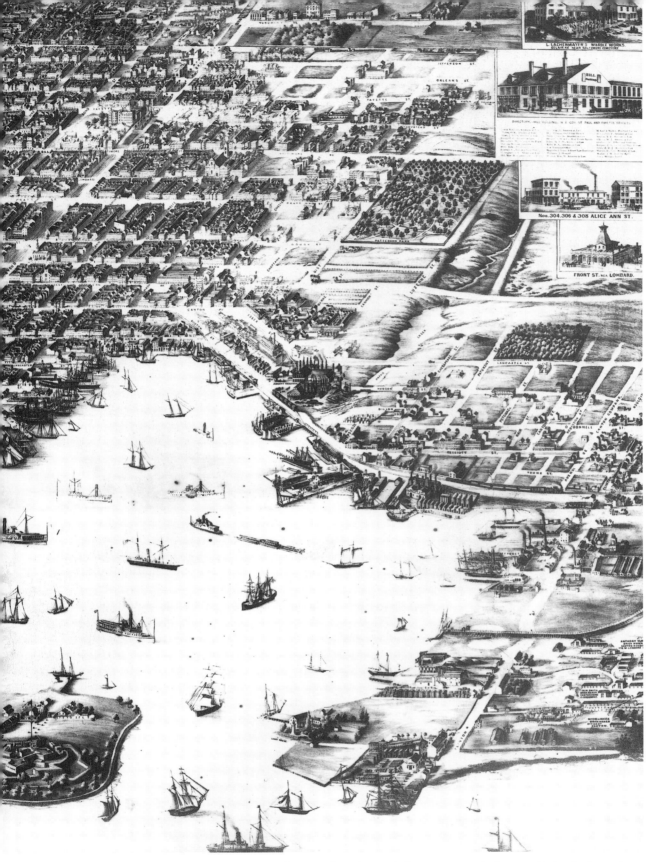

and shipyards of Fells Point are at center and the proliferation of warehouses below Pratt Street in the Inner Harbor basin can be seen at left. Intense activity is shown all along the near shore of the harbor as well, especially in the cluster of ocean-going passenger ships just left of center docked at the B&O Railroad piers on Locust Point. Maryland Historical Society

century the Canton Company was owned by that railroad.

Canton has been a source of many fortunes. The initial Canton Company stock became a fad on Wall Street—some thought it was in China—and, according to the Baltimore *Sun,* its early promoters were not averse to holding "rigged" land sales in order to "puff and inflate the price of the stock." Pennsylvania Railroad's holding company paid $15 million for the Canton Company in 1929, collected handsome dividends over the next three decades, then, in 1960, sold the company to International Mining Company, a New York–based conglomerate. The railroad kept substantial waterfront holdings for itself, including its general cargo and coal and grain piers.

Even with its holdings thus reduced to 184 acres, Canton Company continued to be the largest private marine terminal operator on the East Coast. For another two decades it carried on a range of activities at terminal facilities on the main river east of Lazaretto Point, where piers were equipped to handle ore, bananas, containers, vehicles, and general cargo. The Canton Railroad, a small road started by the company in 1906, connected the piers with industrial plants in northeast Baltimore.

In 1977, Pacific Holding Company purchased International Mining; Pacific was subsequently acquired by the Murdock Development Corporation of California, making Murdock owners of the Canton Company. In September 1980, the Murdock interests resold a portion of the Canton holdings, including the railroad, to Consolidation Coal Sales Company for the development of a major East Coast coal-loading terminal (see p. 188). The first coal trains arrived at the terminal in 1983—just as the bottom fell out of the world coal market. Meanwhile, the Canton Company, 150 years old in 1979, continued to operate some scattered holdings from the Murdock offices in Baltimore's World Trade Center. The Maryland Transportation Authority purchased the Canton Railroad as a subsidiary in order to exercise state control over rail service to its new Seagirt container terminal.

New York native Peter Cooper founded an iron works on the north side of Boston Street, using ore dug at Lazaretto Point. A man of many accomplishments, Cooper had built the *Tom Thumb* in 1829 to prove that a steam railroad engine could go around the short curves in the existing B&O line and that the railroad was therefore a viable operation with a promising future.

Cooper eventually sold his iron works to Horace Abbott, who, during the Civil War, took on the assignment of furnishing protective iron plates for the federal gunship *Monitor.* He completed the task ahead of schedule and in time for her to engage the *Merrimac* in Hampton Roads and save the wooden fleet of the U.S. Navy. The action opened a new era in naval architecture.

ON BOSTON STREET

Along the Canton waterfront, the new is superimposed and the old is seldom totally erased. The

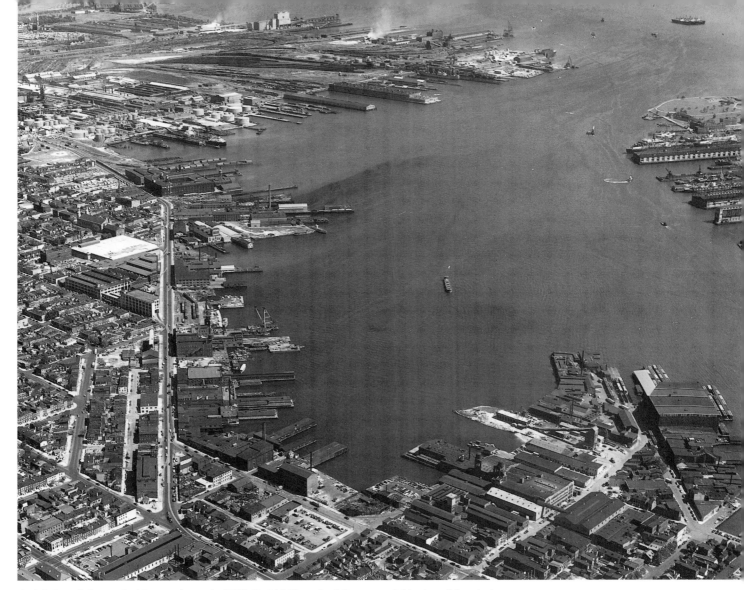

Aerial view of Canton looking southeast, in 1952. Fort McHenry is at the upper right edge of the photo.
Maryland Historical Society

remaining visible traces carry the observer far back into Baltimore, and American, history.

The 1952 aerial view printed here looks southeast along Boston Street, with Fell Street angling to the water at lower right. The photo shows Canton at the peak of its commercial and industrial activity. Many of the buildings shown here have since been leveled or recycled.

The section of Boston Street in the foreground was known as Canners Row. Many of the buildings here handled produce brought in by the sailing fleet: oysters from the bay, vegetables from the Eastern Shore,

pineapples from the Bahamas. Infill accommodated growth as Baltimore assumed its role as the world's leading canning center. In 1908 Cantonians uncovered a charred 130-foot clipper ship buried 400 feet inland from the current shoreline. It had burned at its pier.

Last century, the American Can Company built a large complex which manufactured cans on the triangular tract formerly occupied by the Abbot iron works. Today the site is home to The Can Company, a restaurant, retail, and office complex. The Can Company and neighboring Safeway market straddle

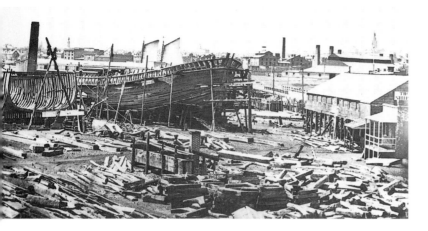

Top: First location of Booz Brothers shipyard, at Canton around 1875. In the steambox at center workers softened timbers. The mold loft at right was for laying down full-size patterns. Beyond the mold loft stands the old bridge over Harris Creek. The Booz yard moved to Federal Hill in 1879. Peale Museum

Bottom: A model "adaptive reuse" project. The Can Company, a 280,000-square-foot office-restaurant-retail complex, was opened in 1998 by Struever Brothers, Eccles and Rouse, using most of the former American Can Company buildings. On this site, across Boston Street from the present-day Shipyard apartments, Peter Cooper built his *Tom Thumb* railroad engine in 1829 and Horace Abbott later fabricated the protective iron plates for the Civil War gunship *Monitor*. Struever Brothers, Eccles and Rouse

the remains of Harris Creek, which enters the harbor by means of a concrete viaduct under Boston Street. On the bank of this creek in 1797, shipwright David Stodder turned out the U.S. Frigate *Constellation.* Inland from the mouth of the creek, the heart of the Canton community is marked by the twin towers of St. Casimir's Church on O'Donnell Street.

WATERFRONT REVIVAL

The 1980s saw the beginnings of a stunning transformation of Canners Row into Baltimore's "Gold Coast," a collection of upscale waterfront townhouses, condominiums, marinas, and gathering places for eating and drinking.

NORTH SHORE. Bowing to neighborhood pressure and a weakening market for office space, a Timonium developer moved ahead in 2002 with a residence-only project on a former cannery site just east of Fells Point. Twenty of the five dozen luxury townhouses were built out on a pier, with price tags in the $750,000 range.

THE ANCHORAGE. Just past North Shore is the pioneer housing development on Canners Row, the string of forty townhouses and a ninety-five-unit condominium tower built in the mid-1980s by business friends of then mayor William Donald Schaefer. One downside of the development is that the townhouses were allowed to block the magnificent waterfront view down Montford Street.

THE SHIPYARD. Across Harris Creek from the Anchorage Towers is one of the most acclaimed renovations on the waterfront. It consists of fifty-six apartments artfully fitted into a brick building constructed in 1874 as a chair factory. From 1913 to 1985 the building was occupied by Edward Renneburg and Sons, which fabricated steel plates and machinery for the

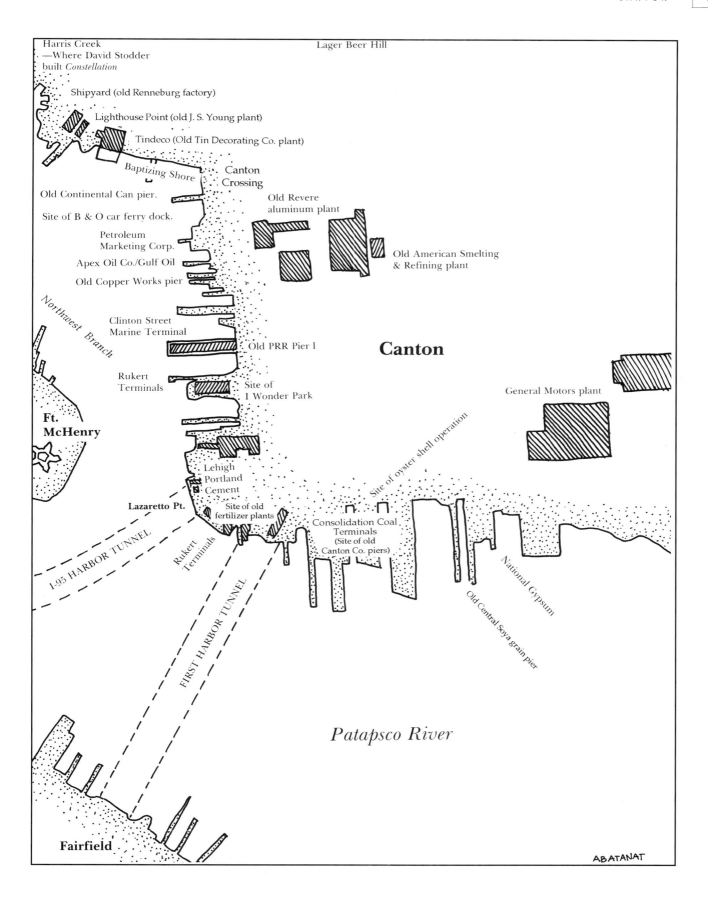

Harris Creek
—Where David Stodder
built *Constellation*

Lager Beer Hill

Shipyard (old Renneburg factory)

Lighthouse Point (old J. S. Young plant)

Tindeco (Old Tin Decorating Co. plant)

Baptizing Shore

Canton
Crossing

Old Revere
aluminum plant

Old Continental Can pier.

Site of B & O car ferry dock.

Petroleum
Marketing Corp.

Apex Oil Co./Gulf Oil

Old Copper Works pier

Old American Smelting
& Refining plant

Northwest Branch

Clinton Street
Marine Terminal

Old PRR Pier l

Canton

Rukert
Terminals

Site of
I Wonder Park

General Motors plant

**Ft.
McHenry**

Lehigh
Portland
Cement

Site of oyster shell operation

Lazaretto Pt.

Site of old
fertilizer plants

Consolidation Coal
Terminals
(Site of old
Canton Co. piers)

I-95 HARBOR TUNNEL

Rukert
Terminals

FIRST HARBOR TUNNEL

National Gypsum

Old Central Soya grain pier

Patapsco River

Fairfield

ABATANAT

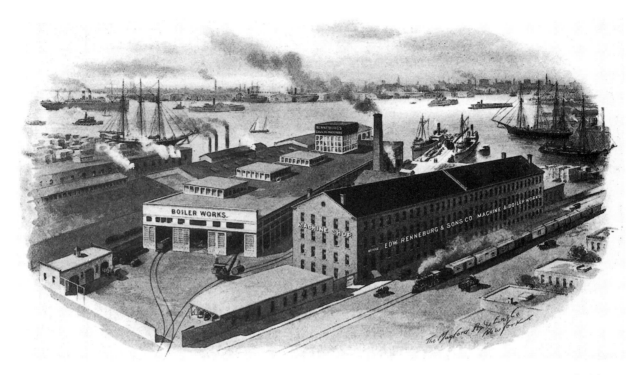

The Renneburg factory in the early 1900s. It was converted into the Shipyard Apartments in 1985. *Baltimore: Two Hundredth Anniversary*

local canning industry and the Chesapeake menhaden fishery. Like the Anchorage Towers, the building was built at the old Booz Shipyard site, hence the name for the new housing project.

LIGHTHOUSE POINT. East of the old Renneburg factory—now the Shipyard Apartments—were large buildings occupied by J. S. Young and Company, manufacturer of licorice (for flavoring tobacco), dyes, and tanning extracts. The factory was served by some of the last four-masted schooners on the bay, bringing logwood from the Caribbean to provide substances required in dye making.

The modern-day reincarnation of these sites is a marina–boat storage–restaurant–retail space–rental apartment–office conglomeration called Lighthouse Point. The old smokestack of the J. S. Young operations, shortened and topped with a beacon, simulates a lighthouse.

The owner and developer, Dr. Selvin Passen, caused a stir in 1997 when he proposed to put townhouses atop his existing boat storage building, called a "boatel," in which small pleasure boats are stacked atop one another on racks. The city Fire Department shot off a memo to Housing Commissioner Daniel P. Henson III opposing the housing plan. If a fire broke out inside the boatel and the sprinkler system failed, fire fighters could not get close enough to the flaming building to rescue the inhabitants, the memo warned. The results "would be catastrophic."

Henson issued a construction permit and sat on the memo, concealing it from the public for nineteen months while Passen took steps to improve the fire suppression system, including fireproofing of shields that would allow firemen greater access to the building. On March 15, 2000, Henson's successor, Patricia A. Payne, appointed by the O'Malley administration, blessed the improvements and sustained Henson's

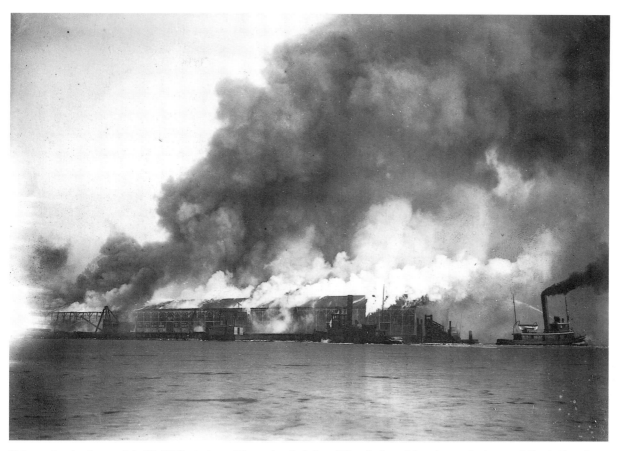

This spectacular fire, on July 17, 1932, destroyed Pennsylvania Railroad Piers 2, 3, and 4 and severely damaged Pier 1. The piers were rebuilt two years later. Maryland Historical Society

issuance of the permit. The resultant structure provides great waterfront views for eighty rental units, though architectural critics, never easy to satisfy, consider the view from the units much prettier than the view of them. In 2004, Passen introduced plans to relocate his controversial boat storage operation to a site on Clinton Street. The space freed at Lighthouse Point will be converted to parking, and the facades will get a facelift.

TINDECO. The large, solid building east of the old licorice plant, with its own power plant on the water, was the home, from 1918, of the Tin Decorating Company of Baltimore, one of the world's largest manufacturers of lithographed tin packages and boxes. It could produce five million colorful boxes a day. Production ended in 1965, as tin containers gave way to plastic ones. Reborn in 1986 as Tindeco Wharf, the building has become one of the city's most prestigious new residential addresses. It was the first waterfront project for local developers Struever Brothers, Eccles and Rouse. The former power plant became the Bay Café, which became a popular watering hole for young Baltimoreans.

In 1990, Struever Brothers revived and added three stories to the Continental Can building next door to Tindeco on the east side. Thus was born Canton Cove, with eighty-nine condominium units featuring balconies and large "window walls," many of them offering sweeping views of Fort McHenry and the outer harbor. The name chosen was a variation of Canton Hollow, the sailors' name for the sheltered

A European circus elephant is hoisted ashore at Pier 1 in June 1947. Maryland Historical Society

Canton Waterfront Park landscapers preserved this steel gantry, left over from the railroad days, when train cars were barged alongside visiting ships. The steel structure held hoists that raised and lowered the seaward ends of the tracks, so that they could meet the tracks of the car-float barges as the tides rose and fell. An intact pair of gantries, with tracks still hooked on, can be found across the harbor, west of the grain pier. Photo by author

waters out front, where commercial sailing ships once anchored awaiting berthage in Fells Point and the Inner Harbor basin.

CANTON WATERFRONT PARK. An old rail yard site east of the renovated Tindeco and Canton Cove buildings underwent dramatic transformation in the 1980s. As the decade opened, entrepreneur Edwin F. Hale Sr. owned it and leased it to the Norfolk, Baltimore and Carolina (NBC) shipping line, which used World War II landing ships to provide overnight container-shipping service to Philadelphia and Norfolk. As Hale tells it, Mayor William Donald Schaefer came along, seeking ways to restore life to Canton after the "road fight." Mayor Schaefer noticed that the site offered a beautiful view of Fort McHenry, and he arranged a city purchase so that the site could be turned into the park that pleases so many today.

CANTON CROSSING. The bend in the shoreline, where Boston Street intersects with Clinton Street, emerged in 2003 as a new demarcation point between community life in southeast Baltimore and the industrial waterfront. Ed Hale, the local developer who precipitated this eastward creep of public usage, is a man who straddles both worlds. In the 1980s he was lauded for his foresight in establishing a trucking company and a barge line that kept the containers coming to Baltimore when an ever-increasing number of ships carrying them stopped coming up Chesapeake Bay, stopping only at ports closer to the ocean. A decade later Hale had refashioned himself as a bank owner (1st Mariner) and assembler of waterfront real estate. His Canton Crossing plan includes offices, retail, condominiums, parking, and two hotels. The crowning use, in Hale's mind, would be a new cruise ship terminal, replacing the facility at Dundalk Terminal. He has offered to build one for lease to the state, at a cost likely to reach $50 million when homeland security measures are included.

◢ ◢ ◢

Canton Crossing is but one manifestation of the revival of Clinton Street in recent years. The old railroad piers and warehouses, largely abandoned when most shipping moved to new terminals in the outer harbor, have taken on a new life. The key to this revival, the Baltimore *Sun* reported in April 1998, was "the quiet growth of non-ILA [International Longshoremen's Association] companies that hire workers at half the cost or less paid by maritime operators who lease space at the state-owned marine terminals." Hale told the *Sun*, "You can sugarcoat it any way you want, but the freight is going to the cheapest spot." Another factor, of course, is that the state terminals do not handle bulk cargo.

Canton Crossing spreads across the former Exxon site, to which the oil giant brought its fuel, hauled up Chesapeake Bay in tankers, to be stored for local distribution. The practice ended soon after the catastrophic spill from the Exxon *Valdez* in Alaska. Exxon moved its distribution operations to Fairfield, where it could utilize the Colonial Pipeline, ending any risk of a similar maritime disaster for the company on Chesapeake Bay. Another petroleum company, Apex,

John Williams laid out this half-acre park across from his Clinton Street tavern in 1901. It became known as I Wonder Park and was popular with dock workers. Williams used goats to maintain the park and someone donated six mulberry trees. The Maritime Commission built an office and warehouse on the grounds in 1941, and I Wonder Park was no more. The site was at 2100 South Clinton Street. The little cars of the Conrail coal-loading pier can be seen in the background. Robert F. Kniesche Collection, Maryland Historical Society

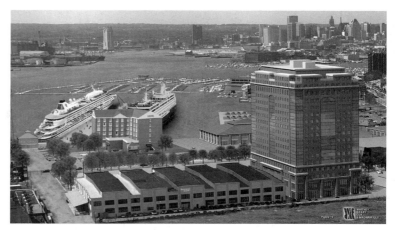

This architect's rendering shows how Canton Crossing would look as a cruise terminal. Whitney, Bailey, Cox and Magnani

with storage tanks just south of the Exxon site, has continued to bring its products to Clinton Street by ship after the Exxon operation there closed.

The Exxon facility traced its beginnings to 1868 when the Canton Oil Works was established on the site to refine crude oil from Pennsylvania into fuel oils, grease, and wax. The lighter materials, naphtha and gasoline, were considered waste at the time, and were drained into ponds and burned. Initially the oil was brought in by cattle car in barrels, but in 1883 a pipeline was opened from the Pennsylvania fields; this was eventually extended to Oklahoma.

The refinery, then called Baltimore United Oil Company, was purchased by Standard Oil in 1892. The wharves were a colorful sight in the early 1900s. Three magnificent oil sailers—steel-hulled four-masted barques—were chartered by Standard Oil to carry oil and kerosene from Canton to the Far East, returning with tea or manganese ore. The *Daylight* (3,756 tons) and the *Arrow* and *Eclipse* (3,090 tons each) gave way to steamers at the beginning of World War I.

In 1913, with the opening of the Panama Canal, crude oil was brought to Baltimore by water from California and Mexico. The pipeline from Pennsylvania was discontinued in 1925, and in 1957 the refinery itself was closed. The facility was changed to a storage and distribution center exclusively.

Canton Crossing and the oil docks mask two unrelated early uses of this shoreline. The old Canton Race Track, at Clinton and Boston streets, was the site of the 1840 Whig Convention, at which Henry Clay

orated and William Henry Harrison was nominated for the presidency. And the foot of Cardiff Avenue was the site of Baltimore's first public bathing beach, opened in 1893 when workers' homes had no running water for baths. The area became known as "baptizing shore" when several Baptist churches used it for Sunday afternoon ceremonies.

As demand grew for copper-based paints to protect ship bottoms from saltwater worms and barnacles, the Baltimore Copper Smelting Company was established on Clinton Street in 1850. Within a decade it became the largest smelting operation of its kind in the United States, importing ore from Chile and Cuba and contributing to the wealth of Baltimore's two most famous childless entrepreneurs, Johns Hopkins and Enoch Pratt, whose philanthropy ultimately provided the city with a university, a hospital, a medical school, and a system of free public libraries.

The successor to this nineteenth-century operation, American Smelting and Refining Company, closed its doors in 1975 and moved to Texas, idling a large physical plant one block inland from the waterfront and adding to the desolation created when Revere Aluminum closed its plant just to the north in

U.S. Naval Ship *Denebola,* a former Sea-Land vessel, docks in readiness at Pier 1, Canton in 2003. Photo by author

1967. One reason for American Smelting's move was the prohibitive cost of bringing the old plant into compliance with modern standards for its discharges into the Patapsco River. The name of Cardiff Avenue remains a reminder of the skilled Welsh copper workers employed there in the early days.

THE RAILROADS

Clinton Street played a major role in the competition among the railroads for port traffic. At the time of the Civil War, the B&O monopolized rail transportation between Washington, D.C., and Baltimore. The Baltimore end terminated at Camden Station, on the west side. Riders to or from the north had to make a cumbersome cross-town connection at the President Street station of the Philadelphia, Wilmington and Baltimore Railroad (predecessor of the Pennsylvania Railroad) on the east side.

The dynamics changed in the 1870s with the com-

pletion of two cross-town tunnels. On the east side, the Canton Company built the Hoffman Street tunnel to improve rail service to its piers. On the west side, Pennsylvania Railroad interests built the Baltimore and Potomac tunnel under Wilson Street, ostensibly as a route to southern Maryland but with a "spur" to Washington that enabled the Pennsy to outflank B&O and break its monopoly. By running trains through the two new tunnels, the Pennsylvania affiliates inaugurated through passenger service from New York and Philadelphia to Washington, in June 1873. The same tunnels, antiquated and beset by cracks and leaks, are used by Amtrak today.

In 1886, the B&O extended its own service to Philadelphia by way of Canton, using the ferries *John W. Garrett* and *Canton* to transport whole trains across from its Locust Point rail yards. A nearly obliterated pier one block south of Cardiff Street marks the terminus of the B&O ferry service. The ferries were B&O's only north-south link until 1895, when the railroad completed the present-day Howard Street tunnel connecting Camden Station with the station at Mount Royal to the north, which connected in turn with the line to Philadelphia. Passenger service on this line was discontinued in the late 1950s and the unneeded Mount Royal station was turned over to the Maryland Institute for use as an art school. Freight trains continue to use the tunnel, as the city was reminded in 2001 when one of them caught fire while in passage. Smoke billowed out both ends, disrupting cross-town traffic for days.

South of the site of B&O's old ferry docks on Clin-

Cranes frame the downtown skyline as Rukert workers stack aluminum ingots brought by ship from Russia. The terminal is across the river from Fort McHenry. Maryland Port Administration

ton Street is the old Pier 1 terminus of the Pennsylvania Railroad's Baltimore freight operations. This decaying pier, with four ship berths for general cargo, is now operated by the Maryland Port Administration.

Pier 1's building is used largely for storage and parking, but its lengthy pier has proved a perfect place for the berthing of large government cargo ships, on call for service in the event of national emergency, in the same manner as the Navy hospital ship *Comfort,* which berths on Newkirk Street when it is not on duty elsewhere. Since 1996 the Navy Military Sealift Command has used Pier 1 to store several ships formerly owned by Sea-Land Corporation, each named after a star. These 946-foot-long, roll-on-roll-off cargo ships, with top speeds of 33 knots, can be fully activated and under way on five days notice. Most of the Sealift Command ships are managed by Keystone Ship Berthing, a Maryland subsidiary of Sealift Companies of Jacksonville, Florida. As many as eight of

the government ships rest at Canton, Locust Point, and South Baltimore piers, providing a boost to the port economy, when times are quiet overseas.

RUKERT TERMINALS

South of Pier 1 is the complex of Rukert Terminals Corporation, one of the harbor's fastest-growing private terminal operations, with some twenty warehouses spread over 120 acres of waterfront land. Rukert specializes in unloading and storing bulk cargoes that the state terminals can't or won't handle, including lead, nickel, mountains of imported salt for Maryland's roads, and aluminum ingots from St. Petersburg, Russia.

The Rukert operation had its start in 1921 when the strong-willed Capt. W. G. N. Rukert, with a dream and an unsecured loan of $800, purchased a second-hand truck and rented a garage downtown. In 1930, with the help of Willoughby McCormick,

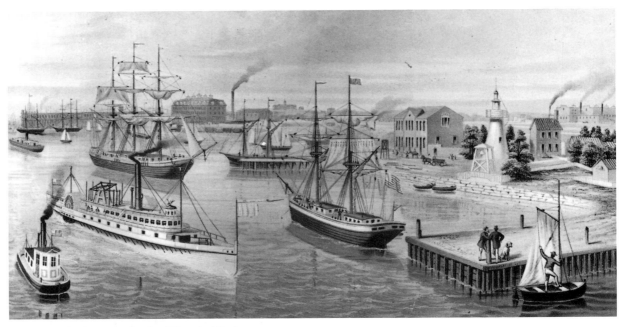

Lazaretto Point in 1872. Maryland Historical Society

founder of McCormick, the spice company, "Cap" Rukert purchased some docks in Fells Point. Over the next several decades he acquired historic Brown's Wharf in Fells Point and properties along Clinton Street in Canton. His son, Norman, took over the company in 1961, distinguishing himself meanwhile by the writing and publication of port histories. His *Historic Canton* was an important source for portions of this chapter. He was active in the Maryland Historical Society and operated a small maritime museum at Brown's Wharf. He died in 1984.

The Rukert operations have engulfed several earlier Clinton Street businesses. In 1878, Bernard N. Baker and James C. Whitely formed a partnership to supply bunker coal to ships. Their 400-foot trestle pier was fed with wooden drop-bottom cars. A later version, built just south of the first site in 1917 by the Pennsylvania Railroad, was 1,100 feet long and could handle 900 tons an hour, enabling Baltimore to become the East Coast's leading coaling station before oil replaced coal as the primary ship fuel. Rukert has built a new

pier on the site, for unloading aluminum ingots and similar cargoes by crane.

South of the coal pier site are lands that once housed Lazaretto Point's fertilizer industry. Rukert cleared the sites in recent years. The Lazaretto area became the world center of fertilizer production a century ago, when farmers from Maryland, Virginia, and other nearby states needed heavy soil replenishment to sustain their tobacco crops. The Lazaretto Guano Works was the pioneer company, bringing in tons of bird droppings from islands off the coast of Peru. The noxious material was gathered by convicts and Chinese laborers, each of whom was required to bring five tons a day to a main pile. From there it was put aboard the sailing ships by means of a long canvas tube. Crew members wore crude masks of oakum during the loading and could remain in the cargo hold only for 20-minute periods because of the strong ammonium odor.

The product evolved from guano to phosphate of lime, then bone meal and synthetics. The names of

companies operating on the site changed to American Agricultural Chemical Company, then Agrico Chemical Company, and now IMC, a Rukert subsidiary that barges in phosphates and nitrogen, then distributes the material to customers for their own custom blending. In recent years, Rukert took over and removed fertilizer plants to the south on Clinton Street to provide open air storage for imports of aluminum and other materials.

LAZARETTO POINT

Lehigh Portland Cement Company's tall storage towers mark Canton's most historic spot, Lazaretto Point, whose lighthouse was an important city landmark for 125 years. Originally called Gorsuch Point, it was a source of iron ore for the Principio Furnace Company in the early 1700s and for Peter Cooper's iron works a century later.

Around 1801 an isolation hospital for smallpox victims was built here and the point took on the name Lazaretto, which means fever hospital or pesthouse in Italian. In 1831, a 34-foot-high round brick lighthouse was built near the hospital to guide harbor traffic. The light was used to demonstrate the new Fresnel lenses in 1852, and in 1916, was the first lighthouse in Maryland and Virginia to be electrified. But the growth of piers and fertilizer factories caused the view of the light to be blocked, so in 1926 the famous old landmark was demolished and a steel tower erected in its place 100 yards closer to the water.

In 1870 the smallpox quarantine operation was

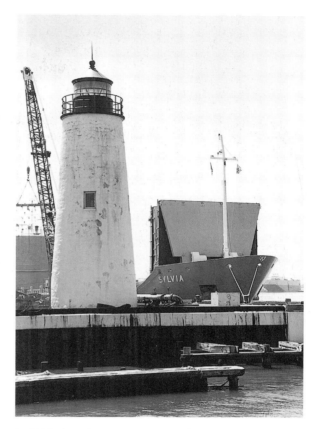

In 1985, the Rukert company erected this replica lighthouse, as a memorial to their founder and his son. *Sylvia,* a visiting small bulk carrier, is typical of the vessels that bring cargo to the Rukert facilities. Photo by author

moved to Curtis Bay. After that, the Coast Guard used the lighthouse site for buoy-tending operations. In 1954 the light on the steel tower itself was turned off, because it was being blocked by surrounding buildings, and in 1958 the Coast Guard moved its buoy operations to its yard on Curtis Creek. In 1962 the 4.2-acre site, with its rotting piers and decayed buildings, was sold to Lehigh Cement for $175,000.

CONSOLIDATION COAL PIER

East of Lazaretto Point is one of the world's most modern coal terminals, which replaced old ore and general cargo piers of the Canton Company in the early 1980s. Much of the coal shipped through Balti-

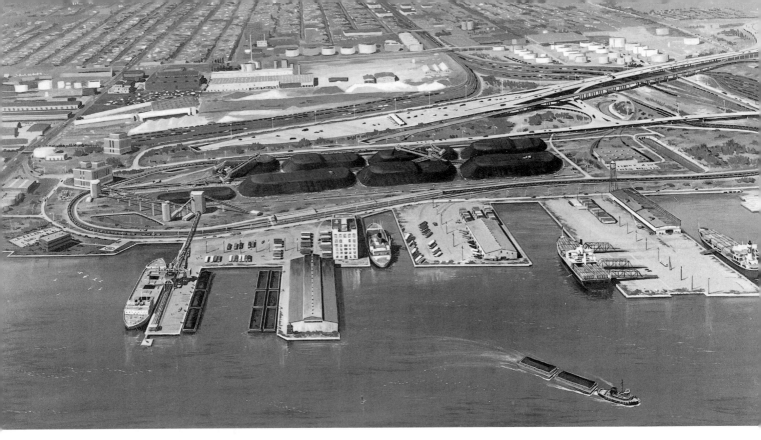

Drawing illustrating the operation of Consolidation Coal Sales Company.

more is a high-grade metallurgical kind used in steel plants. It is brought in from the nearby Appalachians by railcar and carried by giant cargo ships to customers in Western Europe and the Far East.

The architect's drawing (*above*) shows how the ship-loading terminal operates. Arriving rail cars pass through a long, low thawing shed in the middle foreground and are then uncoupled in pairs for the rotary dumper, which can handle fifty cars an hour. The coal falls into an underground hopper and then is carried by conveyor to the top of a great silo-like transfer-sampling station inland from the main ship pier. From here it is sent directly out to a waiting ship or conveyed to the large black storage piles that dominate the center of the drawing. Two gigantic machines called stacker-reclaimers, moving on tracks, have the capability of stacking the arriving coal or reclaiming it from the stacks for shiploading. The facility opened in 1983 with a capability of handling 10 million tons of coal annually. The volume that could be put aboard

each large ship increased after 1990 with the deepening of the channel between Baltimore and the Atlantic Ocean from 42 feet to 50 feet. Consolidation Coal Sales Company, now a subsidiary of Consol Energy in Pittsburgh, paid $30 million for the site and invested another $80 million in its conversion to a coal pier. With coal markets down in recent times, the company has begun to handle break-bulk items, including metals and lumber.

The Canton Company piers have played important roles in port history. The Pier 10–11 complex, shown at right in the drawing, was a major Army supply base for the European Theater in World War II. At Pier 10, Sea-Land Service's *Mobile* arrived on April 9, 1963, to inaugurate container service between Baltimore and Puerto Rico; this pier became the first in the port to be designated for container freight.

Bugeye *Russell A. Wingate* and "buyboat" *Louise* unloading at oyster shell plant. The site was cleared in 1985 to make way for the Consolidation Coal pier. Robert F. Kniesche Collection, Maryland Historical Society

OYSTER SHELLS

Coal pier construction forced the shutdown of an oyster shell operation near the foot of Clinton Street which had been constructed in 1911 by the Potomac Poultry Food Corporation. The company, which produced crushed oyster shell for use as a calcium source for laying hens, originally obtained its supply of shells by buying them from shucking operations all over the Eastern Seaboard and bringing them here in boats.

In the 1950s, the company was purchased by Southern Industries of Mobile, Alabama, and renamed Oyster Shell Products Corporation. Southern had discovered vast beds of oyster shell in the Gulf of

Mexico and speculated that similar reefs could be found in Chesapeake Bay. Their search uncovered large beds, up to 30 feet thick and amounting to millions of tons, accumulated before man came along to harvest the bay's product. The shells were anywhere from several hundred up to 5,000 years old, some under ten feet of silt.

In 1960, Southern negotiated arrangements with the State of Maryland and C. J. Langenfelder and Son, a local company, whereby Langenfelder would dredge the old shell reefs, provide shells to the state every spring for reseeding commercial beds, and supply the Canton company with shells the remainder of the season. Langenfelder set up a base at the old ferry

U.S. Navy Hospital Ship *Comfort* in Canton between missions.
Maryland Port Administration

dock at Love Point, across the bay, accumulating a mountain of oyster shells that was visible to passing boaters. Langenfelder continued supplying the state and other enterprises following the shutdown of its Canton customer.

USNHS *COMFORT*

Formerly an oil tanker, now a navy hospital ship, the *Comfort* has been based in Canton since 1987, ready to head for a trouble spot anywhere on the Atlantic Ocean or in the Middle East on a moment's notice. It is one of several ships which the navy keeps in readiness in Baltimore harbor. A sister ship, the USNHS *Mercy,* is based in San Francisco Bay. Since coming to Baltimore, the *Comfort* has been dispatched to provide assistance for actions in two Middle East wars and the 2001 terrorist attack on New York City's World Trade Center. The vessel, longer than three football fields, has twelve operating rooms and 1,001 beds, one more than its sister ship, enabling it to claim itself the largest floating hospital in the world. It carries the most

advanced diagnostic equipment, along with technicians who can operate and repair it. A skeleton crew and medical staff can be quickly augmented by medical personnel from the Bethesda Naval Hospital whenever it embarks on a mission.

WESTERN ELECTRIC

Riverview Amusement Park, a Baltimore recreation spot for thirty years, once stood on Old Point Breeze, at the extreme eastern end of the Canton shoreline. The park came down in 1929 to make way for the Baltimore works of the Western Electric Company, which closed in the mid-1980s. The Bell system plant employed some 6,500 persons and was a major supplier of insulated cable. This included coaxial cable, armored submarine cable, and thousands of miles of ordinary telephone wire produced each year. In 1983 the American Telephone and Telegraph Company began to phase out plant operations, and developers converted it into an industrial park. Because of its proximity to the big marine terminals, it became popular with maritime businesses for offices and storage.

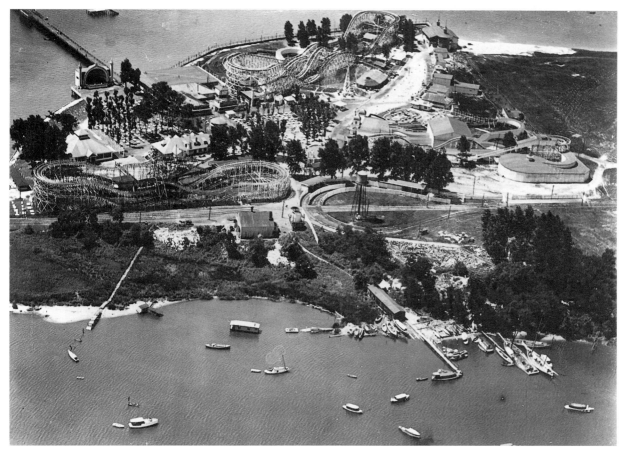

Riverview Amusement Park, an attraction for Baltimoreans until Western Electric took over the site to make telephone cable.
Maryland Historical Society

DUNDALK MARINE TERMINAL

Dundalk was created out of landfill, including tailings from the Allied Chemical Chrome Works. It served first as Baltimore's municipal airport. Great flying "clippers" docked on Colgate Creek, taking on passengers for Bermuda, the Caribbean, and Europe. But the field itself was a problem: with unstable earth under the crust, runways wrinkled and buckled when large planes landed. Aviation authorities were glad to give up Harbor Field and move the operation to Friendship Airport (now Baltimore-Washington International) south of the city.

Among other things, these facilities are fast-turn-around container terminals. Ships enter, unload their great boxes, take on other boxes and leave, all before their arrival can be published in the newspaper. Dundalk also supplies a landing area for Asian and European autos and heavy trucks and farm equipment. Lumber, wire, and other items fill the grounds, beside the great stacks of containers. The terminal rents storage areas to terminal operators, automobile processors, and manufacturers. It provides tracks for trailer trains—railcars bearing containers from the Midwest or as far away as the Pacific Coast.

Dundalk Marine Terminal is the heart of the modern-day port of Baltimore. Because of its size and scale of operations, it is among the world's most interesting and exciting harbor facilities. For reasons of safety and security, few visitors are ever given an opportunity to observe its fascinating activity. An imposing ten-lane entrance for arriving trucks only hints at the bustle inside. At water's edge, ten giant container cranes stand like sentinels, welcoming large ships, and piquing the curiosity of folks passing in smaller boats. The newer, adjacent Seagirt terminal offers three cranes now and has room for more. These terminals should have a visitors' gallery and tour bus, so that the public could see first-hand what the port of Baltimore is all about.

The Maryland Port Authority purchased the land at Dundalk for $4 million in 1959, as one of that new agency's first steps to modernize the port and make it accessible to truck traffic. Now expanded to 570 acres, mostly fill material, the facility can handle as many as thirteen ships at one time.

FACING PAGE:
Dundalk terminals thirty years apart. Above, the *Yankee Clipper* is moored at Harbor Field, the municipal airport, in 1939. In the more recent photo, container ships line up at Dundalk Marine Terminal in about 1970. The former Western Electric plant is at left in both photos. Maryland Historical Society; Baltimore Gas and Electric Company

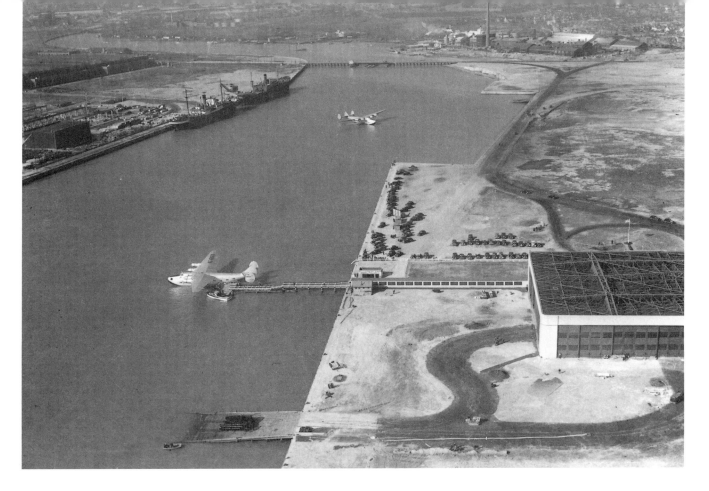

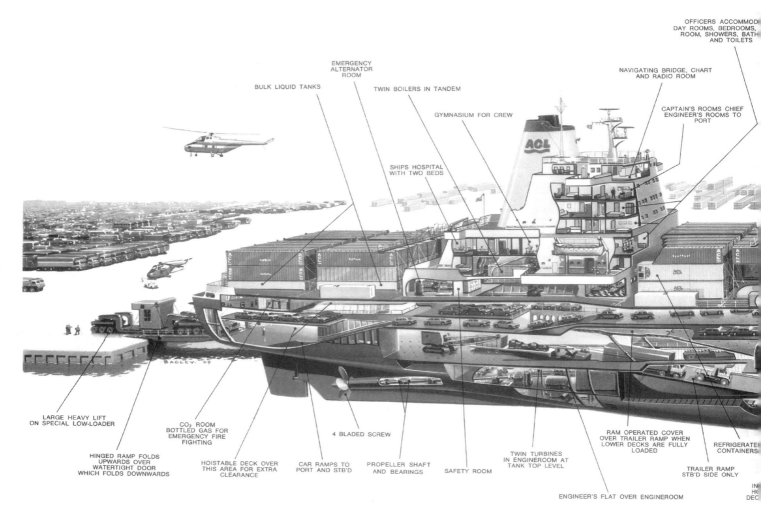

OFFICERS ACCOMMOD
DAY ROOMS, BEDROOMS,
ROOM, SHOWERS, BATH
AND TOILETS

EMERGENCY
ALTERNATOR
ROOM

NAVIGATING BRIDGE, CHART
AND RADIO ROOM

BULK LIQUID TANKS

TWIN BOILERS IN TANDEM

GYMNASIUM FOR CREW

CAPTAIN'S ROOMS CHIEF
ENGINEER'S ROOMS TO
PORT

SHIPS HOSPITAL
WITH TWO BEDS

LARGE HEAVY LIFT
ON SPECIAL LOW-LOADER

CO₂ ROOM
BOTTLED GAS FOR
EMERGENCY FIRE
FIGHTING

4 BLADED SCREW

RAM OPERATED COVER
OVER TRAILER RAMP WHEN
LOWER DECKS ARE FULLY
LOADED

REFRIGERATE
CONTAINERS

HINGED RAMP FOLDS
UPWARDS OVER
WATERTIGHT DOOR
WHICH FOLDS DOWNWARDS

HOISTABLE DECK OVER
THIS AREA FOR EXTRA
CLEARANCE

CAR RAMPS TO
PORT AND STB'D

PROPELLER SHAFT
AND BEARINGS

SAFETY ROOM

TWIN TURBINES
IN ENGINEROOM AT
TANK TOP LEVEL

TRAILER RAMP
STB'D SIDE ONLY

ENGINEER'S FLAT OVER ENGINEROOM

IN
HO
DEC

The marine terminals mean big dollars to Baltimore and Maryland. Shipowners can spend thousands of dollars on a single port stop. In 1978, the Baltimore *News-American* found that, even then, it cost nearly $78,000 for the Greek-owned bulk carrier *Samos Glory* to load a grain cargo at Port Covington. This included $5,400 for six days' dockage, a $31,300 stevedoring charge for loading the grain, $12,250 for overtime use of the grain elevator, about $3,000 in piloting charges for bringing the ship to and from the mouth of the bay, $270 each time for line handlers to help dock and undock the ship, about $500 for each use of a tug, and $750 for the services of a local ship agent.

Food, fuel, and other stores must be taken on while the ship is in port, and this activity nurtures a large marine service industry in Baltimore. One company specializes in fast handling of ships' laundry. Another offers tank barge loads of fresh water. Ship chandlery firms supply rope, wire, anchors, replacement parts, and all kinds of other equipment. A Highlandtown chandlery stocks Asian, Scandinavian, Greek, Italian, British, German, and Indian food specialties and has a cleric supervise and certify the slaughter of animals for Moslem crews. "A Greek ship wants 30 pounds of feta cheese, a British tramper requests five cases of steak and kidney pies, a Japanese auto carrier orders 75 pints of boiled octopus, a

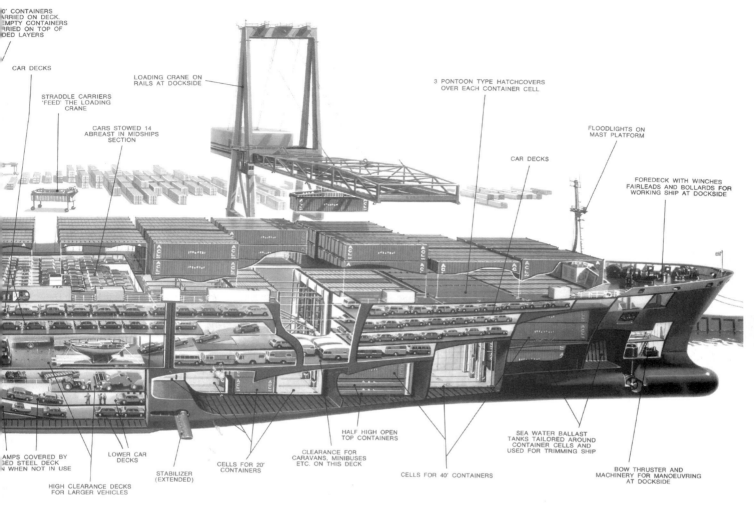

Anatomy of a container ship. Atlantic Container Lines

Russian container ship would like five cases of face soap, a Norwegian tanker 300 pounds of lute fish," the same *News-American* article reported.

THE CONTAINER REVOLUTION

One factor that helped Baltimore maintain its position as a general cargo port was its early adaptation to the container method of shipping. Containers brought a revolution in ocean shipping in the late twentieth century, and ports that saw the container as only a fad were left by the wayside.

The potential for containers became evident to Baltimore port planners when Dundalk Terminal was

in the development stage. As a former airfield, Dundalk was perfectly suited to handle the big boxes. It had the large open spaces needed to hold them while they awaited ship arrivals. It had "marginal" berths (berths alongside the shore, as opposed to the berths at long finger piers that characterized railroad marine terminals), which were ideal for installation of the huge cranes needed to transfer the boxes between shore and ship and store them in stacks. The wonderful serendipity of Dundalk's availability helped turn Baltimore, for a time, into the second largest container port on the East and Gulf coasts, after New York.

The typical shipping container is a box of stainless

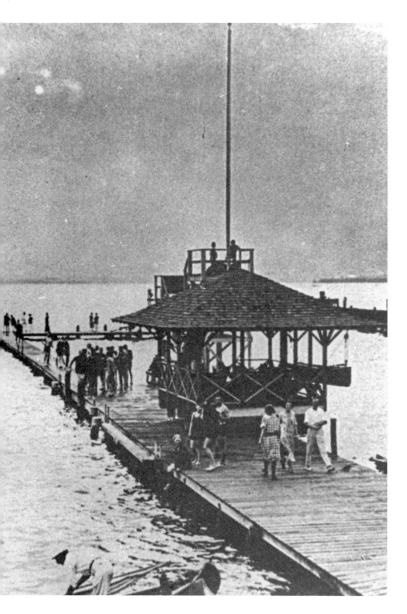

Old swimming hole. These 1920s photos capture the action at the Maryland Swimming Club, which flourished on Dundalk Avenue until authorities filled in the shoreline for Harbor Field. The club originated in 1903 at the former summer home of the McShane family, who operated a nearby foundry. In 1894, William McShane gave the name Dundalk to the foundry's railroad stop, which stood between St. Helena and Turner Station. During World War I, Bethlehem Steel Company built the town of Dundalk on two farms near the foundry site, to provide housing for workers at Sparrows Point. Dundalk-Patapsco Neck Historical Society

steel and aluminum, either 20 or 40 feet long, 8 feet wide, and 8 feet high, with double doors at one end. It is like a truck van without wheels; in fact, part of the time it is a truck van, hauled to or from dockside on a flat-bed trailer. The most important aspect of the container is that it is "intermodal," meaning that the same container can be hauled from shipper to customer, via ship, truck, or rail, throughout the world.

In the "old" days, which is to say from the time of the ancient Phoenicians up to about forty-five years ago, all general cargo (called "break-bulk cargo") was brought to the dock in boxes, bags, cartons, crates, drums, or whatever, then rolled aboard or hoisted by ship or shoreside crane, and stowed by hand—a slow, tedious process. The container, by contrast, can be loaded at the shipper's factory and transferred "intermodally" all the way to the recipient—without any need to open the box or rehandle its contents except possibly for random inspection by customs agents.

The containers one sees at a shipping terminal may

contain almost anything imaginable: rugs, furniture, vehicles, chemicals, bulk liquids, heavy machinery, livestock (some containers are ventilated), perishable commodities (some are refrigerated)—anything that will fit in a box and is of sufficient quantity to justify the container freight rate.

Containers are sped to all parts of the world on ships especially designed to carry them. The ships operate as "liners," that is, with definite routes and regular published schedules, so that a ship line's customers can determine how to route their cargoes and when to get them to the docks. Some shippers make these arrangements themselves; others hire specialists called "freight forwarders" to make sure the cargo reaches its destination by the most economical and efficient means.

The container business as we know it is the invention of a North Carolina trucker named Malcolm McLean, who bought an old vessel in the mid-1950s and outfitted it so that it could take his truck trailers to sea. He developed a virtual monopoly, moving general cargo from New York to Puerto Rico and from the West Coast to Alaska. For nearly a decade, McLean's Sea-Land Service was one of the few steamship lines in the world using containerization, but the potential was soon obvious. A standard dock crew of twenty-two or twenty-three men could handle sixteen times more container tonnage per hour than noncontainerized loose cargo. Faster cargo handling meant drastically reduced labor costs per ton handled and led to other important savings to the shipper: less time lost at harbor piers, and therefore more trips per vessel; less pier rental time; reduced pierside storage charges. The secure, weatherproof containers also brought drastic reductions in pilferage, breakage, and weather damage.

The economics involved in the container ship's takeover of general cargo shipping were described by Helen Delich Bentley, then reporting for the Baltimore *Sun,* on December 23, 1968. Bentley was covering a settlement between ship owners and the cargo handlers' union, the International Longshoremen's Association (AFL-CIO). At the time, she explained, it cost the container ship operators $8,000 a day to keep up finance payments on one of their new vessels even if it was laid up at the dock, whereas break-bulk operators, using World War II freighters long since amortized, paid only $300 a day for an idle ship. Faced with such high lay-up costs, the container operators "will pay labor any price before succumbing to a strike," Bentley wrote. And, for them, the price was not that high. A $1.60 hourly wage increase over three years added only 35 cents a ton to the cost of handling containers, compared to $3 a ton to the cost of handling break-bulk.

Sea-Land Service established a container service between Baltimore and Puerto Rico in 1963, using Pier 10 at Canton. The venture was so successful that Sea-Land worked with the Canton Company to develop the Seagirt terminal, between Canton and Dundalk, especially for Sea-Land's container ships. Seagirt opened in 1967. Meanwhile, Dundalk Terminal was redesigned to handle container traffic, and its container facilities were expanded in 1973. In 1979

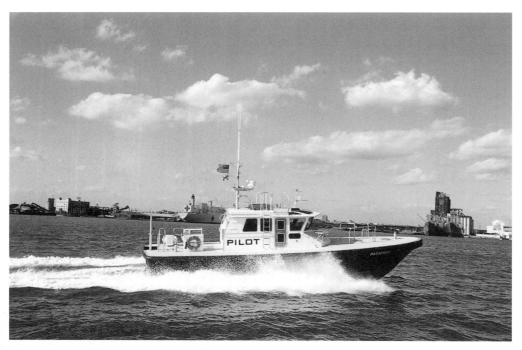

The *Patapsco,* newest launch of the Association of Maryland Pilots, passes the Canton waterfront in 2002. Photo by Kathy Bergren Smith

the Maryland Port Administration, by then renamed, opened a three-berth container terminal at South Locust Point. In 1981 dredge spoil from the new harbor tunnel was pumped to Seagirt to expand the acreage there. The MPA meanwhile purchased land at Masonville, on the south side of Middle Branch near Hanover Street, and optimistically announced plans to open a new 350-acre container terminal there in the 1990s. Automobile storage and shipment was subsequently found to be a better use for Masonville, but the container traffic through the port of Baltimore has held its own, growing from almost nothing to over 4 million tons a year.

SAFE PASSAGE TO BALTIMORE

Baltimore's maritime family consists of people with many skills, from crane operators to engineers to purchasers of freight services. Perhaps the most admired

of all the specialists are the men, and in recent years several women, who pilot the great ships up and down Chesapeake Bay. They take over from the opensea captain and become "temporary master" of the ship, responsible for its safe traverse of the bay and arrival in port, without harm to ship, crew, or the marine environment.

Pilots board incoming ships off Cape Henry at the mouth of the bay. Their small launch brings them alongside the moving ship, whose crew drops a rope and rung ladder. The pilot must catch and climb the ladder even in the worst of storms and heavy seas.

During the 150-mile run on the bay, the pilot must be prepared to contend with strong winds, changing channel depths, rain, snow, and the surprise moves of inexperienced recreational boaters. Association President Eric A. Nielson told *Port of Baltimore* magazine that one skill needed is that of "being able to handle a situation when everyone around you is panicking or

simply doesn't know what to do. You need to be a leader."

The Association of Maryland Pilots celebrated its 150th birthday on June 3, 2002. It is the oldest pilots' association in the United States, and its pilotage run on the Chesapeake Bay between Cape Henry and the port of Baltimore is the nation's longest.

The Maryland association, with sixty some members, can claim one of the best safety records in the world. Applicants must have a four-year maritime college degree, several years of working on ships, and possession of an Unlimited Tonnage Ocean Master's License merely to be considered by the association. The applicant must spend another five years learning the intricacies of Chesapeake Bay before becoming a fully licensed pilot.

The association shares its headquarters on Dillon Street with the Association of Maryland Docking Pilots. This group was formalized only a few years ago to bring together the specialists—usually associated with a tug boat company—who board at Key Bridge, take over from the bay pilot, and direct the tugs in the docking and undocking of the ship. The ship owner pays the separate fees for the two pilot services, but knows that his vessel is in good hands, being handled by skilled people with local knowledge.

TYPES OF SHIPS

A container ship is easily recognizable from the boxes stacked high on deck, secured in place by guy wires. Several other types of ships stop at Dundalk or at spe-

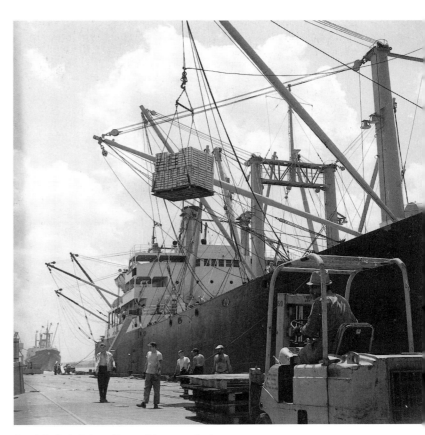

Break-bulk freighter. These ships carry their own cargo booms; the tall supporting columns are distinctive features. Maryland Historical Society

cialized terminals nearby. The most typical are pictured on these pages. Some ships combine various features shown here. For instance, some container ships have ramps for loading and unloading vehicles; some ships can carry bulk liquid in one hold, mixed general cargo in another, and grain or ore in a third. To a practiced eye, deck equipment quickly reveals a ship's purpose. An interesting game for boaters can be checking the ships they see against the listing of vessel arrivals in the daily newspaper. The announcement lists cargo carried, where the ship is from, where it is going, and its nation of registry.

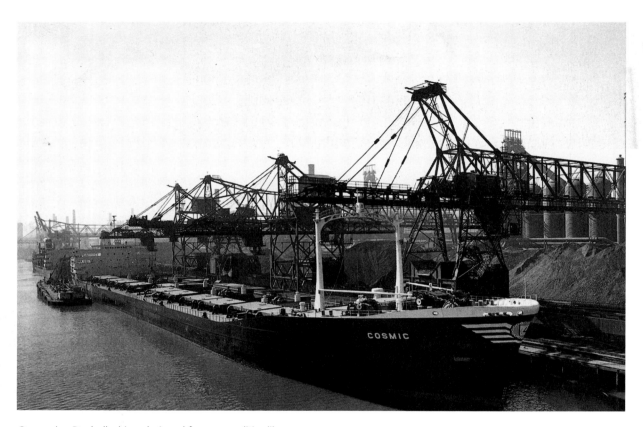

Ore carrier. Dry bulk ships, designed for commodities like ore, coal, and grain, usually carry no booms; their decks are clear, except for access hatches through which cargo is loaded and unloaded by machinery on shore. Baltimore Gas and Electric Company

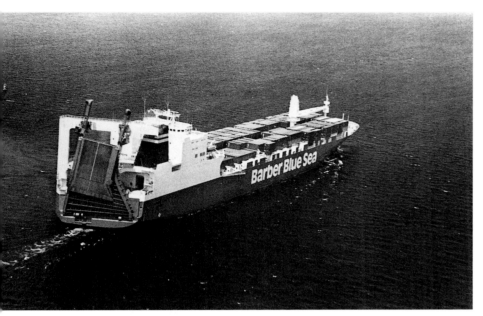

Some container ships carry ramps at the stern to handle rolling cargo. Autos, buses, trucks, tractors, and similar vehicles are driven on and off, while containers are handled by dockside cranes. Barber Blue Sea Line

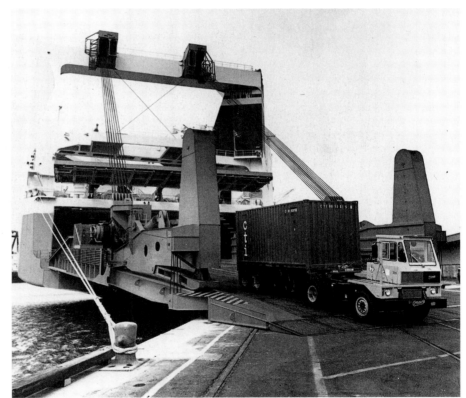

Ramp becomes a two-lane highway.

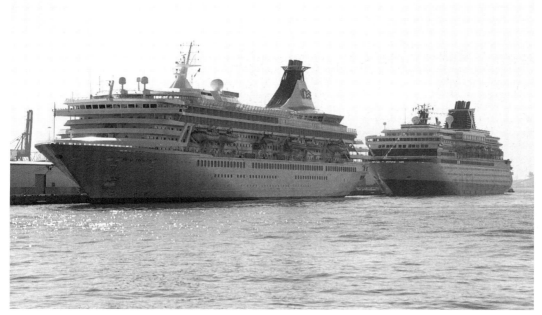

Passenger ships at Dundalk in 2002. Regular transatlantic passenger service ended in Baltimore years ago, but Dundalk's passenger terminal has seen a boom in cruise ships, venturing to Canada, Bermuda, and the Caribbean. Maryland Port Administration, photo by Bill Allen

Automobile carrier. These tall, bulky vessels have become the most frequent commercial visitors to the port of Baltimore. Designed for RoRo (roll-on, roll-off) cargo, including cars and heavy equipment, the vessels can carry as many as 5,580 automobiles. Their high flat sides enable them to pass through the Panama Canal. Maryland Port Administration, photo by Bill Allen

Oil tanker. The decks of liquid bulk ships usually carry a maze
of pipes and valves, in place of hatches.

SPARROWS POINT

Thomas Sparrow was granted a tract of land on the north side of the Patapsco River in 1652. It remained farmland until 1887, when Pennsylvania Steel Company acquired it; two years later the first blast furnaces were producing pig iron. The shipyard came two years after that. Bethlehem Steel bought the plant and shipyard in 1916 and greatly expanded their respective capacities, eventually employing 30,000 people. The plant became the largest steel plant on tidewater in the world and Maryland's largest private employer.

The year 2003 marked the end of the road for Bethlehem Steel Corporation. Succumbing to years of economic pressure from foreign competition, the bankrupt company sold its assets, including the Sparrows Point and Burns Harbor, Indiana, steel plants, to International Steel Group of Cleveland for $1.5 billion. ISG, which had formed in 2001 to acquire bankrupt steel companies, stood to become the largest steelmaker in North America as a result of this and other deals. It vowed to keep Sparrows Point open but would have to reduce the workforce.

The plant sprawls over 2,200 acres of land. Importing ore from South America and Australia and coal and coke from China and Japan, it was capable, under Bethlehem, of producing 9 million tons of steel annually. The adjacent shipyard produced tankers

The town of Sparrows Point in the 1920s. The company town, built in the early days of the steel plant, offered stores, banks, restaurants, six churches, and cheap rent—$35 a month for six rooms—for plant workers. About 9,000 people lived here in the 1920s. Over the decades between then and 1980 the town was leveled bit by bit, to make room for the expanding plant. Dundalk-Patapsco Neck Historical Society

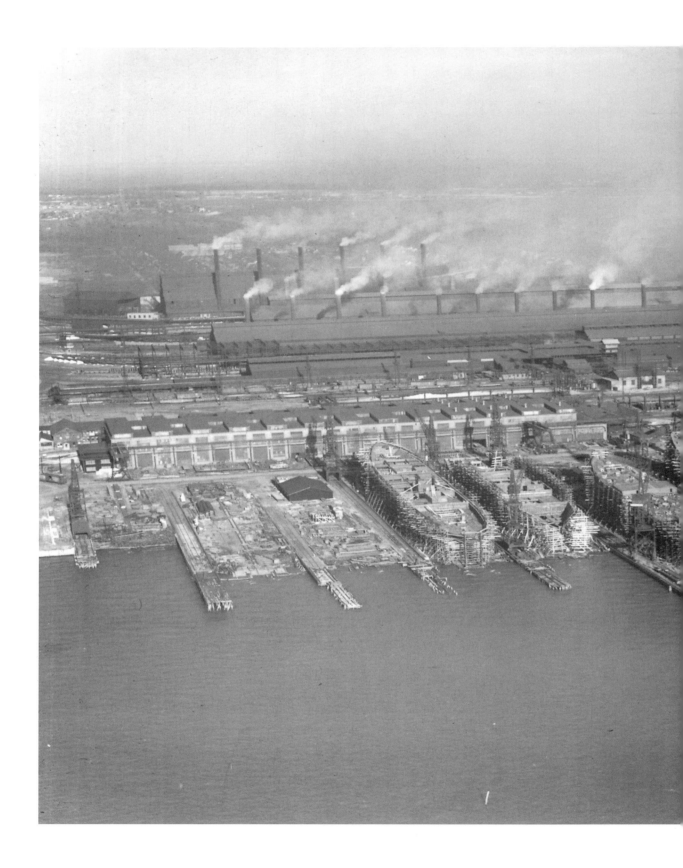

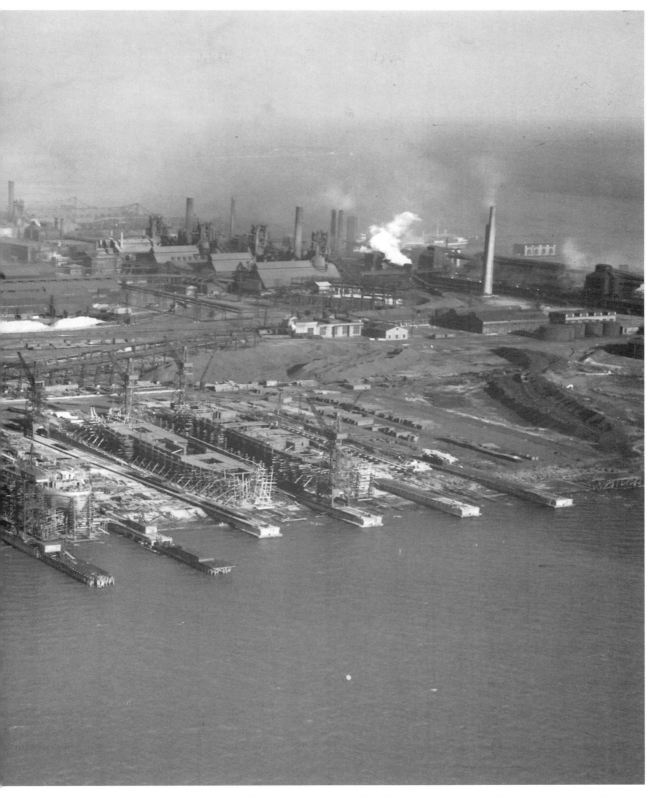

Sparrows Point steel plant and shipyard in April 1940, already engaged in World War II production. Robert F. Kniesche Collection, Maryland Historical Society

Sparrows Point as it appeared before
Bethlehem Steel acquired it in 1916.
Compare to current map, below.
Maryland Historical Society

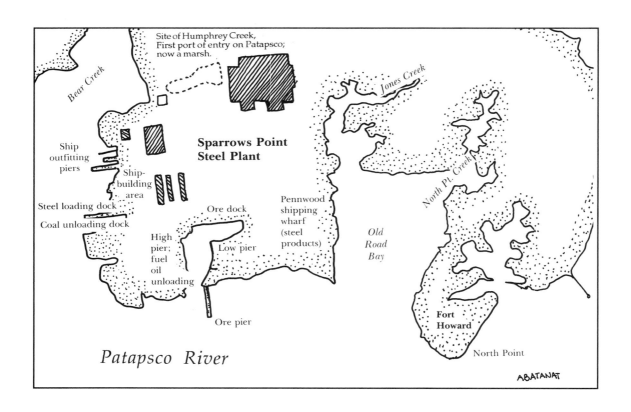

Men have been building ships in this general vicinity on Bear Creek, near the mouth of the Patapsco River, for 300 years. Bethlehem Steel and its predecessors sent more than 500 ships down the ways of this shipyard, established in 1891. Here, workers prepare a new ship for launching. Robert F. Kniesche Collection, Maryland Historical Society

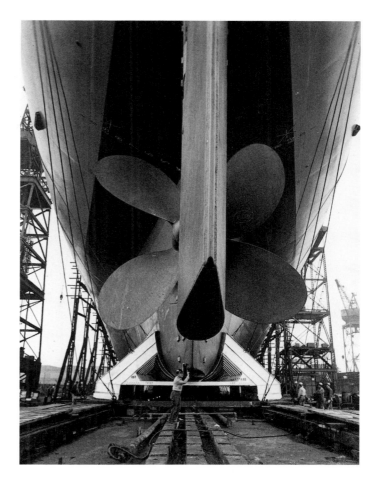

weighing in at up to 300,000 deadweight tons. As shipbuilding shifted overseas in the 1980s, Bethlehem diversified the shipyard into ship repair and tunnel construction. It sold the shipyard in October 1997 for a reported $16 million to Veritas Capital of New York, operating as Baltimore Marine Industries. In November 2003, the Boston investment group Garletta Willis agreed to purchase the 250-acre yard for $9.75 million and announced plans to build double-hulled barges and repair ships, including large cruise vessels. Fifty acres at the north end of the site will be developed as an industrial park.

In its determination to survive as a steelmaker, Bethlehem had moved ahead in 1999 with a $615 million modernization plan that included constructing a new, $300 million cold-sheet mill and replacing bricks in a 150-foot-high blast furnace at a cost of $100 million. The state and Baltimore County contributed $80 million to the package.

▰ ▰ ▰

Over the years since 1897, the steel companies have dumped their slag over more than 1,400 acres of public waters, using the infill for new furnaces, piers, and storage, as can be seen by comparison of the two maps opposite. The new land was free. Only since 1976 has the state required compensation for taking public water. The first Bethlehem application under the new rule, to fill in a 10-acre cove for coal storage, was made in 1981.

Sparrows Point is bounded by Bear Creek, the Patapsco River, Old Road Bay, and Jones Creek. The creeks offer little of interest to visitors. Bear Creek, on the west side, has numerous branches and inlets, giving hundreds of persons, many of moderate income, the opportunity to have a house and dock on the water. Repair yards and dockage are available at Lynch and Peachorchard coves on Bear Creek; however, a series of drawbridges makes the creek inconvenient for sailboaters. The Owens line of sturdy pleasure boats was built at Lynch Cove. The company was taken over by the Brunswick Company when wooden boat construction gave way to fiberglass, and the plant was converted to the production of bowling alley floors. This business also folded.

Jones Creek and Old Road Bay border the steel plant on the east. The Young shipyard on Jones Creek builds and repairs wooden sailboats.

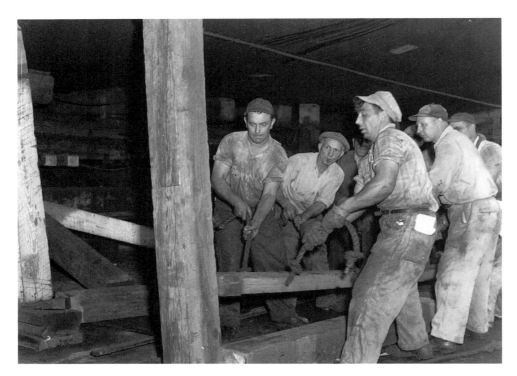

Launch time approaches. Sparrows Point workers knock over wooden supports used during construction. As the supports are removed, the ship settles onto reusable launching cradles called poppets. Tons of grease are applied to the slanted shipways. As the ship is christened by the distinguished lady with flowers and a wrapped bottle of champagne, a handle is pulled, triggering release of the cradles. Huge hydraulic rams emerge near the bow, in case the ship fails to slide down the ways of its own accord. Maryland Historical Society

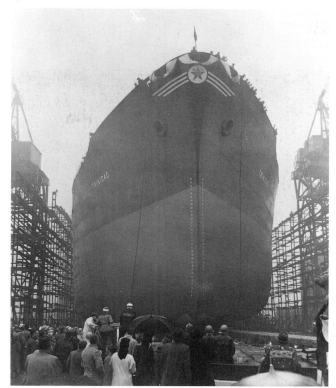

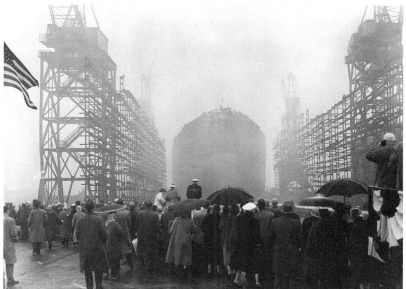

Launching in a fog: Going, going, gone.
The Texaco *Trinidad* slides into the water
and out of view. Robert F. Kniesche
Collection, Maryland Historical Society

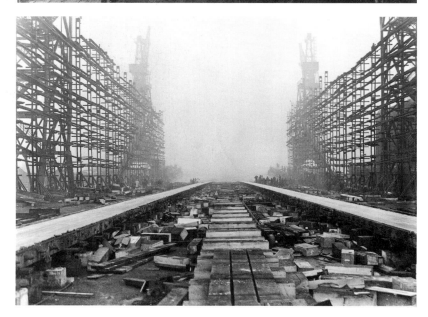

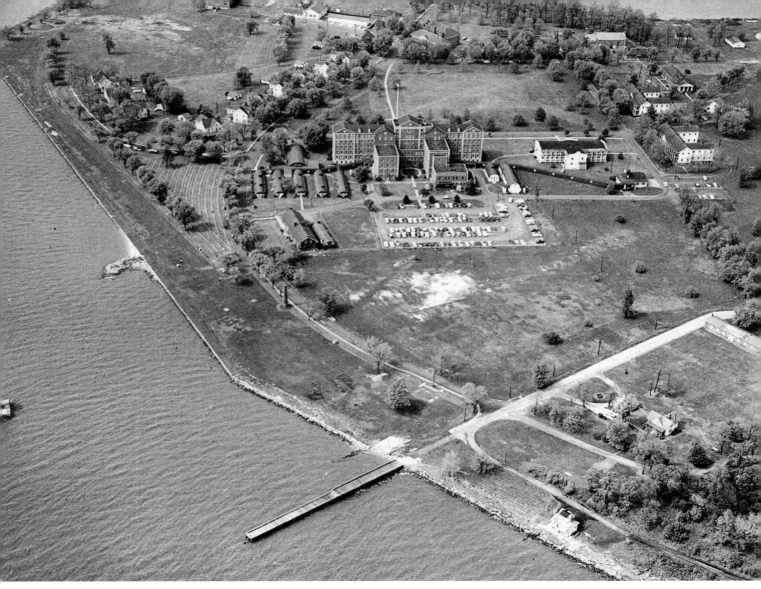

Above, North Point, former home of the Fort Howard Veterans Administration Medical Center. Roads at lower right lead to old gun emplacements shown in the photograph at right. Dundalk-Patapsco Neck Historical Society

NORTH POINT AND NORTH SHORE PARKS

North Point and Old Road Bay offer the first sheltered anchorage for vessels entering the mouth of the Patapsco River from the north. The earliest European colonists used the anchorage as a loading and distribution center for oceangoing vessels, before harbors were established farther up the river. Small flat-bottomed boats brought tobacco hogsheads from points along the Patapsco and upper Chesapeake Bay and returned to their plantations with supplies from Europe.

More recently, North Point provided a tranquil setting for the Fort Howard Veterans Affairs Medical Center. This was closed in 2000, leaving only an outpatient clinic. The fort, named for Col. John Eager Howard, a Revolutionary War hero and noted Baltimorean, was built in 1896 to defend Baltimore from possible naval attack. It remained under army command until 1940. The old gun batteries are part of a shoreside park operated by the Baltimore County Department of Parks and Recreation. The park is closed during the winter, but the grounds of the fort are open year-round and afford a sweeping view of the river entrance and Chesapeake Bay.

Like Fort McHenry, North Point played a key role in the British siege of Baltimore during the War of 1812. On Sunday afternoon September 11, 1814, three weeks after the sacking and burning of Washington,

D.C., Admiral Cockburn's fleet arrived at the mouth of the Patapsco River, bent on subduing Baltimore and destroying her shipyards, in retribution for the maraudings of the sleek Baltimore clippers.

Anchoring in Old Road Bay, the British fleet began landing troops and supplies on North Point early the next morning. At 7 A.M. a force of 4,700 soldiers, sailors, and marines began the march on Baltimore. The master plan called for a simultaneous attack by water, employing the fleet to take out Fort McHenry, while the land forces plundered the town and set fire to the shipyards.

Every American knows the star-spangled outcome: the leader of the British land force, Maj. Gen. Robert Ross, was dead of sniper bullets within hours of the landing; a 3,200-man militia of Baltimore residents, striking out from its campground at the junction of North Point Road and the Philadelphia Road, conducted an effective delaying action (the Battle of North Point); the fortifications at Hampstead Hill (now Patterson Park) proved too strong for direct assault, and the British, looking for an opportunity to take them by flank, were compelled to stand around all night in a downpour. Because of shallow water and sunken obstacles, Cockburn's ships were unable to get close enough to conduct an effective bombardment of Fort McHenry. Perceiving this, the dispirited land

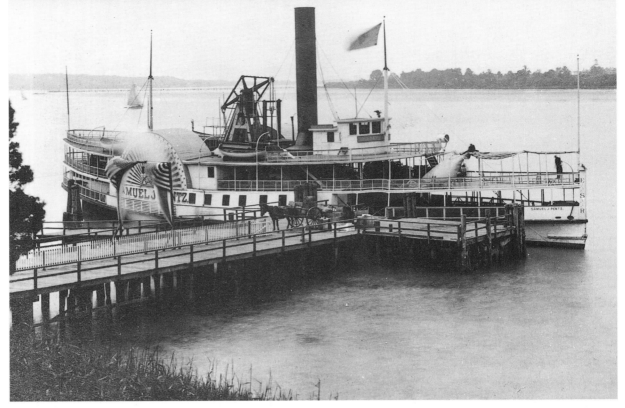

The *Samuel J. Pentz* carried Baltimoreans to Holly Grove Park on Sparrows Point until the 1870s. The *Pentz* appears here later, on a freight run, at an unknown location. Maryland Historical Society

forces stole back to North Point. By dawn's early light of September 14 it was clear to everyone that the attack had failed. The British troops were reboarding their ships as Francis Scott Key began penning his famous poem.

East of North Point is Cuckhold Point, a ramshackle area of taverns, boat ramps, and outboard rentals, catering to the Millers Island fishing trade. On old maps it is called Cockles Point. A channel provides a shortcut to Middle River, but deep-draft boats must avoid it.

A succession of resorts and amusement parks attracted Baltimoreans to the north shore of the Patapsco in earlier times. The *Samuel J. Pentz* brought patrons from Light Street to Holly Grove Park on Sparrows Point until the 1870s. Parks named Tivoli and Penwood were located on the same spot in later decades, until displaced by the expanding steel mill. At Tivoli Park on July 3, 1883, a rotted pier collapsed, plunging 300 persons into the water as they jammed up to board a tug-drawn barge for the return trip to the city. Sixty-three persons died, including thirty-

four women and twenty-three children. Most of them were on an outing organized by Corpus Christi Church in Mount Royal. It was the harbor's largest and most heartbreaking disaster in terms of loss of life.

In 1906, Bay Shore Park was opened to the east of North Point. It featured a 1,000-foot pier, a boardwalk, a roller coaster, a large pavilion, and a famous water merry-go-round that dunked its riders every few seconds. The park advertised "high class restaurants" and "no intoxicants." In 1947, Bethlehem Steel purchased the 900-acre tract and tore down the buildings but made no effort to develop the land. The amusement equipment was moved to a new park, called Bay Island Beach, which was opened the following year on "Pleasure Island," just west of Hart Island. The resort was connected to Cuckold Point by a causeway, and featured a casino, midway, and bathhouse. It was purchased by Bethlehem Steel in 1964 and burned to the ground. The causeway was removed. Again the site was put to no use. It can be visited by small boat.

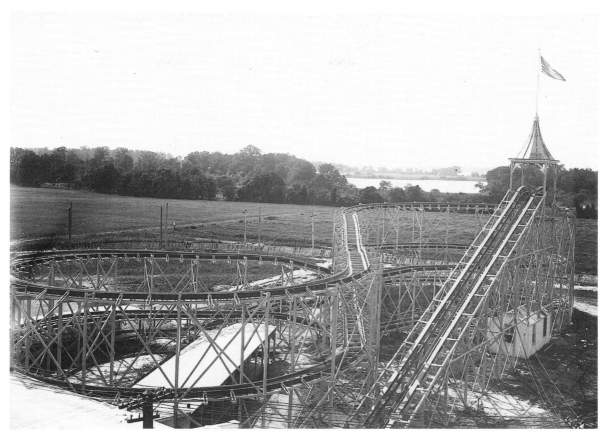

This spindly roller coaster was one of the thrills at Bay Shore Park on North Point. This view looks west, across Shallow Creek toward North Point Road. Peale Museum

The people-dipper, Bay Shore Park's water merry-go-round, about 1940. It dipped its riders in the water every few seconds. Dundalk–Patapsco Neck Historical Society

DREDGING THE CHANNELS

In 1987 an area between Hart and Miller islands, which flanked the northeast approach to the Patapsco River entrance, began receiving the spoil from Baltimore's greatest harbor-dredging project—a project tied up in controversy for over a decade. The purpose of the $400 million plan was to deepen by 8 feet the 42-foot shipping channel from Baltimore all the way to Hampton Roads. This would enable large bulk carriers—ships carrying coal, grain, ore—to transport economical loads to and from Baltimore. The steel plant could receive 125,000-ton iron ore carriers at Sparrows Point rather than the 65,000-tonners previously in use, thus reducing by nearly half the number of ship visits necessary to feed its mills. Baltimore's competitive role in supplying European coal demands would be greatly enhanced. The relatively light-displacement container, auto, and other break-bulk vessels would not be affected by the dredging; a depth of about 36 feet suffices for many of these ships. Nor would the dredging bring a parade of environmentally threatening large oil tankers up the bay; with completion of the Colonial oil pipeline, much of Maryland's gasoline and light fuel oil was coming from the Gulf Coast to Baltimore by pipeline.

The controversy raged over whether the project was safe environmentally. Residents along the shore facing the islands pointed to the foul nature of the materials to be dredged from the shipping lanes and dumped at the disposal site. Indeed, a researcher for the federal Environmental Protection Agency reported in 1978 that, as a result of industrial pollution, the muck at the bottom of Baltimore harbor contained more toxic heavy metals than bottom mud anywhere else in the entire Chesapeake and Delaware Bay area. She found the level of toxic sediments even worse than in Norfolk's filthy Elizabeth River: twice the amount of zinc, twice the cadmium, four times the lead, five times the copper, and eleven times the chromium. "Hot spots" were found at the Inner Harbor, Colgate Creek, Bear Creek, and Old Road Bay, near industrial installations. The researcher, Patricia G. Johnson, pointed out that the dangers posed by these metals when they enter the food chain are well documented. However, she said that her research did not show whether the metals would cause such damage if disturbed by dredging or would simply settle out again.

Court battles over use of the Hart-Miller site for disposal of the spoil ended in 1981, with the state winning permission to proceed with the plan. The site at Hart and Miller islands was seen as the only practical place in the area large enough to receive the vast

Figure 1

Back River

Hart Island

Miller Island

Chesapeake Bay

N

Figure 2

New Beach

- 1,140 Acres -

Dike

1 Mile

2 Miles

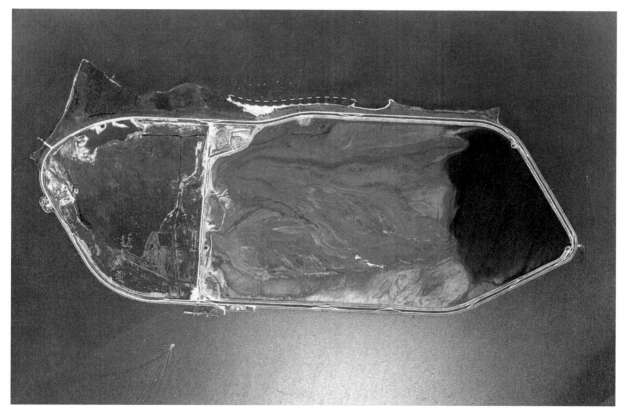

Hart and Miller islands became Hart-Miller Island as dredging spoils were deposited beginning in 1987. Maryland Port Administration

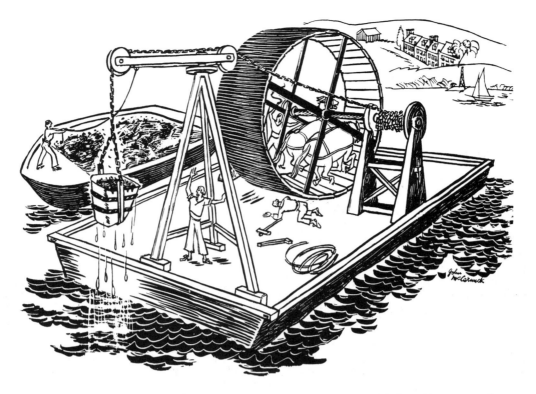

Dredging 200 years ago: the "mud machine." Drawing by John McCormick for *Baltimore* magazine

amounts of spoil generated by scooping out eight feet of mud and sand at the bottom of the shallow portions of the shipping channel.

Construction of a holding dike off Miller Island began late in 1981, using state funds. But the actual dredging was stalled until 1987 by controversy over how the estimated $240 million in costs would be apportioned among the state and federal government and private users benefiting from the deeper water.

As it turned out, the site was not large enough to hold all the dredged material. As Hart-Miller began to reach capacity at the end of the century, the Port Administration looked for other sites. In October 2002, the state's transportation department put a $49,139,000 figure on a plan to place spoil in and near Cox Creek, on the south side of the Patapsco River east of the Key Bridge. The plan entailed use of 137 acres that included an old Kennecott copper plant and 206 acres purchased from CSX railroad. The Port Administration embarked on experiments to see if the sludge could be put to "innovative use," in products from bricks to garden fertilizer.

Meanwhile, the quest for sites to dispose of "clean" spoil, that from open bay dredging, led to an expensive but bold plan to rebuild the vanishing islands of the Chesapeake. Poplar Island, off Tilghman Island, had been nearly submerged by erosion and rising waters and was the first to return to life, bargeload by bargeload.

◤ ◤ ◤

Considering the pollution from industry, along with the debris and raw sewage washed into the harbor during heavy storms, one would expect Baltimore's harbor water to have the esthetic qualities of a cesspool. The reason this is not the case was discovered during a three-year study conducted by the Chesapeake Bay Institute of the Johns Hopkins University between 1958 and 1961. The study found that the harbor flushes itself far more rapidly than anyone would expect, because of a layer of water that moves out of the harbor at intermediate depths. It had been assumed that flushing was accomplished by the sluggish two-layer process that occurs elsewhere in the

Watching an eclipse of the sun from Bay Island Beach, next to Hart Island, August 1951. The 105-foot tower at right is a range light for Craighill Channel. It guides ships approaching Baltimore harbor from the south. Robert F. Kniesche Collection, Maryland Historical Society

bay, whereby salty bottom water slowly moves up the bay, while fresher surface water slowly moves out. Instead, the researchers found that both bottom and top layers flow into Baltimore harbor, while the middle layer, of intermediate salinity and density, flows out. The surface layer of incoming low salinity or fresher water is driven primarily by the powerful Susquehanna River, which enters the bay about 40 miles north of Baltimore. This unusual action, combined with in-and-out flows of the tides, causes 12 percent of the harbor water to be replaced with bay water each day.

THE MUD MACHINE

In 1783, John and Andrew Ellicott built a wharf at Pratt and Light streets to export their flour. To deepen the water they used scoops drawn by horses and raised by a windlass. This was the first dredging effort in Baltimore harbor. That same year, Maryland's assembly created a board of port wardens to manage the port and see to its dredging. Their greatest immediate challenge was to control Jones Falls and fill in the large marshy areas at its mouth. The wardens had authority to levy a penny per ton on cargo entering and leaving the port (raised to 2 cents in 1788) in order to raise funds for dredging.

In 1790 the wardens approved the construction of the first "mud machine," a contraption operated by

Two skipjacks and a bugeye head for the oyster beds in this photo, taken at dawn. Chesapeake Bay is Maryland's richest treasure and, historically, one of the most prolific seafood producing bodies of water in the world. Its protection from man's excesses is a continuing concern. Robert F. Kniesche Collection, Maryland Historical Society

horses treading on a circular "horseway." The mud machine proved effective in digging mud from the harbor and placing it on a scow, but the unloading of the scow was slow and difficult. In 1827 the horses were replaced by a Watchman and Bratt steam engine—the first power-driven dredge—but this put expenses beyond the scope of the 2-cent user tax. Maryland's senior U.S. senator, the Revolutionary War hero Gen. Sam Smith, introduced a bill in Congress for the first time seeking federal assistance for Baltimore harbor dredging.

The port wardens were reduced to a single warden in 1850; that individual was replaced by a harbor board in 1876, a structure which operated for eighty years until replaced by the Maryland Port Authority in 1956.

INDEXES